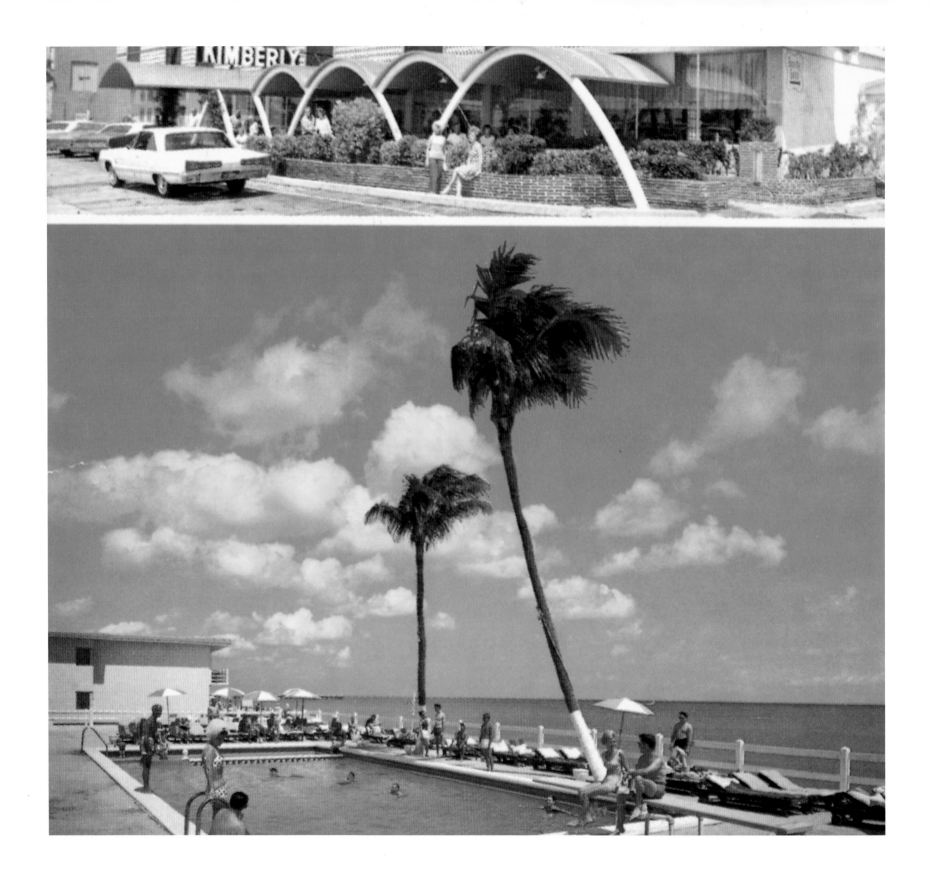

MiMo

ERIC P. NASH & RANDALL C. ROBINSON JR. MIAMI MODERN REVEALED PREFACE BY LAURINDA HOPE SPEAR

CHRONICLE BOOKS

SAN FRANCISCO

Library of Congress Cataloging-in-Publication Data available.

ISBN 0-8118-4204-5

Manufactured in China.

Designed and typeset by Ph.D.

Distributed in Canada by Raincoast Books
9050 Shaughnessy Street Vancouver,
British Columbia V6P 6E5

10 9 8 7 6 5 4 3 2 1

Chronicle Books LLC
85 Second Street
San Francisco, California 94105
www.chroniclebooks.com

PHOTO CREDITS: *A=Above, AL=Above Left, AR=Above Right, B=Bottom, BL=Below Left, FL=Far Left, L=Left, R=Right, T=Top.* A.P. Worldwide 28. Courtesy of Bass Museum 67. Teri D'Amico 40A, 41AR, 42, 44R, 48, 51R, 160, 161. Black Star 65L, 77R. Courtesy of CBS Archive 76. Corbis 77L. Thomas Delbeck 11, 27, 50, 54R, 55, 78, 79, 97R, 100, 102, 143, 146, 159. Esto Photographs 148. Courtesy of Norman M. Giller 57, 84, 85, 93L, 95, 104. Courtesy of Graceland 66. Robin Hill 47, 56L, 58, 61, 64, 65R, 69, 71, 72T, 73, 75, 88, 92, 93R, 98, 99A, 115, 125, 139, 144, 147, 150, 151, 152, 153, 157, 162, 164, 165, 167R, 168, 172, 173, 175, 184. Courtesy of House Beautiful 149. Kobal 17, 32L, 68. Library of Congress 38. Allen Malschik 18, 19, 62. Arthur Marcus 52, 59R, 126, 167L, 171. Eric P. Nash 9, 14T, 40T, 43, 94L, 128, 131, 170, 180T. Laura Nash 16, 36, 41AL, 41T, 44L, 45, 46, 51L, 56R, 59L, 72A, 74, 80, 81, 90, 94BL, 108, 114, 116, 117, 118, 119, 120, 122, 130, 154, 158, 176, 178, 179, 181, 182, 183. Ph.D 10 (map). South Florida Historical Society 10, 15, 31, 35, 135, 155. Vintage images 7, 8, 10, 14A, 22, 23, 25, 26, 54L, 83, 86, 91, 97L, 96, 99T, 105, 106, 107, 180B. Julian Wasser 32FL.

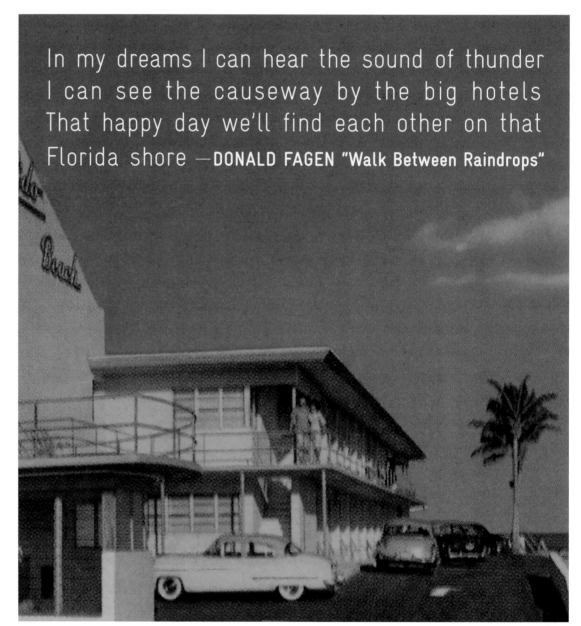

In my dreams I can hear the sound of thunder I can see the causeway by the big hotels That happy day we'll find each other on that Florida shore —DONALD FAGEN "Walk Between Raindrops"

TABLE OF CONTENTS

This book on Miami Modernism seems to me long overdue. Many of the architects that Eric Nash and Randall Robinson cover—Igor B. Polevitzky, Marion Manley, Alfred Browning Parker—are fine Modernists who have not gained the recognition they deserve.

As a native Miamian, I grew up with MiMo. Miami has its own look. A similar kind of midcentury modern can be seen in Los Angeles, Palm Springs, and even Tel Aviv, but MiMo buildings are different. As the authors note, no single element defines them all other than the common denominator of a shared time and place. MiMo includes the Subtropical Modern office buildings downtown, the Resort Modernism of the famous hotels in Miami Beach, and the motels in Sunny Isles. But MiMo is related to vacation architecture, or fun, or hedonism, being kind of off-duty. MiMo comes to grips with the fact that we are in the subtropics.

One thing I find especially interesting in this book is that Nash and Robinson include what I feel are the often-ignored buildings, like Norman M. Giller's Driftwood Motel in Sunny Isles (recently demolished)

and Robert Fitch Smith's Biscayne Plaza Shopping Center. These buildings have a lot to offer contemporary architects: the way inexpensive materials can have a certain glamour, how to accommodate the automobile, and how to respond to the subtropical climate.

I knew many of the architects in this book. I was interested in MiMo when I was a graduate student at Columbia University with Robert A. M. Stern in the 1970s, at a time when few were taking an interest in the subject. Even Morris Lapidus was not in good repute then. When I came back from my first summer working in Lapidus's office, I had to beg Bob Stern to invite Morris to lecture at Columbia, which after all was Morris's alma mater.

When I returned to Miami as a working architect in 1977, I very much liked Igor B. Polevitzky's aesthetic. He worked from a theoretical viewpoint, and he had a good eye. I went to see his last partner, Vernor Johnson, who gave me all the hard copies of his original work, because they were disintegrating and he didn't have any use for them. Becky Smith curated Polevitzky's work for the Historical Museum of Southern Florida.

I also knew Marion Manley, the first woman architect in Florida. A neighbor of mine was a newspaperwoman named Prunella Woods, and she and the great local environmentalist Marjorie Stoneman Douglas and Manley were the best of friends. Prunella was *scandalous*, and so far ahead of her time that she was shocking even to me. She called Marion "Archie," for architect.

Archie was something of a role model for me. She was a woman whom no one could take advantage of. I'm a little controlling, but not like her. She could be on the job site and control every last workman. She was just a tough cookie, which you had to be as a woman back then.

Another architect who is not as well known as he should be is Alfred Browning Parker. While Lapidus was his own best public-relations man, Al was his own *worst* P.R. guy—he moved to a farm in Vermont at one point, but he's a marvelous character, very much in the Wrightian vein.

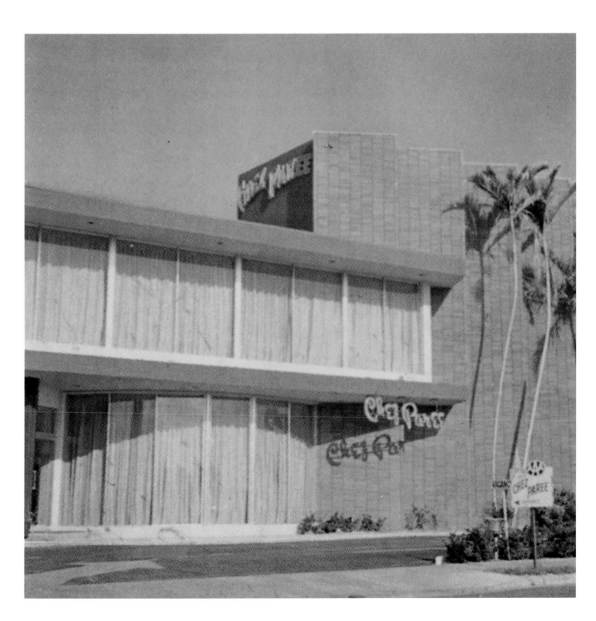

There's a real need to cultivate appreciation of MiMo architecture, because as Nash and Robinson note, these buildings are being knocked down even as you read this book. Barbara Capitman, who helped save the Art Deco buildings in South Beach, would have felt the same way about preserving MiMo. She was just working at an earlier time, with earlier buildings. MiMo has the potential to become as great a draw for Miami as Deco is, if we manage to save it.

—Laurinda Hope Spear

Laurinda Hope Spear cofounded the Miami-based firm Arquitectonica with her husband, Bernardo Fort-Brescia, in 1977. She has been a prime mover in putting the city on the global architectural map with colorful, concept-challenging, iconic buildings like the Pink House and the Atlantis high-rise condominium. As this book is going to press, Arquitectonica's Children's Museum opened on Watson Island in Miami's Biscayne Bay, along with the Cyberport Intelligent Building Complex in Hong Kong and a Peace Keeping Memorial at the United Nations in New York.

AN INTRO TO MIMO

Ever since Ponce-de-León sought the Fountain of Youth in 1513 near present-day St. Augustine, newcomers have looked to inscribe their personal mythologies on Florida's mutable landscape. Before Walt Disney turned central Florida wholly over to fantasy with the Magic Kingdom, South Florida had Miami, the Magic City, so named because it became a city almost overnight, without having been a town.

In Miami especially, reality begins with a dream. Julia Tuttle, known as "the mother of Miami," one of a handful of women credited with a role in founding a major American metropolis, dreamed of transporting the civilization of her native Cleveland to the subtropics, a Cuyahoga on Biscayne Bay. In 1895, she enlisted the help of one of the world's richest men, Henry Flagler, who had already made his fortune as a cofounder of Standard Oil with John D. Rockefeller but dreamed of linking mainland Florida into a railroad empire running across the water to Key West. It was an engineering feat considered impossible at the time.

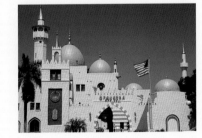

The peculiar dementia that seizes the newcomer to Florida takes the form of real-estate fantasies. In 1926, a wayward aviator named Glenn Curtiss, who got rich manufacturing Flying Jenny biplanes during World War I, conceived of the Arabian Nights–themed development of Opa-locka north of Miami, with miniature Moorish castles set on impossible-to-navigate concentric streets with names like Bagdad and Ali-Baba. Even the state anthem, "The Swanee River (Old Folks at Home)," was penned by a man, Stephen C. Foster, who never set foot there.

MiMo, shorthand for Miami Modern coined by one of the authors of this book, Randall Robinson, along with the Miami interior designer Teri D'Amico, whose photographs appear here, refers to the architecture that flourished in South Florida from 1945 until the late 1960s. MiMo is a manifestation of a dream: post–World War II American society's faith in progress and a future that rolled ahead endlessly like a shiny new stretch of Interstate. As multifaceted as South Florida itself, MiMo is not a single style, but rather a confluence that includes the world-renowned resort glamour of Morris Lapidus, the sublime Subtropical Modernism of Igor B. Polevitzky, and the flamboyant Latin infusion of Enrique Gutierrez, the architect of one of the South-lands' Modernist masterpieces, the Bacardi USA building. The common denominator is a time—the heady decades after the war—and a place—the subtropical environs of South Florida.

MiMo is made up of as many strands as a jungle liana, but can be divided into two major branches: the fantasy Resort MiMo of Miami Beach and Subtropical Modernism, an adaptation of the International Style to the local climate.

Resort MiMo is dominated by the towering figure of Morris Lapidus, whose lavishly ornamented hotel interiors were created as backdrops for the make-believe films that newly successful Americans imagined their lives could be like. Despite, or perhaps even because of, its popular appeal, Resort MiMo was considered something of an embarrassment

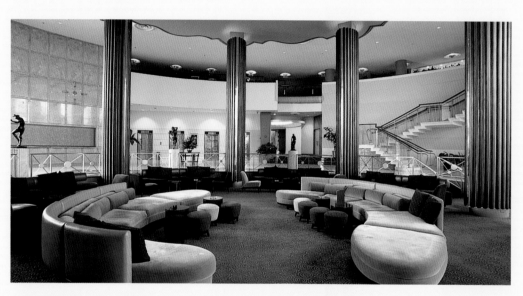

IN THE LAPIDUS OF LUXURY (ABOVE): Resort architect par excellence Morris Lapidus designed stage sets for America's emerging middle class, like the lobby of the Eden Roc.

SIGN LANGUAGE (OPPOSITE): Stylish supergraphic numerals adorn Gilbert M. Fein's residential and commercial building at 1200 Ocean Drive, turning the entire facade into a billboard.

ARABIAN NIGHTS (PREVIOUS PAGE): The architect Bernhardt Muller constructed fantasy domes and minarets for Opa-locka City Hall in 1926.

group of architects led the Miami chapter of the American Institute of Architects and their work was well represented in its monthly publication, *Florida Architect*, which Polevitzky happened to edit.

Other Subtropical Modernists included Marion Manley, the first licensed female architect in Florida, who, along with Weed, defined Subtropical Modernism at the University of Miami in Coral Gables just after the World War II. Alfred Browning Parker and Kenneth Treister, who identify them-selves as spiritual descendants of Frank Lloyd Wright, trained at the University of Florida and integrated elements of Wrightian organic architecture into their commercial buildings as well as their considerable residential practices.

Wright's legacy took a more populist form in Miami, notably in ubiquitous two-story apartment-motels by Gilbert M. Fein and others, who found an expressive, demotic vocabulary in free-style adaptations of Wrightian elements like faux gabled roofs, built-in planters, and stone pylons.

MiMo covers all forms of Modernism, from high to low. Miami's counterpart to the Modernist coffee-shop creations of Los Angeles, known as Googie, is the Pop

by the architectural establishment, and Lapidus did not gain critical acclaim until long after his working career.

Even half a century later, Lapidus's Fontainebleau and Eden Roc hotels still exert a fascinating appeal. This book explores equally eloquent palaces for the nouveaux riches like the Deauville and the Seville by Lapidus's chief disciple, Melvin Grossman, who also designed the iconic Caesars Palace in Las Vegas in 1966.

But resorts are only the best-known face of MiMo. In the same period, inventive Modernists like Igor B. Polevitzky, Robert Law Weed, and Robert Little sought to adapt the austerity and other signature elements of Mies van der Rohe's International Style to the local environment in a loosely federated school of Subtropical Modernism. This

Art iconography of Motel Modern in Sunny Isles, north of Miami Beach and on Biscayne Boulevard.

This book is by no means a complete catalog of Miami Modern. One visit will convince you that the subject is worth as many volumes as there are hybrids of Modernism in the sub-tropics. Think of this instead as a virtual tour guide to a dimension "not only of sight and sound, but of mind," in the words of a popular 1960s-era television show. Indeed, MiMo architecture is so prevalent in some parts of Miami that the experience is like entering a Twilight Zone.

The first chapter, "A Tale of Two Streets," recaps the history of this young city as seen through its two main MiMo thoroughfares, Biscayne Boulevard, or U.S. Highway 1, which was the first highway to the Magic City, and Collins Avenue, the spine of Miami Beach. Most of the sights are within an hour's drive of South Beach (traffic permitting).

The following chapters take you back in time to Miami Beach's dazzling debut as America's first international jet-set resort ("Resort MiMo") and Greater Miami's ascent toward its role as a hemispheric capital, and into the future for the outlook for preservation of this trove of mid-twentieth-century Modernism. MiMo is not strictly limited to Miami; Fort Lauderdale an hour to the north orbits in Miami's sphere of influence like a bright planet and is given its own chapter ("Fort Lauderdale Modern").

Along the way, you will learn to recognize the earmarks of MiMo buildings in "A Field Guide to MiMo" and see it in all its variety of expressions, from office towers with a subtropical flair to Vegas-style kitsch in "Motel Modern." MiMo is distinguished not only by great individual buildings ("Stars"), but also by whole neighborhoods and cityscapes that remain intact ("Constellations," in keeping with the space-age theme). The city's twentieth-century vintage is celebrated in its public buildings in "Monumental MiMo."

Profiles of the architects and larger-than-life personalities who helped shape the character of South Florida, from Lenny Bruce to Morris Lapidus, appear as road markers. Some of the city's lost MiMo treasures are memorialized in the Necrology sections at the end of the chapters.

Whether you're taking this tour by armchair or behind the wheel, put on your shades, slap on some of Miami's own Coppertone, set the stereo to Johnny Mathis or a bossa nova, and take a spin.

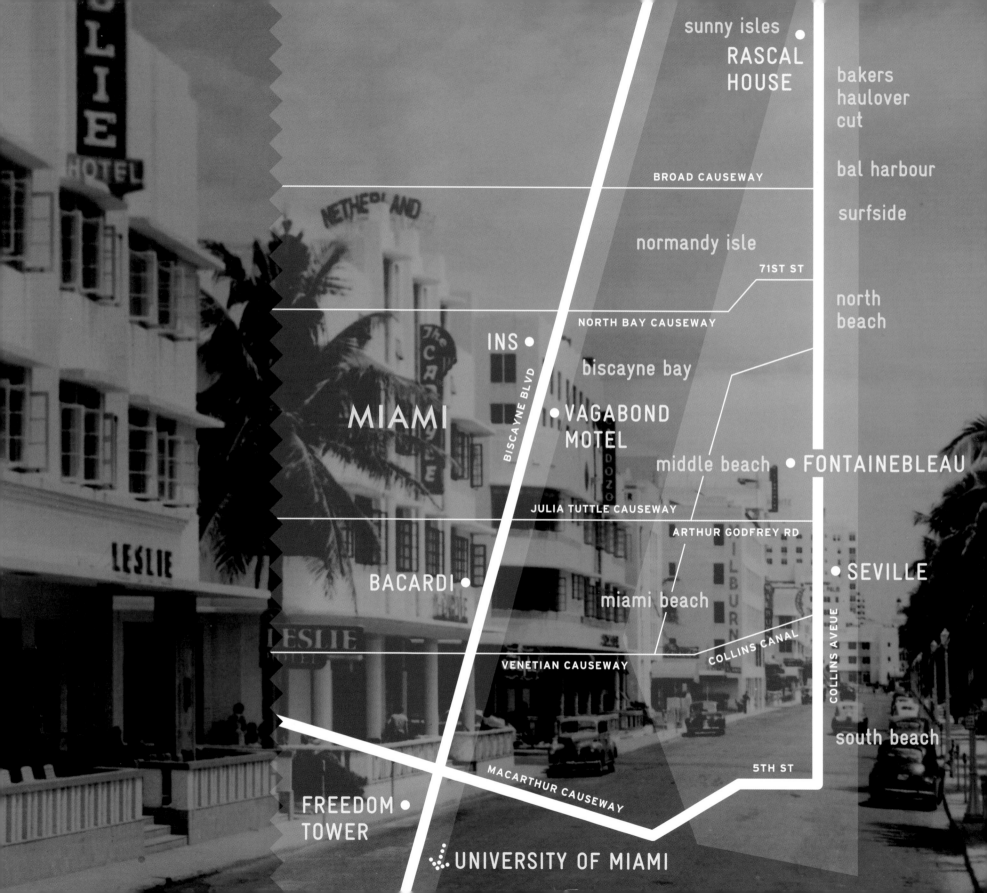

ONE

By the end of the nineteenth century, when Philadelphia and Boston were already centuries-old capitals of culture and commerce in the Northeast and New York was a teeming city of 4 million, South Florida was still as wild and woolly as any dime-novel Western. At the same time, the public conceived of Florida's exotic jungle landscape as a kind of American Eden. In a world of easy mobility, it's difficult to re-create the sway this subtropical state held over the popular imagination, when a fat Florida orange in a Christmas stocking was a present from a magical land where snow never fell.

The American character was formed by the existence of the wild frontier, according to historian Frederick Jackson Turner, which provided a safety valve to civilization for misfits, malcontents, poor people, and pioneers, a fair description of the early population of Florida. The U.S. Census Bureau declared that the Western frontier was officially closed in 1890, but in a real sense Southern Florida was America's final frontier. This was in large part due to the fact that land was simply uninhabitable until the twentieth-century developments of pesticides for mosquito control and air-conditioning. Well past other parts of the East Coast, Southern Florida remained an unspoiled place where Americans could reinvent themselves, a key theme in the development of Miami.

Since its beginnings as a fort during the Second Seminole War in the 1830s, Miami has been shaped by a rich polyglot of influences. Many of the first settlers were New Englanders joined by Bahamians of European and African descent. The tiny railroad outpost, alternately muddy or dust blown according to the season, was able to incorporate itself in 1896 only because of a convenient abundance of African-American laborers of voting age. Balmy winters ensured that the native population of Southern Crackers (not a pejorative, but so named for the cracking whips of cattle drivers who rode herd across Florida's grasslands) would be balanced by a considerable number of Yankee snowbirds of every social strata.

Modern-day Miami was forged by the confluence of tourism, transportation, and technology. The railroad had put Miami on the map as a tourist destination by the end of the nineteenth century, and the post–World War II period left the city with the infrastructure of a major airport and seaport, making it a crossroads of the Americas and the hub of Latin America and the Caribbean.

With much fanfare, Pan Am unveiled its four-engine, double-decker Clipper American service at its new terminal on Northwest Thirty-sixth Street in 1949. By 1952, more international travelers passed through Miami International Airport than Idlewild in New York. The first regularly scheduled domestic jet route in the United States opened between Idlewild and Miami International in 1958. When a new terminal opened the following year, it was the largest centralized passenger terminal in the world.

The Interstate system made Miami more accessible than ever. Air-conditioning, virtually nonexistent before the war, was installed in every major hotel by 1955. Mechanically cooling the air had actually been envisioned more than a century earlier by a Florida physician, Dr. John Gorrie, who saw that cool weather correlated with a drop in malaria cases (he missed the key vector of the mosquito), but American warm-weather rituals of straw hats and porch swings were slow to die out until postwar advances made air-conditioning affordable for the masses. The advent of air-conditioning turned South Florida into a year-round playland and a viable locale for a major metropolitan area (the fifth largest in the country at the time of this writing).

"Going home with Florida sand in their shoes" was the expression for the tens of thousands of World War II veterans who returned to take advantage of low-cost federal housing loans and find jobs in Florida's booming economy, pent up from years of wartime inactivity. The state's population grew by more than 80 percent by the end of the 1940s, and the population of Miami Beach doubled from 28,000 in 1940 to 46, 282 in 1950. The Florida economy also benefited from the postwar innovation of paid vacations. The Social Security system and an improving health-care system created a new retiree class, made up of many who had vacationed in Miami in the 1930s.

A PLACE IN THE SUN (TOP): Miami Beach offered low-cost homes for returning veterans.

THE ASCENT OF MAN (ABOVE): A period brochure charts the evolution of Miami from prehistoric wilderness through Native American and Conquistador days to railroad town and shining city of the future.

Before Gleason there was Godfrey.

As a self-invented twentieth-century city, Miami Beach had a fuzzy enough grasp of history to name a major thoroughfare after an all-but-forgotten TV broadcaster. It's hard for present-day audiences to comprehend Arthur Godfrey's influence. The former radio personality wasn't much to look at. With fleshy features, sun-blotched skin, and a shock of red hair, he was best known for sporting loud Hawaiian shirts and playing the ukulele.

But at his peak in 1952, when the Godfrey show appeared on both TV and radio, CBS reported that his weekly audience was 40 million people and that he "goes into more homes in America every morning than the milkman." His homely Irish mug was on the cover of TV Guide sixteen times. Even ukulele sales skyrocketed, from a steady 5,000 a year for two decades to nearly 2 million in his first six months on TV.

He sold. He sold like mad: toothpaste, peanut butter, cold medicine. His program accounted for 12 percent of CBS's corporate profits. He *was* the profit margin at CBS. Executives joked that he could smooth-talk folks into changing whom they would vote for. It wasn't far from the truth. Godfrey was a confidant of presidents and talked LBJ into adopting the long-range B-52 bomber for the broadcaster's good buddy General Curtis LeMay, commander of the Strategic Air Command.

"Godfrey was one of the first broadcasters to address each listener individually, to shed the tuxedo and 'ladies and gentlemen' approach and

talk to one person at a time," wrote his biographer Arthur J. Singer. Godfrey sounded as if he was right there in the kitchen, talking to you with his sleeves rolled up. Like Bing Crosby, Godfrey understood how to make a new, mass media as intimate as a whisper.

Godfrey was also a master pitchman for Miami Beach. Hank Meyer, Miami Beach's indefatigable public relations director for three decades, who later convinced Jackie Gleason to move there, suggested that Godfrey originate some of his shows from the Kenilworth Hotel in the posh postwar section of Bal Harbour. The show was the first network program to air live from Miami Beach, and indeed one of the first to be televised beyond the

New York studios of the four major networks, CBS, NBC, ABC, and DuMont.

One of his first broadcasts in February 1953 began with Godfrey in a boat. He dove into the water and swam to the shore of the Kenilworth. "Don't take my word. Come on down. Experience it for yourself," the man with the barefoot voice importuned, while an audience of 54 million, a third of the nation, looked on hungrily.

In a society increasingly motivated by image and desire rather than need, the tiny, flickering black-and-white picture of Godfrey under a palm tree that appeared in living rooms in wintry Scranton and Cleveland was the greatest tourism ad the city ever produced. "The phones rang off the hook," Hank Meyer recalled. "From that point on, Arthur owned the Beach."

Few who cross the Julia Tuttle Causeway into Miami Beach remember the hickory-smoked voice that made it famous when they come upon Arthur Godfrey Road. But if the U.S. Department of Defense had its way during the Cold War, Godfrey's voice would be the last one heard on earth. A tape-recorded message from Godfrey was secured in a vault to be played on the Emergency Broadcast System in the event of an all-out nuclear war.

"It was thought by the Eisenhower administration that two voices were well known and were trusted, and it was pretty tough to imitate us," Godfrey recalled in an interview for Public Television archives. "One was Edward R. Murrow. And the other was Godfrey."

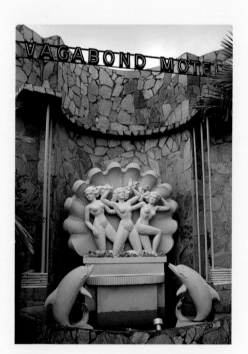

Grace figures of a triple Venus on the half-shell
flanked by dolphins, sculpted by the architect Robert
M. Swartburg, adorn his Vagabond Motel on Biscayne
Boulevard. Motel MiMo's pop baroque trappings
promised luxury for all.

But all was not well in paradise. Not all inhabitants were equally welcome. Long into
the postwar era, Miami was organized along the racial lines of the Jim Crow South. African-
Americans were restricted from the desirable waterfront neighborhoods and confined to the
inland side of Flagler's railroad, which ran along the coastal ridge. They were also barred
from Miami's beaches, until attitudes loosened somewhat after the war. None were allowed
in Miami Beach after dark until 1947, and the color barrier against staying in Beach hotels
wasn't broken until 1963, when Harry Belafonte defied it by staying at the Eden Roc.

Until then, Miami's African-American population, many of whom earned their liveli-
hood working in Miami Beach resorts, lived in Overtown, across the tracks of the Florida
East Coast Railroad from downtown Miami. The district's main thoroughfare, Northwest
Second Avenue, had been a thriving center of African-American culture since the 1910s and
was known as Little Broadway, featuring jazz royalty from Count Basie to Duke Ellington and
Nat "King" Cole.

In a classic case of "urban removal," the neighborhood was virtually razed to make
way for the concrete spaghetti of Interstate 95, which served the dual function of making
downtown more accessible to automobiles and dispersing the African-American population
away from the city center. The massive downtown interchange carved the neighborhood into
four sections and tore out its heart. The population of Overtown was reduced from forty thou-
sand to ten thousand by the time the Interstate was completed in the mid-1960s. Overtown's
residents fanned out to points north, including Brownsville, Allapattah, and Liberty City.

Miami is an American immigrant city in the making. In the 1930s, Miami Beach's
Jewish population swelled as hoteliers from the Catskills colonized South Beach. By the
1950s Miami Modernism was almost split along ethnic lines into the Jewish "Brooklyn
Baroque" of the Miami Beach resorts and the predominantly gentile Subtropical Modernism.
Although Jews assimilated into the mainstream after the war, anti-Semitism had been rife
in Florida through the 1920s and 1930s. In North Beach before the war, one gentiles-only
hotel even posted a sign that read, "Always a view, never a Jew." Some clubs in Palm Beach
retain a "gentleman's agreement" excluding Jews to this day.

Miami's makeup would never be the same after New Year's Day, 1959, when Cuban dictator Fulgencio Batista fled Havana with a suitcase full of cash, one step ahead of Fidel Castro's revolutionary *barbados* (bearded ones). By the end of the year, 35,000 mostly upper-class Cubans left the island nation for Florida. More than 60,000 Cubans emigrated each year until the Cuban Missile Crisis in 1962, when Castro halted all direct flights to Miami. Operation Pedro Pan, an airlift arranged by the Catholic Church, brought another 14,048 Cuban minors to Miami.

The first wave of immigrants settled in Riverside, west of downtown, an area known thereafter as Little Havana. Cuban immigrants began taking over the empty storefronts along the Tamiami Trail, formerly a Jewish enclave that became a casualty of flight to the suburbs. Southwest Eighth Street, better known as Calle Ocho, became the vital center of the immigrant community. Later arrivals settled in Hialeah. One out of ten Cubans left the country after the revolution. In 1959, Cubans represented 2 percent of Miami's population; by 1964, 14 percent was Cuban, and in 1980, the Marielito refugees freed by Castro raised the population to 42 percent.

While Greater Miami thrived through the 1960s, the resort scene fell out of fashion and its glittering hotels and condominiums became a symbol of Florida's overdeveloped coastlines. But a new source of revitalization was discovered in Miami Beach's Art Deco heritage, the concentration of small hotels built in the late 1930s. Barbara Capitman, the leader of Miami Beach's urban preservation movement and a key figure in establishing the Art Deco District in 1979, changed people's minds about South Beach by introducing the humanistic urbanism championed by writers like Jane Jacobs, who thought that big and new wasn't necessarily better. The messy, urban vitality of the old began to be appreciated in Miami.

South Beach was propelled into the limelight by the "pastel revolution" incited in the late 1970s by the New York artist and industrial designer Leonard Horowitz. Horowitz employed his architectonic painting style to bring out the rich details of the once all-white Deco buildings, which had been muddied down with earth tones in the 1960s and 1970s. The bas-reliefs sprang to life, and the world began to take note of the city that had already become the financial center of Latin America.

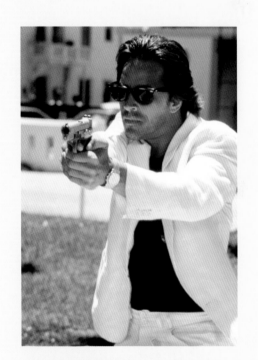

THE REVOLUTION WILL BE TELEVISED: The "pastel revolution" in South Beach, when the old Art Deco hotels were repainted in bright tropical hues, gained national attention from the hit television series *Miami Vice*, which starred Don Johnson as an undercover cop in unstructured Italian suits.

Television producer Michael Mann, who was scouting locations for a new police show, liked the look of refurbished Deco, and *Miami Vice* became the most-watched show on television. Seashell pink and aqua seemed to become the national colors in the mid-1980s, along with a menswear look of big, unstructured jackets over pastel T-shirts. (The show's stylists came up with the look, which hitherto had not been seen in Miami, as a way to disguise the heroes' gun holsters. Real Miami tough guys actually packed heat in Euro-style purses. Never mess with a man with a purse in Miami.)

It may seem strange to pin a city's revival on the success of a television show, but Miami's fortunes have long been intertwined with show biz. MiMo's peak in the early to mid-1960s coincided with the Fab Four, the King, the Chairman of the Board, the Great One, and the Greatest. Miami Beach lived up to the hype. For a moment, Miami Beach was a nexus of American entertainment, sports, and politics. Presidents and movie stars, columnists and kingmakers, mobsters, spies, and call girls slammed doors at the Fontainebleau suites like something out of a Feydeau farce.

The stars, resorts, and nightspots outshone the jet-set oases of Palm Springs

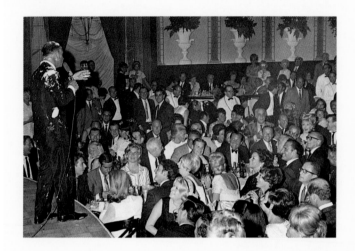

YOU HOCKEY PUCK! (LEFT): Don Rickles gets pie-eyed at the Eden Roc. Tuxedoes and evening dress were not uncommon in Miami Beach's glamour days. How many celebs can you spot in the crowd?

THE GIRL CAN'T HELP IT (OPPOSITE): Eighth wonder of the world, Jayne Mansfield poses poolside in a leopard-print bikini at the Montmartre (demolished). In its heyday, Miami Beach was Hollywood East for stars like Mansfield, who epitomized the aesthetic of more is more.

and Vegas. The Beach was the Borscht Belt South. In high season, you could take in Sinatra at the Fontainebleau, Sammy and Liberace next door at the Eden Roc, and Dean and Jerry at the Beachcomber. Every Catskills *tumler* from Milton Berle to Joey Adams broke them up in the "French-Haitian darkness" of the Boom-Boom Room. Joe E. Lewis yocked that the Eden Roc's Pompeian lounge was designed by Frank Lloyd *Wrong*. Georgie Jessel, Eddie Cantor, and Henny Youngman played pinochle in the Fontainebleau's Poodle Lounge. Tourists applauded when Garbo walked across the marble lobby. Celebs from Walter Winchell to Murph the Surf made the scene.

Flashbulbs: America's sweethearts, Eddie Fisher and his fiancée Debbie Reynolds canoodling *thisclose* in 1955. Steve Allen and Jayne Meadows doing the *Tonight* show live from La Ronde Room at the Fontainebleau in 1957. Jayne Mansfield, the bombshell whom no dress could quite contain, billowing out of her bikini top at the now-gone Montmartre Hotel. Jayne and her hubby, Hungarian muscleman Mickey Hargitay, honeymooned at the Eden Roc in 1958. "Miami Beach rolled out the rug for her," Hargitay said. "There were plans to name a street for her." The street turned out to be an alley behind the Twenty-third Street Fire Station, but it was the thought that counted.

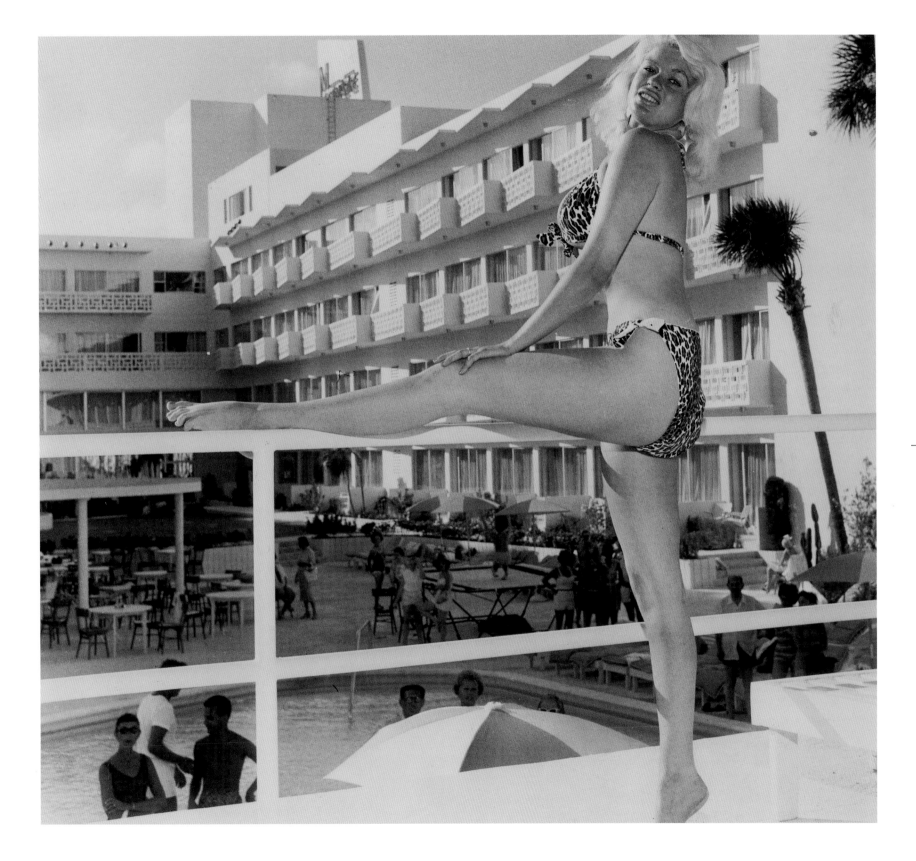

BREAKFAST AT PUMPERNIK'S

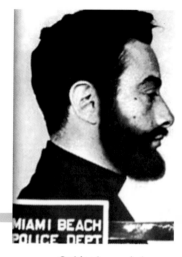

MIAMI BEACH
POLICE DEPT

Midcentury Miami Beach was such a happening place that you could hang out at Pumpernik's deli, Wolfie Cohen's old spoon across the avenue from the Deauville, and enough interesting people would show up to do a talk show, the way a young disc jockey named Larry King did. Lenny Bruce fell by King's show to trade barbs with Don Rickles, a caustic comic making a name for himself. Bruce did a bit where he dressed in a real Florida state prisoner's uniform and asked a cop on the street for directions.

Bruce supplemented his income from comedy gigs in Miami clubs by posing as a priest collecting money for a leper colony in British Guinea. "I had it made: a priest with a disease—an unbeatable combination," he wrote in his auto-biography, *How to Talk Dirty and Influence People*.

"The first place in which I chose to solicit funds was Miami Beach," Bruce wrote. "Honey was stripping there, at the Paddock Club, and I was working at the Olympic Theater in Miami. We were living at the Floridian Hotel." He hung his priest's vestments in the closet next to his stripper wife's G-string and spangles.

Wearing a clerical dog collar, Bruce cruised residential neighborhoods in Honey's 1949 Chevy ragtop with leopard-skin seat covers until he was busted on April 23, 1951. The arrest report for Leonard Schneider for vagrancy and panhandling read:

Received a call to investigate a man dressed as a priest soliciting funds for a lepor [sic] colony.

Found subject at the corner of 48th Street & Alton road, dressed as a priest, subject stated to the undersigned that he was soliciting funds for some non-sectarian organization that had sponsered [sic] a lepor [sic] colony.

Subject had no identification of any nature on his person and stated that he was not working, but that maby [sic] he would go to work this week end. Subject stated he was a comedian on the stage and appeared localy [sic] in night clubs under the name of LENNY BRUCE.

Subject was interrogated several times and the more he was questioned the more confusing his story became. Subject was taken by St. Pat's and questioned by one of the priests there and he inturn (sic) could not arrive at a definate (sic) decision as to subjects true object of work.

Bruce beat the rap because he actually was a licensed minister for an organization of his own creation called the Brother Mathias Foundation. He and Honey split for Pittsburgh.

"Lenny never stayed at swank hotels, even when he was making plenty of money," Larry King recalled. "His favorite hotel in Miami was the Shoreham Norman, an old, well-kept Jewish hotel down on Fifth Street where most of the clientele were older Jewish people. Lenny *never* stayed at the Fontainebleau."

BISCAYNE BOULEVARD: A RIVER THROUGH TIME

Biscayne Boulevard, which parallels the shore of Biscayne Bay from downtown Miami north to the city line at Eighty-seventh Street and beyond, cuts through layers of Miami's history the way a river wends through geological strata. Just a century and a half ago, bobcats, bears, herons, anhingas, and panthers were practically the only observers of an abandoned military outpost called Fort Dallas, which stood near the site of a former Seminole burial ground on the north bank of the Miami River, where the boulevard begins today. The fort was built in the 1830s during the Second Seminole War, but the U.S. Army abandoned the unforgiving mosquito-infested backwater by 1859. A decade later an enterprising Ohioan named William Brickell set up a trading post on the south side of the river. Buffered by the river from the hubbub of downtown, Brickell's lands would later become Miami's first exclusive suburb and winter retreat.

In 1890, the settlement of Lemon City sprang up on the shore of Biscayne Bay two miles north of the Miami River in an area called Billy Mettair's Bight, near the present intersection of the boulevard and Sixty-first Street. With deepwater access, the thriving community boasted a handful of hotels and saloons, dozens of houses, and a few businesses. In 1892, Lemon City became the first part of the Miami area to be connected to points north with the arrival of a paved road originating in Lantana, in present-day Palm Beach County. While Miami was still a gleam in the eye of an Ohio visionary, Lemon City and Coconut Grove, an 1880s village two miles south of the river inhabited by bohemians and "wreckers," who made a living by scavenging shipwrecks, were bustling outposts. The coming of the railroad catapulted Brickell's trading post and the settlement at the mouth of the river past Lemon City. The village's location on the water ceased to be an advantage as the railroad, slightly inland, became the area's primary lifeline.

The railroad, the area's first step toward becoming a twentieth-century metropolis, came in 1896 when the daughter of one of Brickell's rivals, a wealthy widow from Cleveland named Julia Tuttle, offered half of her six-hundred-acre estate on the north bank of the Miami River to railroad tycoon Henry Flagler if he would extend his rail line sixty-six miles south from its terminus in Palm Beach. Tuttle, a dreamer like many who came after her, was not content to live the narrow life of a society matron back home, but instead envisioned a metropolis on Biscayne Bay.

A killer frost in the winter of 1894–95 convinced Flagler to extend his empire south from Palm Beach. The citrus crop had withered all across Florida, except in the southeast part of the state where Tuttle's homestead was located. Folklore has it that Flagler made his decision upon receiving a bouquet of fresh orange blossoms from Mrs. Tuttle. In fact, it was James Ingraham, Flagler's chief surveyor, who wrapped unharmed orange blossoms from the area in moist cloth to bring to Flagler. If the weather was so kind to citrus, Flagler reasoned, it would be equally welcome to wealthy tourists. His railroad would make Miami only a two-day journey for winter vacationers from the urban centers of the East, which in the early twentieth century meant the rich.

The first train, laden with construction supplies, whistled into the terminal at the present-day location of Flagler Street and Northwest First Avenue on April 15, 1896, and the town was incorporated three months later on July 30. Voters expressed a desire to name the town Flagler, but he demurred

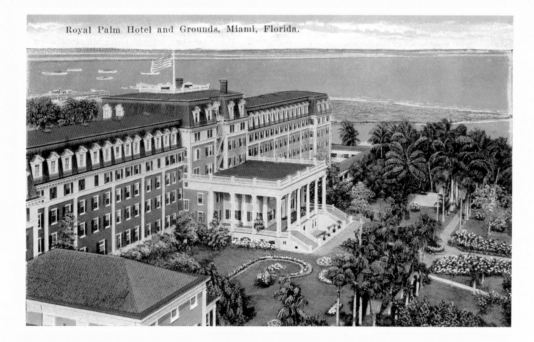

Royal Palm Hotel and Grounds, Miami, Florida.

END OF THE LINE (ABOVE): Railroad tycoon Henry Flagler built the magnificent Royal Palm Hotel (demolished) to entice passengers on his extension of the line from Palm Beach to Miami.

INSTANT SKYLINE (OPPOSITE): Downtown Miami, seen here between the wars, was poised to become the capital of the Southeast and the financial hub of Latin America. Miami is called the Magic City because it grew from railroad depot to urban center without ever having been a small town.

and the local name of Miami, said to mean "sweet water," was adopted. A royal palm tree, in honor of Flagler's planned hotel, became the symbol of the city seal. From the very beginning, Miami had its roots in tourism. Flagler's grand resort, the mansarded Royal Palm Hotel, opened in January 1899, on the property at the confluence of the Miami River and Biscayne Bay given to him by Mrs. Tuttle, close to where Biscayne Boulevard begins today. The hotel, a grand, five-story affair in canary-yellow clapboard, constructed at a kingly cost of $750,000 to accommodate six thousand guests, was built to stimulate travel on Flagler's railroad.

During the boom of the 1920s, a line of upscale hotels sprang up along Biscayne Boulevard north of the manicured grounds of the Royal Palm. An upstart city on the move, Miami bustled with stores, theaters, banks, real-estate offices, and restaurants that catered to the winter tourist trade. Photographs from the period show office workers in straw boaters riding crowded streetcars in a clamorous downtown. The portion of the boulevard along the downtown waterfront, once lined with docks and wharves, was transformed into Miami's most prestigious address by the creation of

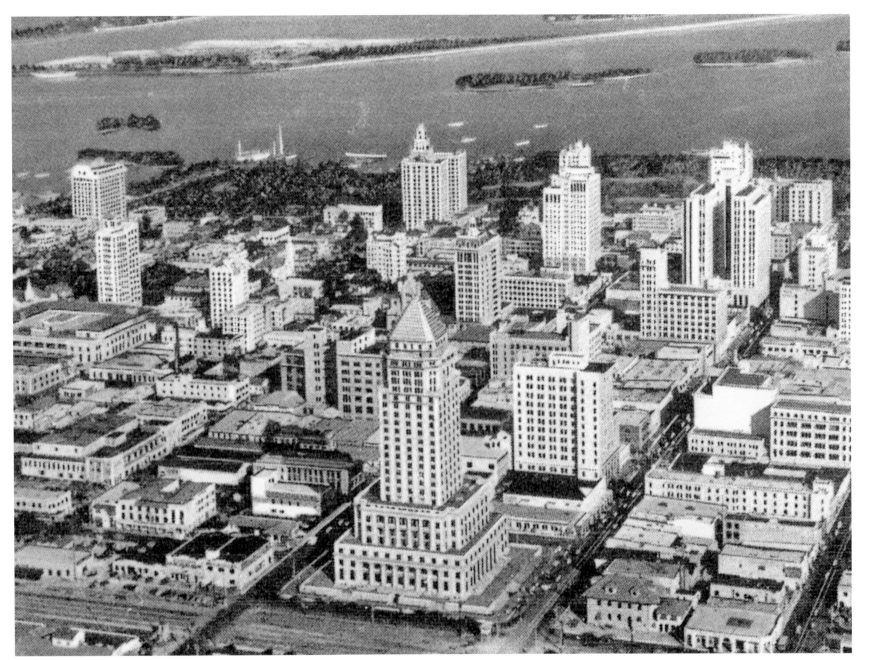

Bayfront Park, Miami's "front yard," in 1924. The project included the extension of the boulevard to the exclusive Edgewater area north of the city limits at Twelfth Street. The stretch along the park was landscaped into a grand allée with four rows of royal palms, giving the resort the exotic flavor of Rio de Janeiro. Today, driverless, electric people movers follow the elevated concrete path of the downtown Metromover loop, which truncated the allée of palms when it was built in the 1980s.

By 1931, the Royal Palm, once home to millionaires like John Jacob Astor, royalty, and opera stars, was a white elephant and a firetrap, and was razed to create an eight-block swath of downtown real estate that was partially filled in after the war with some exemplary MiMo office buildings. One of these, the Dupont Plaza Center of 1957, still stands at the very foot of the boulevard.

Biscayne Boulevard still evinces traces of all periods of Miami's architecture, sometimes in startling juxtaposition. The Mediterranean Revival–style Freedom Tower at Sixth Street, originally built as the headquarters of the *Miami Daily News* in 1925, is one of three evocations of Seville's Giralda tower in Miami by the New York–based firm of Schultze & Weaver, along with the Biltmore Hotel of 1925 in Coral Gables and the late, lamented Roney Plaza of 1926 in Miami Beach. In the 1960s, when the building served as a processing center for thousands of Cuban refugees fleeing Castro's regime, it was given the name Freedom Tower.

During the boom of the 1920s, the Shoreland Company, which was developing the City Beautiful suburb of Miami Shores several miles to the north, announced the extension of the boulevard to connect the then-remote development to the growing city. The bust of 1926 brought an end to the development company and its plans for easy access to the Miami Shores development.

Although the bust of 1926 nearly kept Modernist architecture from appearing in Miami until after 1935, there were some notable exceptions. In a portent of how American cities would develop after the Depression and World War II, Miami's first suburban commercial district emerged on Biscayne Boulevard north of Thirteenth Street in the late 1920s. The modern concept of the tranquil, leafy, and aesthetically pleasing suburban setting, easily accessible by private automobile, came appropriately wrapped in the up-to-date Modernist style of the period, Art Deco.

In 1927, Henry Phipps of the U.S. Steel Corporation and his family's Bessemer Properties completed the extension of the boulevard north to Miami Shores, slicing through private properties on the way, including what was left of Lemon City, relegating the once-thriving settlement to a footnote. Closer to the center of town, Phipps and family envisioned the blocks immediately north of Thirteenth Street as Miami's first posh suburban commercial destination. Although only a dozen blocks north of Flagler Street, where the grounds of the Royal Palm began, the family's Biscayne Boulevard holdings were then considered to be far from downtown's hustle, bustle, and congestion. The boulevard's intersection with the County Causeway (now the MacArthur Causeway) became the grand entrance to Phipps's new, suburban Biscayne Boulevard. The four corners of the intersection

were chamfered, and the streetcar line to Miami Beach, which followed the causeway over the waters of the bay, ran through the center of the resultant traffic island.

Phipps's vision began to take shape in 1929 with the opening of a Sears Roebuck store at the strategic intersection. Designed by the Chicago firm of Nimmons, Carr & Wright, the Sears store is recognized as Miami's first Art Deco building. On the next block, the Boulevard Shops by Robert Law Weed in 1930 is another fine vestige of the boulevard's Deco heyday.

A close parallel can be drawn between the Sears store and the development of suburban Biscayne Boulevard with the landmark Bullocks Wilshire department store by John and Donald Parkinson in 1928 and the development of Wilshire Boulevard in Los Angeles. Both stores signaled the rise of suburban commercial centers that in most American cities came to dominate and often obliterate traditional downtowns. Both featured prominent towers and became Deco icons in their respective cities. Both stores were built up to the sidewalk in the traditional urban manner but, in a sign of what was to come, also faced rear parking lots with spacious, covered drop-offs for those

arriving in chauffeur-driven automobiles. Finally, both would become victims of the very pattern of flight from the city center that they heralded.

The year 1929 also saw the opening of the North Bay Causeway over Biscayne Bay, aligning with Seventy-ninth Street. Known as the Seventy-ninth Street Causeway and later the John F. Kennedy Causeway, the connection between Miami and Miami Beach was developed by Henri Levy, a leading developer of the North Beach section of Miami Beach and parts of Surfside. Fortuitously, the causeway's completion coincided with the growing popularity of Hialeah Park Race Track directly to the west. The connecting thoroughfares of Seventy-first Street in North Beach, Normandy Drive in Normandy Isle, the North Bay Causeway, and Seventy-ninth Street in Miami became an almost straight shot due west from Miami Beach, linking its hostelries and wealthy winter residents with the racetrack and betting.

The opening of the North Bay Causeway made the intersection of Seventy-ninth Street and Biscayne Boulevard strategic as well, and a sprinkling of other Modernist commercial buildings followed in the 1930s. However, the main development of the

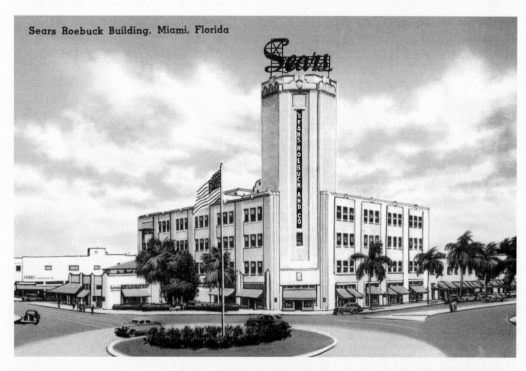

Sears Roebuck Building, Miami, Florida

DECO DEPARTMENT STORE: Designed by a Chicago firm, the former Sears building on Biscayne Boulevard is considered Miami's first Art Deco structure. Unlike many major American cities, including New York, Chicago, and Los Angeles, which defined their skylines with Deco structures during the Roaring Twenties, Miami proper has relatively few Deco buildings because of a real-estate collapse after the 1926 hurricane. However, the city emerged from the Great Depression earlier than other cities, and set its own style of Tropical Deco.

boulevard occurred after World War II, when it became Miami's prestige suburban office address. A string of high-style Subtropical Modern office buildings sprang up in the 1950s and 1960s. On the choice ten waterfront acres between the MacArthur and Venetian causeways stands Naess & Murphy's Miami Herald building of 1960, a high-style Modernist building that reflects the boulevard's postwar suburban cachet.

Catercorner from the Herald is the shell of the 1953 Jordan Marsh department store by Weed-Russell-Johnson Associates. The "store with the Florida flair" offered not only free parking for three thousand cars, but also moorings for customers arriving by boat. In 2002, Jordan Marsh, which had been enveloped by the Omni shopping complex in the late 1970s, was retrofitted with a MiMo touch as the new home of the International Fine Arts College.

Meanwhile, Biscayne Boulevard's status as U.S. Highway 1, the main north-south route from Maine to Key West, made it the logical location for motels catering to motorists arriving in the promised vacationland of Miami. An eye-grabbing Motel Modern culture emerged that was contemporary with, yet distinct from, that of Sunny Isles north of Miami Beach. The lots on the boulevard were smaller than those on the ocean. Most of the boulevard motels were built as typical roadside motels or prewar motor courts, serving the overnight trade, as opposed to the longer-stay destinations in Sunny Isles.

Today the MiMo constellation at Seventy-ninth and Biscayne stands as a poignant vision of the future as it looked in the 1950s. With its swooping glass lounge, the former Admiral Vee motel resembles an airport control tower. In spite of the effects of urban blight, the futuristic bridges that span the roadways of Biscayne Plaza Shopping Center, the continuous second-level catwalks, and the sculptural floating staircases still evoke the optimism of the era. The southeast corner of the shopping center once housed a popular Junior's Jewish-style deli, which formed a social center for the booming northern suburbs. Despite its automobile-oriented design, the plaza had an inescapably urban feel, exempli-

fied by a newsstand that once stood at the busy intersection in front of Junior's. The wooden shed, similar to those in traditional big-city downtowns, lasted until the 1990s. You can still make out its pale footprint on the bare pavement, from your passing car.

By the 1970s, Henry Phipps's tony suburban Biscayne Boulevard was succumbing to decay and urban renewal. Between Fifteenth and Thirty-sixth Streets, most of the neighborhood's fine 1920s mansions and commercial buildings were leveled in misguided redevelopment efforts. The remaining wharves north of the deepwater slip at Northeast Eighth Street were transformed into Bicentennial Park. Built to relieve a densely populated urban core that may yet materialize, Bicentennial Park fell into desolation and disrepair soon after it was completed in 1976. It has figured recently in vigorous debates on the proper use of vacant public waterfront land.

At the time of this writing, Cesar Pelli's new Center for the Performing Arts was rising across the elevated I-395 expressway from Bicentennial Park. Plans to bring the expressway below grade are gaining momentum, as if inspired by the brisk pace of construction at the performing arts center.

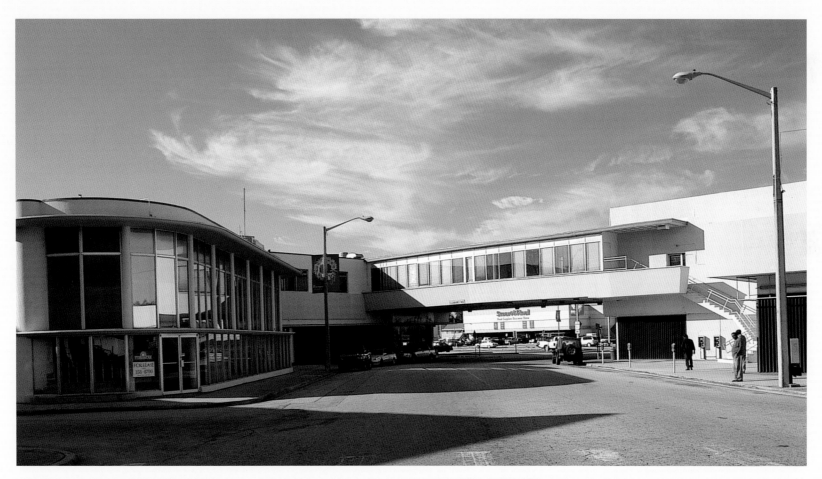

FIFTIES FANTASIES (ABOVE): Biscayne Plaza, Miami's first major suburban shopping center designed by Robert Fitch Smith in 1953, is a fine example of automobile-oriented architecture, complete with space-age touches like curved-glass corners, floating staircases, and overhead pedestrian walkways.

(OPPOSITE) Jordan Marsh, the "store with the Florida flair," even featured boat moorings to cater to its carefree clientele.

Despite a layer of blight and decrepitude, the boulevard percolates with indications of urban vitality. Signs in Creole hint at Miami's large Haitian community to the west. A restaurant in a glass lobby sporting 1950s-era George Nelson bubble lamps vies for attention with streetwalkers on the corner. Hipsters and drifters cluster at drive-up snack bars, a unique Biscayne Boulevard phenomenon. With seating provided by stools at pass-through windows, the snack bars are perhaps a portent of creative urban uses to come.

AN AMERICAN RIVIERA: COLLINS AVENUE

Like flipping through the pages of a picture-postcard history book, a drive on Collins Avenue traces the development of Miami Beach in almost chronological order. Cruising palm-lined MacArthur Causeway is a cinematic experience celebrated in countless movies from *Scarface* and *The Birdcage* to *Bad Boys II* and *2 Fast 2 Furious*. As you approach Miami Beach, you encounter one of the most extraordinary man-made sights in the United States: a cyclorama of skyscrapers stretching across Biscayne Bay. The effect is like being inside a snow globe looking out.

Try to imagine this paludal landscape as it stood less than a century ago, an inhospitable thicket of mosquitoes and mangrove forests, home to flora and fauna peculiarly adapted to the tidal environment, like the mangrove tree itself, the only land plant that thrives in saltwater, and the suckerfish, a fearsome-looking sea creature that can retain its own water on land and even leap to catch its food. What the land did offer was miles of virgin beaches, more sunny days than any state in the union, and pitch-perfect winter weather. A Chinese geomancer would say that Miami Beach, like Palm Beach, is a site supremely blessed for prosperity, because the sun rising from the ocean shines directly upon it. But it took a strange kind of visionary to cultivate the harsh beauty of this land. Miami Beach had more than its share.

Once a finger peninsula connected to the mainland, Miami Beach became the island it is today when Bakers Haulover Cut was dredged in 1924. The MacArthur Causeway connects with the Beach at Fifth Street, where in the early 1960s a young heavyweight contender named Cassius Clay trained at Angelo Dundee's little second-story sweatbox of a gym on

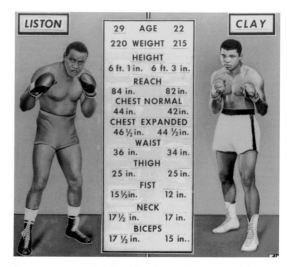

the corner of Washington, then would run home across the causeway in chinos and combat boots under the broiling midday Miami sun. This was before his epic battle with Sonny Liston at the Miami Beach Convention Center a dozen blocks north on February 25, 1964, when he rocked the boxing world by becoming world champion and then rocked it again a few days later by changing his name to Muhammad Ali.

Ahead lies the toy city of South Beach, a miniature skyline of Art Deco hotels that gleams Oz-like in the early morning sun. To the east is Ocean Drive, the sybaritic side of South Beach since the 1920s, and the premiere public beach of Lummus Park, named for the brothers J. N.

and J. E. Lummus, the pioneering bankers who filed the first plats of what would later become known as South Beach. In a rare gesture of civic vision, the brothers sold their oceanfront property between Sixth Street and Fourteenth Place to the city to create a park in 1912. Early photos show a shoreline much closer to the hotels than it stands today.

Less than a century ago, Miami Beach was the site of a plantation belonging to John S. Collins, an enterprising Quaker from New Jersey, for whom the central avenue is named. In 1868, Collins invested in a coconut plantation that stretched sixty miles north from Biscayne Bay to Lake Worth in Palm Beach County. The tender coconut shoots imported from Trinidad were eaten by wild rabbits, and the plants that did bear fruit were too remote from the nearest port at Key West to become a viable commercial operation. Collins came to Miami in 1896 to survey the failed plantation, then returned several years later to settle on a portion of the land that today is Middle Miami Beach. With a single-mindedness typical of those who would tame South Florida, he made a go of his own farm and prospered growing avocados, mangoes, and

potatoes. His success led him to envision a canal through the mangrove forests, which would cut the distance to the markets and depots of Miami from seven miles to two.

But where Collins saw only land for producing truck vegetables, his family, led by his son-in-law Thomas Pancoast, father of Miami Beach architect Russell Pancoast, envisioned something far more valuable: miles of virgin waterfront property directly across Biscayne Bay from the booming new city of Miami. By the early 1900s, the peninsula's ocean shore was already a favorite spot for day-trippers who arrived by ferry to picnic and "surf bathe," as it was called.

Coming from New Jersey, the Collins family was familiar with the success of Atlantic City. Here was a southern equivalent. To appeal to investors, Thomas Pancoast named the family's development company the Miami Beach Improvement Company, the first recorded evidence of the name of the city he founded in 1915 with the Lummus brothers and a mid-western tycoon, Carl Graham Fisher. Once John Collins's canal was complete, Pancoast set out to build the world's longest wooden bridge where the canal debouched into the bay. The Collins Bridge would be two and a half miles from anchor to anchor and run along the route of today's Venetian Causeway.

Pancoast ran out of money before reaching the halfway point, leaving what looked like the world's longest fishing pier. Fisher, a hyperactive, self-made millionaire from Indiana who had a winter home in the luxurious Brickell area of Miami, saw the half-finished bridge and marveled, "Where is it supposed to go?"

Fisher was cut from the same can-do cloth as Teddy Roosevelt. He had already made his fortune with Prest-O-Lite, the first automobile headlamp that did not run on kerosene. He also founded the Indianapolis Motor Speedway. He was looking for new worlds to conquer, and the half-mad scheme of turning a subtropical sandbar into a resort for millionaires appealed to him. In exchange for his rescue of the bridge project, Pancoast deeded him a swath of land between today's Fifteenth and Nineteenth Streets on Miami Beach to guarantee the loan. Fisher bisected the tract with Lincoln Road, the grand commercial boulevard of his resort.

In a hellish scene, Fisher hired machete-wielding Bahamian laborers to clear the land of its cover of saw palmetto, yucca, and mangrove forests, as high as seventy feet in places. The work progressed by inches as the men, blanketed by mosquitoes, hacked until their blades dulled against the nearly impenetrable, fibrous mangrove roots. Contemporary accounts said that the pack mules jumped into Indian Creek to drown themselves rather than endure the insects.

Fisher planned to replace the mangroves with pure white sand dredged from the bottom of Biscayne Bay. The cost of the operation was $50,000 a day, $1 million in today's money. Concerned friends back home sent for what was then known as an alienist, a psychiatrist, to examine Fisher, who was reduced to shouting a single, excited expletive, "Goddamn!" in response to anything. In her biography of her husband, Jane Fisher recalled that the money didn't seem to matter at all to him; he often remarked, "I just like to see the dirt fly."

Two million dollars and three million cubic yards of sand later, the denatured strip of land, with not a single leaf or blade of grass left, shone like sugar under the fabled Miami moon. The first cars crossed the bridge into Miami Beach in 1913, and the town was incorporated on July 15, 1915. A true believer in the future of the automobile, speed king Carl Fisher also developed the Dixie Highway, which originated in Mackinac, Michigan, and brought sun-starved midwesterners to enjoy the enticements of warm winters and flowing bootleg gin during Prohibition in loosely regulated Miami. Fisher died at the age of sixty-five in 1939. His memorial states: "He carved a city out of a jungle."

Miami Beach flourished as a playground for America's new class of self-made millionaires, who were considered to be coarse nouveaux riches by the old-money society of Palm Beach. These were the fortunes of which F. Scott Fitzgerald wrote, based on a limitless flow of consumer goods: Harvey Firestone, rubber; James Snowden, oil; Gar Wood, speedboats; James Cash Penney, merchandising. They built enormous Mediterranean Revival estates on the large lots just beyond South Beach. While the mansions on Collins Avenue have gone the way of the Charleston, many still stand on the west side of Indian Creek.

Real-estate speculation swept the island. Land was traded like futures: a buyer could lay claim to a property for ninety days simply by putting a "binder" on it, usually a down payment of 10 percent. The claim might appreciate astronomically in that period, from $500 to $5,000, and be sold again without any land physically changing hands. The binder boys, men in knickered white suits, loitered in hotel lobbies, reading the racing forms, smoking cheroots, and swapping lies and binders.

Despite the ensuing Depression, Miami managed to survive in relative style as a sleepy winter resort for the well-to-do. In 1936, in the very depths of the Depression, total applications for building permits in Miami Beach soared to an average of $1 million a month, for reasons yet unclear. Small hotels and apartment buildings rapidly replaced modest homes on the fifty-foot-wide lots first platted by the Lummus brothers. Between 1930 and 1939, the number of hotels more than quadrupled, from 60 to 250.

Carl Fisher's dream street of Lincoln Road began to live up to the moniker "Fifth Avenue of the South" as a Saks Fifth Avenue flagship store opened at 826 Lincoln Road in 1931. Car dealerships sold Fleetwoods and La Salles on the promenade, which had double sidewalks to accommodate both pedestrians and window-shoppers.

The undisputed king of prewar hotel architects was Roy F. France, a Chicago architect retained in 1935 by Chicago industrialist William F. Whitman to design the Whitman Hotel next to his oceanfront estate on Collins and Thirty-first Street. The Whitman was a watershed in Miami Beach hotel design: its cupola, arches, and balconets were a nod to the de rigueur Mediterranean Revival style, but its pared-down ornamentation signaled an emerging stylistic revolution.

France was joined by others, including L. Murray Dixon and Henry Hohauser, in creating an architecture out of cement block and stucco that wove together elements of Art Deco, Streamline Moderne, the International Style, and Hollywood set design. On the eve of World War II, France had completed the gracefully tapering silhouettes of the St. Moritz, Sands, National, Sea Isle, Versailles, and Cadillac hotels, stretching from Sixteenth to Thirty-fourth Street. A tiara of oceanfront Deco towers, a scaled-down version of an idealized jazz-age Manhattan skyline, ran from Henry Hohauser's New Yorker at Sixteenth Street to V. H. Nellenbogen's Lord Tarleton (now the Crown) at Forty-first Street.

When the Japanese bombed Pearl Harbor on December 7, 1941, South Florida seemed far from the global upheaval. But the U.S. Army Air Corps found Miami Beach to be a ready-made, year-round training ground for producing "ninety-day wonders," the amount of time it took to turn farm boys and office clerks into warriors. By April 1942, army personnel were garrisoned in 70,000 rooms in 188 Miami Beach hotels.

Khaki-clad men shouldering duffel bags down Collins, or falling out for reveille before dawn on Ocean Drive became common sights in the former tourist town. "It was surreal, going to the mess hall early in the morning with the colors of the sunrise on those white buildings," recalls Harvey Shapiro, a poet and airman who trained in Miami Beach. The Municipal Golf Course was converted into a mass drill field, and the beaches were used to stage war games and sea-rescue drills.

Despite the wartime dimout, the madcap nightlife in "Fort Miami Beach" never ceased. "Sumptuous gambling casinos operate full blast," *Look* magazine reported. "Black markets are rampaging. Everyone's having a wonderful time."

But the war was just offshore. In 1942 and 1943, twenty-five ships were torpedoed by wolf packs of Nazi U-boats in shipping lanes between Daytona Beach and Key West. As part of a ragtag volunteer navy, an inebriated Ernest Hemingway chased subs with a machine gun on his fishing boat, the *Pilar*, from his seaside *finca* in Cuba.

By war's end, fully one-fifth of the more than 700,000 men and women who served in the army air corps, as well as a young Navy pilot named George Herbert Walker Bush, had gone through basic training in South Florida. Many held fond memories of their days in the sun and made Florida their home after the war. "Many will come back to us," the president of the Fisher hotel chain predicted during the war, "either as citizens or guests."

Collins Avenue is a virtual time line of the postwar expansion. The 1950s begin with a bang at Forty-fourth Street, where the sweeping curve of Morris Lapidus's Fontainebleau echoes the bend in the road. While this book was being written, the view of the Fontainebleau from the south on Collins was partially restored by the removal of the south wing that blocked the view since 1970. A mural of the view on the sheer back wall of the wing had become an

icon in itself, featured in countless guidebooks and postcards. In a strange twist, removal of the mural sparked calls for its preservation. It was like preferring a billboard of the Grand Canyon to the original.

There is something ineffably glamorous about this strip of American Riviera, where the avenue broadens to become three lanes flowing in either direction alongside Indian Creek. It's almost impossible not to drift into a reverie that the setting is only a rear-screen projection for your own movie, in which you are the star.

Surfside 6, remembered chiefly for its inanely cheerful theme song set to a cha-cha beat, starring Troy Donahue as one of a trio of young bachelor detectives living on a house-boat, was filmed here. So were big-screen 1960s epics like *Goldfinger* and *Tony Rome,* when

Miami Beach was the epitome of luxe Americana. You might be Frank Sinatra with Jill St. John on your arm purring, "Drop me off at the Fontainebleau. I don't live in Miami Beach. I'm just down here losing a husband."

Collins winds through Condo Canyon and the MiMo Palisades of Middle Beach, an environment of nearly continuous high-rise facades that epitomizes the untrammeled development of the 1960s and 1970s But

AMERICAN RIVIERA (FAR LEFT):
Long before *Miami Vice* took the country by storm in 1984, Miami Beach was the capital of cool. Troy Donahue makes like a private eye with cardigan and tail-finned Caddy as Sandy Winfield II in *Surfside 6.*

MISE EN SCENE (LEFT):
The Fontainebleau stands as an icon of Miami Beach chic in *Tony Rome* (1967), with Frank Sinatra and Jill St. John. The hotel's penthouse was dubbed the Sinatra Suite.

the uniform architecture gives this MiMo constellation a certain urban grandeur.

North Beach is actually an archipelago of small communities. Some, like Park View Island just off Collins above Seventy-first Street, are pocket-sized islets, accessible only by small bridges not even depicted on standard maps. Park View is like the mythic village of Brigadoon that reappears every hundred years. Driving through its intact MiMo streetscapes of apartments built for the families of World War II vets, you can easily imagine yourself back in the 1950s. The streets have boys' names like Gary and Bruce, perhaps for the sons of the developers. Today, mainly Hispanic children play in the streets, waiting like the children of the baby-boom generation for their parents' voices to call them home to supper in the lengthening shadows.

Returning to Collins, you pass through the tidy municipality of Surfside, beloved by Isaac Bashevis Singer, past his residence at 9511 Collins and the street named after him. Sonny Liston lived and trained in Surfside in 1964, just to show he

had it made in the white man's world, but Cassius Clay messed with his mind, doing road-work past his house and taunting the surly champ with a bullhorn in the hours before dawn.

At Ninety-sixth Street, the modest charm of Surfside gives way to the haute glamour of Bal Harbour. To the west are the Bal Harbour Shops, Miami's equivalent of Rodeo Drive, and to the east is the Sheraton Bal Harbour, originally Morris Lapidus's Americana Hotel of 1956, still a favorite of high-security VIPs from movie stars to heads of state. Bal Harbour is the northernmost of the communities that share the barrier island with Miami Beach.

North of the Bakers Haulover Cut bridge lies the coconut-palm-studded South Seas landscape of Haulover Beach Park, a rare piece of public parkland that stretches from bay to ocean. The name *Haulover* is said to have arisen from the practice of hauling small boats overland the short distance between ocean and bay.

The last leg of this sentimental journey is through the faded carnival grounds of Sunny Isles, known as Motel Row, where phantasmagoric motels from the 1950s are giving way to forty-story, often fittingly fantastic residential towers. Even as this book was being written, a number of the great ones succumbed, like the Driftwood, the Dunes, and the Suez. It takes an extra amount of sympathetic understanding to project yourself back into Motel Row in its prime.

For a moment, imagine you've been driving south for days down U.S. 1 and then along coast-hugging Florida State Road A1A, which turns into Collins just before entering Miami-Dade County. Your chariot is a classic Populuxe machine, an aqua-and-white 1955 Chevy Nomad with an airplane ornament on the hood, linoleum floorboards, and 2.5 kids in the rear. Tired children press their noses to the glass and cry out to stop at the motel with the camels, or the pyramids, or one of dozens of other desert fantasies lit up in the tropical night. A bed beckons the weary, with the allure of sunrise over the Atlantic Ocean right outside your room.

You pull in for a late-night nosh on the turquoise banquettes of Wolfie's Rascal House at 171st Street, a landmark since 1954, before exploring the vast MiMo wonderland beyond.

GONE WITH THE WIND

Although Miami Beach is celebrated for its Art Deco buildings, Modernism got off to a late start in Greater Miami because of the great hurricane and bust of 1926.

Miami's boom in the first half of the 1920s, wrought in the fashionable revival styles of the time, was fed through the supply line of the Florida East Coast Railroad, which halted freight operations in the summer of 1925 to expand operations. To maintain the flow of building materials, all manner of watercraft were dragooned into service, crowding the harbor.

In January 1926, the schooner *Prinz Valdemar* capsized in the shipping channel, shutting down the port for ten days, bringing new construction to a temporary standstill, and weakening the local economy. Despite the disruption, the palatial Biltmore Hotel in Coral Gables, as well as its Miami Beach counterpart, the Roney Plaza, opened in time for the 1926 winter season. The extension of Biscayne Boulevard was started and, in August, Glenn Curtiss unveiled plans for the ersatz Arabian Nights development of Opa-locka.

Nevertheless, dark clouds continued to form on the horizon. A mild hurricane, the first in fourteen years, passed just north of the city in July of that year. There was little damage, and ever-optimistic Miamians looked forward to an economic recovery to keep pace with booming construction in New York, Chicago, Los Angeles, and other American cities, which were defining their skylines in the Art Deco style.

A second, devastating hurricane in September was the death knell for the boom. Newspaper headlines on the evening of September 17 warned of the hurricane's imminent arrival, but the populace had been lulled into complacency by the mildness of the earlier storm and made few preparations. Forecasters predicted the storm would strike Nassau.

While Miamians lay in their beds in the early morning hours of September 18, the barometer plunged at 5:30 a.m. to the lowest level ever charted by the U.S. Weather Service. Gale winds upwards of 130 miles per hour were recorded before the anemometer itself was swept away in the storm. Large boats were left strewn on Biscayne Boulevard as if discarded by a careless child, and Miami Beach looked like it had undergone mortar fire.

Residents unfamiliar with hurricane patterns rushed onto the Venetian Causeway to view the wreckage in the morning light, not knowing that the sudden calm was only the eye of the storm passing over, and that worse havoc was to follow. Onlookers were stranded on the narrow strip of land and swept into the bay. More than 113 Miamians died in the storm, along with all hopes for a recovery.

Miami underwent an economic bust a full three years before the stock market crash that triggered the Great Depression. As a result, the global Art Deco revolution of the 1920s and early 1930s, which transformed other major cities, was barely felt in Greater Miami.

However, Miami recovered earlier than other cities, beginning in 1935. The recovery was evident in the multitude of modern hostelries that effloresced in Miami Beach, in the style known today as Tropical Art Deco. Miami's only Art Deco skyscraper, the A. I. Dupont Building, rose downtown in the midst of a newly modernized Flagler Street, setting the stage for the arrival of MiMo after World War II.

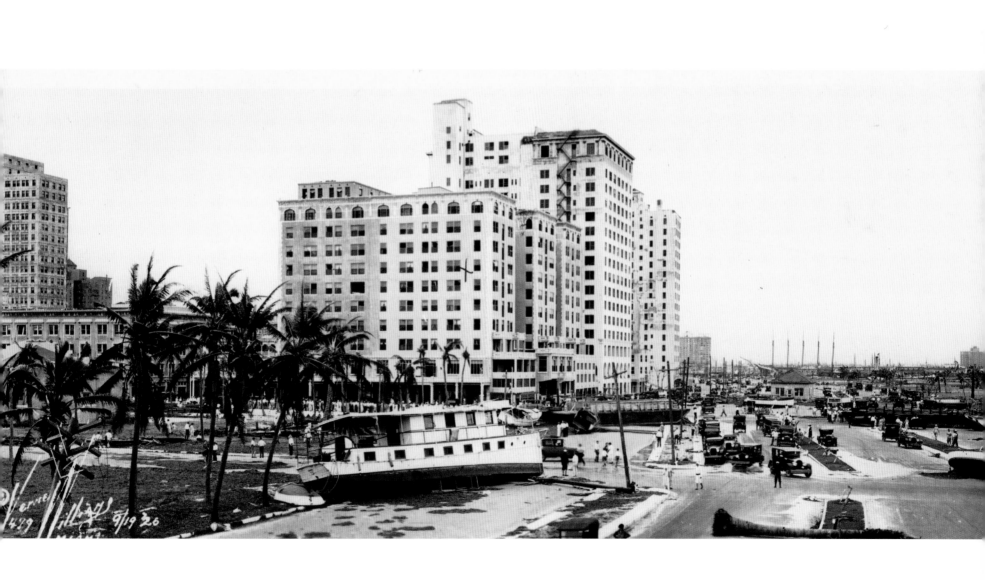

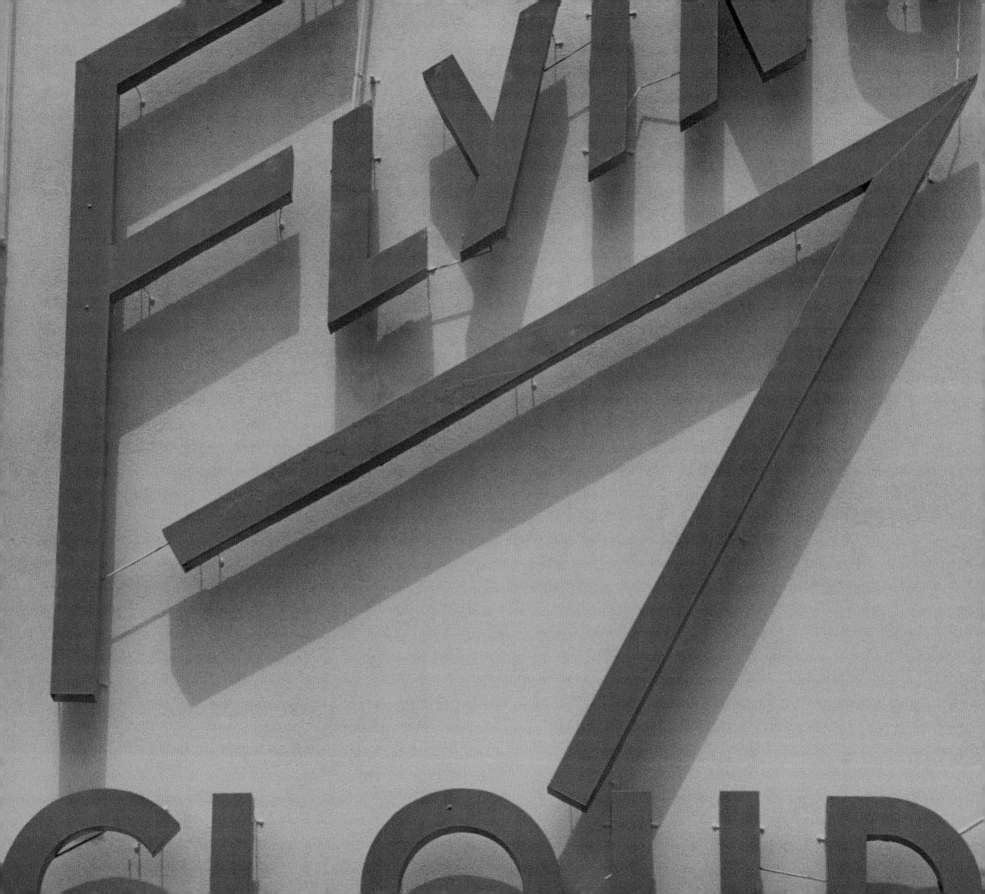

TWO

The broad and varied spectrum of Miami Modern was a natural, if sometimes jarring, progression from the local Modernist architecture of the 1930s. Tropical Art Deco, an inexpensive local synthesis of Art Deco and Streamline Moderne, offered tourists a unified backdrop of Modernist lines, modernized decoration, and colorful, stage-set-like lobbies. Meanwhile, the International Style, in which decoration was anathema and the functional expression of structure and materials was a virtue, made limited but notable appearances in what was still at heart a provincial outpost.

Postwar prosperity put Modernism on a collision course with the public's desire for luxury and display. Art Deco was old hat, but the mass market would never accept the idea that less was more. The fecund and fearless imagination of Morris Lapidus wrote the recipe for Resort MiMo in his iconoclastic Fontainebleau in 1954. The public embraced his academic heresies of highly ornamented interiors, stairways to nowhere, and columns that didn't support anything.

Resort MiMo is a quintessential product of the 1950s and 1960s, reflecting all the stylistic influences of the era, including lavish Hollywood sets, automobile styling, and the space race. It was driven by the same kind of market economics that drove the production of cars and consumer goods, where the premium was on newer, bigger, and better. As with cars, profits depended on the principle of dynamic obsolescence, pioneered by General Motors' design genius Harley Earl, in which newness was determined by stylistic innovation rather than technological advance.

Staying ahead of consumers' insatiable appetite for novelty required a healthy dose of futurism, as expressed in the space-age styling of the 1950s, which became an American obsession after the Russians launched the bleeping, beach-ball-sized Sputnik satellite into orbit in the fall of 1956. The American fascination with speed that manifested itself in streamlined design in the 1930s was updated to keep

HOUSE OF THE FUTURE (TOP): Elevations for Robert Law Weed's Florida Tropical Home of 1933 reflected the stripped-down look of the International Style.

(ABOVE) Although designed for the tropics, the house now stands as part of the Dunes National Lakeshore in Indiana.

pace with the delta- and swept-wing design of military jets. Applied symbols of acute angles, boomerangs, and trapezoids capitalized on the new shape of speed and ran like a leitmotif through MiMo iconography.

Some innovations did represent new technologies: the measured use of glass before the war gave way to double-height plate-glass walls as budgets increased and both glass-production methods and the ability to control the environment with central air-conditioning improved. But other developments were sheer style: the eyebrow features that once sheltered windows from the sun and dripping rain were plastically extended horizontally and vertically to become design elements in their own right. Art Deco symmetry was abandoned for more kinetic asymmetrical compositions, following contemporary trends in visual art. The sheer energy and creativity of the designs reflected the excitement as the center of the art world shifted from Europe to America.

Excess was taken for granted in Resort MiMo. "Let's just say you like ice cream," the maestro Lapidus said by way of an analogy. "Why have one scoop of ice cream? Have three scoops." Resort MiMo loaded three scoops on everything. Lapidus designed his over-the-top resorts for the masses of upwardly mobile Americans, accustoming themselves to luxury for the first time in their lives. "I designed what I do for *them*," Lapidus said, "the immensity of a meaningless lobby; the overabundance of beautiful antiques, the feeling of great opulence. When they walk in they *do* feel, 'This is what we've dreamed of, this is what we saw in the movies, this is what we imagined it might be.'"

The door to less fanciful Subtropical Modernism was opened by Robert Law Weed with his highly influential concrete-and-glass Florida Tropical Home, built for the 1933 Century of Progress Exhibition in Chicago. Remarkably, the original house was transported to what is now part of the Dunes National Lakeshore in Indiana. It has lost its original bright pink color, and the ceramic tiles of the roof deck could not withstand the harsh midwestern winters, but its square-volumed composition with a double-height, glass-walled living space to maximize air circulation can still be appreciated. Its minimal decoration was a portent of the stripped-down postwar style.

Subtropical Modernism arrived in South Florida with Weed's and Marion Manley's vision for the University of Miami campus in 1945, the first Modernist campus in the United States. Weed and Manley brought together under the Miami sun the machine aesthetic and functionalism of High Modernism with the earthy, modern American quality of Frank Lloyd Wright.

Frank Lloyd Wright's influence was pervasive in MiMo residential and commercial architecture. The rootedness in the landscape and incorporation of natural elements of his Taliesin West and the rustic yet High Modernist design of Fallingwater appealed to Americans' sense of national pride and desire for informal living. Architectural pattern books disseminated the surface motifs of Wright's work to countless apartment motels and suburban housing tracts in South Florida.

The task of adapting Wright's tenets to the unique conditions of South Florida was embraced fully by a group of idealistic architects known as the Coconut Grove School. A section of Miami that predates the founding of the city, Coconut Grove had been a haven for bohemians, intellectuals, and artists since the 1880s. This milieu was fertile ground for the ecologically harmonious, handcrafted Subtropical Modernism of Alfred Browning Parker, Rufus Nims, Kenneth Treister, and others.

Subtropical Modernism's International Style and Wrightian aesthetics were in sharp contrast to Resort MiMo. Like Wright's Prairie houses and Taliesin West, the glass walls, low-slung lines, flat roof with wide eaves, and free-flowing interior spaces of Mies van der Rohe's Barcelona Pavilion of 1929 made a potent building model for the flat, minimalist landscape of South Florida. However, High Modernism also influenced vernacular architecture: Gordon Bunshaft provided a paradigm of how to fuse mural art with glass walls for countless motel lobbies from Sunny Isles, Florida, to Wildwood, New Jersey, with his vibrant Venezuelan Pavilion for the 1939–40 World's Fair.

Subtropical Modernists devised a wide-ranging vocabulary of sun-protection devices to shield glass-enclosed, air-conditioned interiors from the scorching South Florida sun. Edward Durell Stone's experimentations with masonry ornament, particularly the perforated screen-block panels of his U.S. Embassy in New Delhi of 1958 were influential around the world, but found a special resonance in South Florida.

Because Subtropical Modernism was built to serve the needs of the year-round population, rather than just the winter tourist trade, the buildings were fully adapted to South Florida's hot, wet summers. Instead of employing air-conditioning as yet another object of conspicuous consumption the way the resorts did, architects designed breezy corridors and courtyards with shaded, covered galleries to supplement air-conditioned interiors and maximize use of the generally mild climate. Le Corbusier's Unité d'Habitation of 1947–52 in Marseilles was a seminal influence, as was the heroic Modernism of Oscar Niemeyer in Brazil.

Subgeneres of MiMo overlapped and influenced each other. Crab orchard stone, laden with connotations of nature, luxury, and leisure, was used by MiMo architects of all stripes. Stucco relief patterns and shadow effects are as common throughout MiMo architecture as sunshine in Miami. Glass mosaic tile was used in gaudy hotels and understated office buildings. Blue-green tile can be found in such diverse buildings as the Eden Roc, the 407 Lincoln office tower on Lincoln Road, the facade of a former Woolworth's in Surfside, and even the facade of good old reliable Wolfie's Rascal House.

Glass construction was embraced across the spectrum, from the canted double-height glass volumes of Motel Modern lobbies to the sublime jalousied walls of Robert M. Little's West Laboratory School on the campus of the University of Miami.

MiMo is a language with several distinct dialects. Following is a primer on how to speak MiMo.

THE ABC'S OF MIMO

ACUTE ANGLES. Close relatives of the boomerang, acute angles were inspired by delta-winged military jets that broke speed records in the 1950s. In the way that streamlining evoked mighty locomotives and nautical designs in the 1930s, the acute angle and the delta-wing shape became icons of speed in the postwar period. The motif was employed in two dimensions as a decorative element and in plan to give buildings a dynamic, futuristic look.

AGGREGATE. Stones, pebbles, or colored gravel in cement, left untreated for texture or polished mirror-smooth, were used to surface walls, floors, and paving.

ALUMINUM. Postwar budgets and advanced engineering and construction methods allowed for the use of this wonder material with a high strength-to-weight ratio. Plate-glass windows and doors are trimmed in aluminum. Through the electrochemical process of anodizing, protective and decorative coatings were added. Gold anodized aluminum was often used in sun grilles.

ARCHITECTURE PARLANTE. Architecture imbued with symbolism to communicate its function. Also known as programmatic architecture.

ASYMMETRY. In a clean break with the past, Modernism rejected Beaux Arts ideals of balance, symmetry, and hierarchy, which pervaded Art Deco. Modern engineering made irrelevant the centuries-old reliance on Classical orders in aesthetic compositions and elevations. In plan, asymmetry expressed the American desire for informality and individuality.

(TOP) Simple geometric forms in metal grilles create abstract compositions in light and shadow.

(ABOVE) Thin rods called beanpoles are a common decorative touch both inside and out.

BAROQUE. The lush ornamentation, lavish materials, and awe-inspiring interior space of late Renaissance architecture provided inspiration for Morris Lapidus and subsequently his colleagues in the pursuit of Miami Beach pleasure domes.

BEANPOLES. Thin metal rods used as decoration and for space modulation appeared in interior and exterior spaces. Often projecting from planters in all manner of balconies, lobbies, stairways, and porches, beanpoles were introduced in the interiors of Morris Lapidus.

BOOMERANGS. The boomerang shape, an aerodynamic curve with primitive connotations, became another shorthand for speed. The nationwide popularity of the boomerang made it ubiquitous in MiMo, appearing in two- and three-dimensional forms in apartment buildings, supermarkets, and motels.

BOXED WINDOWS. After World War II, Art Deco eyebrows were elongated into both horizontal and vertical decorative elements, often framing compositions of windows and faux-brick panels. The boxes, or frames, were often flared or tapered for an aerodynamic effect.

BRISE-SOLEILS. Fixed concrete louvers were introduced as shading devices by Le Corbusier in his seminal residential towers. In the Americas, Oscar Niemeyer of Brazil also enlisted brise-soleils as an essential component of tropical modern architecture.

BUILT-IN PLANTERS. In his Prairie houses, Frank Lloyd Wright often employed successively smaller planters at the bases of exterior walls and corners to anchor the structure to the landscape and create a gradation from the architectural to the natural.

CANTED WINDOWS. To push the envelope of the Modernist use of glass, postwar architects often tilted glass walls outward from the base, typically seen in motel lobbies, storefronts, gas stations, and fast-food restaurants.

BOOMERANGS (TOP): As seen in this mural on a Publix supermarket, convey the sunny spirit of the era.

(ABOVE, LEFT) A 3-D window framed in a palette shape.

(ABOVE, RIGHT) Cutouts are another inexpensive way to mine gold from Florida sunshine.

SAY CHEESE (BELOW): This curved tower, which evokes marine imagery, is also a study in cheesehole ornamentation.

(BOTTOM) Compressed arches are a distinctive MiMo detail.

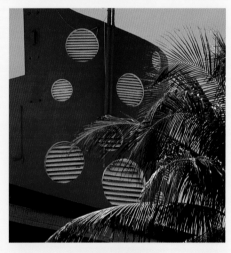

CANTILEVER. A beam or other projection that is unsupported at its projecting end. Cantilevering shows off structural innovation and contributes to asymmetrical design. In the International Style, cantilevering made possible projecting canopies and balconies, also called tray balconies. Shallow masonry cantilevers, a MiMo ornamental device, evolved from eyebrows typical of 1930s Tropical Art Deco.

CATWALKS. A cost-saving device compared with enclosed corridors, exposed, cantilevered exterior corridors were a basic ingredient of two-story motels, residential apartment-motels, and schools throughout South Florida. Sometimes called galleries, the passageways provided a greater sense of independence to individual units.

CHALET STYLE. A close cousin to the bold gables of Wright's Prairie Style houses, the Swiss chalet style distilled the image of domesticity into a gabled front facade with a prominent, long-eaved roof. Multi-unit MiMo apartment-motels were often consolidated under a symbolic unifying gable roof, an expression of the American dream of a home of one's own.

CHEESEHOLES. Another Lapidus coinage, round holes of various sizes used in interior and exterior walls provide visual interest in an organic and Modernist way.

CLERESTORIES. Narrow window bands set close to the roofline let in natural light and emphasize airy structural compositions. Clerestories are a common feature in Wrightian residences and were also adopted by Resort MiMo architects for their Modernist appeal.

COMPRESSED ARCHES. Vertically squeezed or horizontally squashed semicircular arches, forming roofs or canopies, were a popular device borrowed from Brazilian Modernism. In MiMo apartments, these motifs were often the only departure from the antidecorative, anti-hierarchical aesthetic of Modernism, which disapproved of emphasizing entryways.

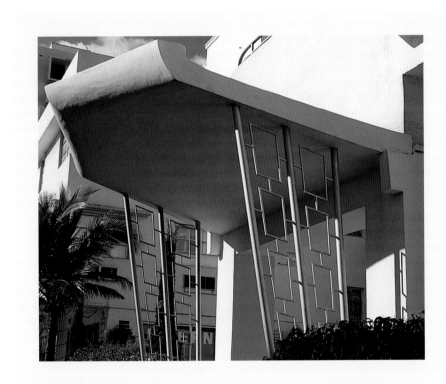

This rakish concrete canopy features rhomboidal decorative railings and canted beanpoles. To keep pace with new resorts in the 1950s, older Art Deco hotels in Miami Beach, like the Hotel Nash pictured here, sometimes jazzed up their entrances and lobbies with MiMo details.

CRAB ORCHARD STONE. Quarried in the Cumberland Plateau of eastern Tennessee, this hard sandstone became a defining decorative material in MiMo from the hotels of Miami Beach to the campus of the University of Miami. The popularity of the stone, which comes in shades of tan, buff, blue gray, and pink, was partly inspired by Wright's reliance on natural materials in his domestic architecture. The use of natural stone in the rec room of the House of the Future at the 1939–40 New York World's Fair strengthened the association of natural stone with leisure, informality, and the good life.

CURTAIN WALL CONSTRUCTION. A nonstructural exterior wall, usually of glass, steel, or aluminum, that is hung on the structural frame. Developed in cool, cloudy Northern European climates, glass curtain walls required shading with grilles, screen block, and louvers in South Florida.

CUTOUTS. The simple device of perforating eaves with circular or square openings hinted at the structural potential of modern materials and provided visual interest. Roof cutouts were usually paired

CONCRETE BLOCK AND STUCCO. Readily available, mass-produced concrete block became the standard South Florida building material from the 1920s onward. Stucco, an inexpensive fine plaster, was used to coat exterior block walls and was molded into decorative features. South Florida's fantasy architecture from Mediterranean Revival to MiMo futurism was often simply stucco "icing" on a standard "cake" of concrete block. In MiMo architecture, stucco was molded into myriad abstract relief patterns to harness the abundant sunshine for ornamental effect.

CONCRETE CANOPIES. Thin concrete roofs, which often projected outward toward a driveway, street, or parking lot, were often used to shelter building entrances. Minimalist canopies with an uplifting sweep or jaunty zigzag celebrate arrival at elegant MiMo apartment buildings.

with a corresponding planter to allow plants to grow through the openings. A palm tree piercing a perforated eave is a classic MiMo touch.

DECORATIVE RAILINGS. Railings along catwalks in motels and motel-apartments were frequently among the few opportunities for ornamentation, and appear in imaginative, abstract geometric and curvilinear compositions. North Beach is particularly rich in decorative railings.

EGGCRATE FACADES. The square or rectangular grid created by exposed edges of concrete floors and walls projecting outward from the building wall. Shallow modules provide shade to windows and a place to anchor brise-soleils, while deeper recesses are often used for terraces.

EXPOSED CONCRETE. In keeping with the Modernist tenet of the exterior expression of structure and materials, exposed concrete was used extensively by Le Corbusier, Oscar Niemeyer, and Marcel Breuer. The material was common in late MiMo, reaching high points in the Miami Marine Stadium and the Kendall campus of Miami-Dade College.

EYEBROWS. An example of styling in MiMo architecture, cantilevered sunshades over individual windows and doors in 1930s Tropical Art Deco evolved into continuous, horizontal cantilevers and vertical elements of varying depths.

FLOATING STAIRCASES. Flights of stairs without risers or sideboards, often cantilevered from a wall so that the treads seem to float without support, embody the space-age aspirations of the era and can be found in all types of MiMo buildings from residences to offices.

FOLDED PLANES. Inspired by the iconic roof of the U.S. Air Force Academy Chapel in Colorado Springs, concrete planes, folded into origami-like configurations, create a wealth of light and shadow effects. Used as

(ABOVE, LEFT) Abstract patterns on the decorative railing satisfied the need for ornamentation.
(ABOVE, RIGHT) Eyebrows, which once pretended to shelter windows from sun and rain, evolved into purely sculptural forms.
(OPPOSITE) Colorful glass mosaic tile captures the sunlight in all manner of MiMo buildings.

a purely ornamental device, folded planes appear in commercial MiMo architecture.

GLASS MOSAIC TILE. Glass tile, primarily from Italy, ranks with crab orchard stone as a common MiMo decorative material. Mosaic tile made a splashy debut in the full-height panels on the facade of the Eden Roc, and was later used to give color and sparkle to spandrels, public interior spaces, fountain basins, bathrooms, and other features.

HYPERPARABOLOIDS. Square and circular planes were warped into eye-catching topological shapes. Resort MiMo architects enthusiastically adopted the popular 1950s motif of acute hyperparabolic curves, seen in the extraordinary roof of the Best Western Marina Inn and Yacht Harbor in Fort Lauderdale or the daringly engineered canopy of demolished Diplomat Hotel in Hollywood, Florida.

INTERIOR AND EXTERIOR BLENDING. Continuity of interior and exterior space is characteristic of Modernist design in all climes, but South Florida's mild weather was especially conducive to the concept, most notably in the homes of Igor B. Polevitzky and the Coconut Grove School.

(ABOVE) Brise-Soleils, suspended in front of glass mosaic spandrels, were built to shelter windows from direct sunlight.

(OPPOSITE) This polychromatic metal grille evokes the Modernist élan of George Nelson's Marshmallow Sofa.

INTERIOR SPACE MODULATION. Modern construction and engineering freed architects from reliance on load-bearing walls, allowing for voluminous interiors unbound by walls and traditional room proportions. Drawing on his expertise in store design, Morris Lapidus pioneered the use of multiple floor levels to create subtle spatial transitions in his hotel interiors. Other space modulation devices include tray ceilings, banks of beanpoles, cheesehole walls, faux support columns, and ancillary enclosed volumes like reception desks and banks of elevators.

INTERSECTING PLANES. The mastery of man over materials was celebrated with masonry, stone, and glass planes that magically seemed to intersect and interpenetrate, in canopies that penetrate glass lobby walls and entire facade compositions.

JALOUSIES. Operable, narrow glass louvers were ubiquitous before air-conditioning, because of their ability to maintain ventilation during rainy weather. Jalousies of frosted glass simultaneously provided privacy and were used in a full range of sizes from small bathroom windows to long, floor-to-ceiling arrangements. The West Laboratory School at the University of Miami was the acme of jalousie construction.

KEYSTONE. A form of oolitic limestone, or oolite, quarried in Florida's Middle Keys, hence its name. Readily available, easy to carve, and textured with fossilized sea life, Keystone was used extensively in Mediterranean Revival and Tropical Art Deco. It was used less frequently after the war, almost invariably in random ashlar. Miami oolite is a softer, more porous type, which makes up the South Florida coastal ridge, commonly given the misnomer coral rock.

LETTERING. Certain typefaces on building signs, especially a round, upward-slanting script style, imparted a sense of carefree, casual 1950s living. Other motifs included sans serif letters, slanting italicized letters, and use of upper and lower cases.

LOUVERS. Originating as sun-protection devices for windows, louvers became elaborate design elements in their own right, but remained part of window compositions. Metal lou-

vers appear in either operable or fixed configurations. Brise-soleils consist of fixed concrete louvers. Wooden louvers were a common feature of Subtropical Modern homes; operable wooden louvers are known by their Cuban name, *persianas*. Often used in door panels, *persianas* were no doubt the inspiration for jalousies. Fixed vertical louvers, in metal or masonry, were also used to block direct sunlight and to create colonnade-like shadows, as in the Collins Avenue facades of the Seville and Golden Sands hotels, and Temple Menorah.

MARINE IMAGERY. Resort MiMo continued the Tropical Art Deco tradition of depicting aquatic images but in more abstract forms, like the graded shades of sea green tile rep-

resenting the ocean's depths on the facade of the Eden Roc. Representations of sea life, such as mermaids, dolphins, sea horses, and seashells, were common in residential and Resort MiMo, as well as Motel Modern, especially in Fort Lauderdale.

METAL GRILLES. Sometimes custom-made in an abundance of finely detailed designs, grilles were used in a similar manner as concrete brise-soleils and louvers to block sunlight. They were a ubiquitous feature of MiMo office buildings until they were made obsolete by reflective thermal glass. Metal grilles are sometimes used simply for decorative effect.

MURALS. Reflecting the popularity of the abstract, billboard-sized murals in Mexico City, large exterior murals appeared in MiMo architecture after 1960. The tile murals of the Bacardi USA building are one of the finest examples of Latin American influence on MiMo. At the Alexander condominium-hotel, Charles F. McKirahan employed a Polynesian-style full-height mural to give the narrow end of the building a strong presence on Collins Avenue.

OOLITE, MIAMI OOLITE. See Keystone.

Fun follows function in this three-story, circular exterior apartment stairwell, which effortlessly integrates beanpoles, decorative railings, spiral stairs, cutout and planter in a marriage of Modernist construction and the carnival spirit of a carousel.

PEDESTAL AND SUPERSTRUCTURE. Large Modernist buildings are often composed of a tower or superstructure atop a broad base. Pedestal-and-tower buildings were usually office buildings, but Resort MiMo architects adapted the configuration, which was subsequently copied around the world and known as the Miami Beach hotel type. In resorts, the wide pedestal was appropriate for housing lobbies, ballrooms, and meeting halls.

PILOTIS. Another adaptation of the International Style, cylindrical concrete support columns raised building masses above open ground levels and created areas of shade often used for parking.

PLATE GLASS. Thick sheets of high-quality glass were cast in broad plates and used in storefronts and hotel and motel lobbies. Steel-skeleton construction allowed for a generous use of glass, which became a hallmark of the International Style and a universal Modernist expression. In South Florida, a truly modern use of glass was not widely achievable until the MiMo period.

POPULUXE. A term coined by the architectural critic Thomas Hine, referring to the flamboyant decorative style of the 1950s and 1960s, which employed bright colors and futuristic contours to impart a sense of luxury to consumer items from appliances and cars to Miami Beach resorts.

PORTE COCHERE. In Resort MiMo, the driveway drop-off area becomes a dramatic ornamental device. In some hotel exteriors, elaborate, fanciful porte cocheres were the only break from otherwise purely Modernist designs.

PYLONS. MiMo commercial and apartment buildings frequently employed vertical masonry panels as the centerpiece of a facade of intersecting planes and volumes. Pylons were also the preferred location for automobile-scale signage. Reflecting the popularity of Wright's Fallingwater, pylons were often clad in crab orchard stone or slump brick.

RANDOM ASHLAR PATTERN. Paving or masonry consisting of stones cut into squares and rectangles of various sizes, or a faux version of this.

RIBBON WINDOWS. Horizontal window bands were another earmark of the International Style, with its non-load-bearing walls. Ribbon windows appear in all types of MiMo buildings, including offices, hotels, and institutional buildings. Banded windows imparted a strong Modernist character to hotels like the Fontainebleau and were shaded with sun-protection devices in Subtropical Modernist buildings.

ROMAN BRICK. Distinctively thinner and longer than conventional brick, roman brick was favored by Frank Lloyd Wright for its horizontality and fine texture, and became popular in the 1950s. Most roman brick in MiMo architecture is actually slumped brick.

ROUNDED EAVES. An easily distinguishable characteristic of MiMo apartment-motels and houses, thick, rounded eaves were used to impart a sense of fullness to otherwise spare, rectilinear structures and to emphasize a sense of shelter.

SAWTOOTHED FLOOR PLATES. MiMo hotel architects often designed floor plates with rooms set on the angle of a sawtooth, so that rooms facing north and south would have ocean views.

SCREEN BLOCK. Mass-produced, cast-concrete block was used in an imaginative variety of geometric and organic patterns to create stunning abstract compositions like the all-screen-block facade of the TechnoMarine Building and Wahl Snyder's McArthur Engineering Building at the University of Miami.

SCREENING. Subtropical Modernists fully integrated mesh screening into their residential designs as they adapted the open Modernist houses of semi-arid California to humid, mosquito-ridden South Florida.

SHED ROOFS. Wright brought the long, sloping shed roof, a feature of what Vincent Scully identified as the Shingle Style, back into the American mainstream with his design for Taliesin West. The shed roof became a shorthand for modern American

(ABOVE) Patterns in inexpensive masonry are used imaginatively to give texture and ornamentation to plain stucco surfaces.

(OPPOSITE, LEFT) Woggles are everywhere, even in this column with a conga-line kink.

(OPPOSITE, RIGHT) A circular cutout punctuates a vertical fin, expressing the era's fascination with the aerodynamic.

domesticity and can be found in countless MiMo houses and motels.

SLUMPED BRICK. Synthetic slumped brick was a ubiquitous decorative material in MiMo. The inexpensive concrete product came in a range of sizes, textures, and colors. Brick imagery balanced Modernism with a sense of tradition and domesticity.

SPACE-AGE IMAGERY. A number of MiMo landmarks capitalize on space-age imagery, such as the University of Miami's Pick Music Library, with its extending pods like those on a lunar landing module, and the Pepsi-Cola Bottling pavilion, with its spiraling floating staircases, a vision straight out of the 1953 film *The War of the Worlds*. Toward the end of the MiMo era, the television cartoon series *The Jetsons* reflected and parodied the period fascination with the future.

SPANDRELS. Panels placed between the window head of one floor and the windowsill of the floor above. MiMo spandrels are often clad in glass-mosaic tile or textured, painted stucco.

TEXTURED STUCCO. Inexpensive stucco lent itself to the creation of textures and abstract decorative relief in the abundant Miami sunshine.

TRAY BALCONIES. Cantilevered balconies with concrete parapets (low walls, usually formed by the projection of a wall above a flat roof) are used for their sculptural form in MiMo hotels and residences.

WOGGLES. The Lapidus version of biomorphic kidney shapes popular in postwar design usually appeared as ceiling coves or trays for indirect lighting.

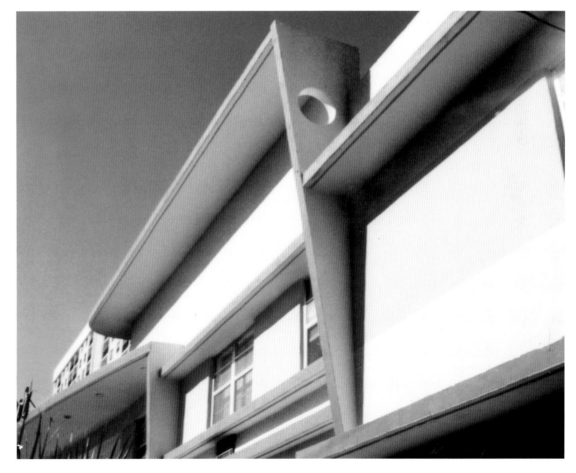

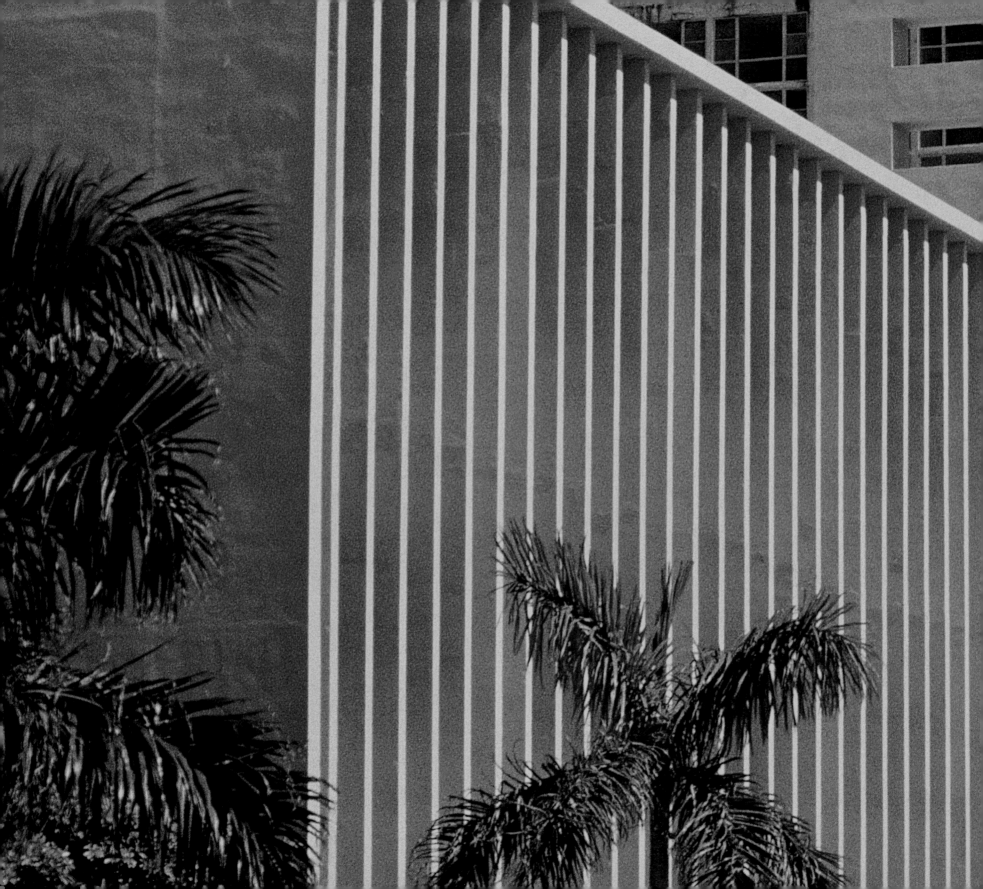

THREE

Miami Beach resorts were delirious stage sets designed to celebrate the arrival of the American middle class, the first broad-based middle class in the history of human society. In response to design vistas opened by Hollywood and over-the-top automobile styling from Detroit, resort architects including Robert M. Swartburg, Melvin Grossman, and the best known, Morris Lapidus, engaged the exciting possibilities of modern materials and engineering to construct a populist fantasy version of Modernism.

These brash architects were unafraid to revel in curves, color, and applied visual symbolism, all tabooed by the prevailing minimalism of the International Style as practiced by Mies van der Rohe and Le Corbusier. As a result, their work was drummed out of the canon of High Modernism and languished in neglect until the Post-Modern movement found the glass box to be a dead end and took a second look at how to reinvent and reinvigorate architecture. Architects like Lapidus are being re-appreciated for their comprehension and manipulation of Modernism, dynamic interior spatial compositions, and witty discourses on the relationship of Modernism to past historical styles. The hyperbolic arches, angles, and signage of the great 1950s resorts looked like heresy at the time, but now can be seen for their wealth of variations on the theme of Modernism.

Igor B. Polevitzky's Shelborne Hotel of 1940 at Collins Avenue and Eighteenth Street was a prototype for the post–World War II Miami Beach resort, because it was the first hotel oriented to the guest arriving by car. The original design of a long driveway with a paralleling thin, concrete canopy leading from the avenue to the hotel close to the beach was radically altered by Morris Lapidus's addition in the 1950s that filled in the open space in front of the tower.

In the original Shelborne, the motorist entered an impressive, block-deep driveway to pull up before a virtually freestanding, curved-glass lobby. The double-height glass enclosure was a forerunner of the architecture of transparency that typified postwar buildings, and served as a show window for the enticements of the lobby within.

SIGN OF THE TIMES (ABOVE): Igor B. Polevitzky's Shelborne Hotel of 1940, seen here in a vintage image before the addition of a front wing on Collins, was the first Miami Beach resort to address the automobile with oversized lettering meant to be read at a distance and a long driveway leading to a glass-walled lobby.

DOUBLE STACK (OPPOSITE): Henry Hohauser's Sherry Frontenac of 1946 featured automobile-scaled illuminated signage and innovative sawtoothed floorplates that gave side rooms an ocean view.

The entryway was part of a carefully designed program of spatial development that melded exterior and interior and was copied to some degree by most of its successors. The progression was audacious: the arriving guest, an arriviste in both senses of the word, was initially drawn in through the glass curtain wall by the distant vista of the ocean seen through double-height windows at the rear of the lobby.

The direction of movement had a participatory, almost cinematic feel as an establishing shot of the hotel was set up. As the car entered the driveway, the camera dollied in. The lobby then framed the central attraction of the beach. Finally, the guests, as stars of the show, were literally put in the picture as they ventured onto the beach. This progression was one of Polevitzky's major influences on postwar resort design. MiMo architects moved from a static, essentially theatrical presentation in Art Deco lobbies, which even featured elements of a proscenium in the format of pleats of masonry representing opening curtains, to a first-hand, participatory experience that captured the individualism and immediacy of postwar life.

Henry Hohauser ushered in the era of the grand postwar resort in Miami Beach with the style-setting Sherry Frontenac in 1946. The Sherry Frontenac abandoned the romantic, tapered massing popular before the war in favor of a more functionalist design, but still played on the region's vernacular by recalling twin ocean liners, complete with smokestacks and a "gangplank" bridge at the penthouse level. The hotel offered a host of postwar innovations. Full-height, vertical panels facing Collins Avenue sported back-lit neon signage at a scale large enough to be read by passing automobile drivers and from great distances. The floor plates of the towers were sawtoothed on the north and south sides to provide ocean views from every room. Instead of the tall, Classically proportioned shallow entry porticos of the Deco-era tower hotels, a low-slung porte cochere offered functional shelter for arriving guests.

The look of the lobby was still Miami Beach luxe, but was understated in response to growing mainstream acceptance of the International Style. An enormous chandelier hung from a rotunda with a clerestory. The bilaterally symmetrical, double-height lobby, dictated by the twin tower design, recalls the interior of an ocean liner.

Robert M. Swartburg's Delano Hotel on Collins at Seventeenth Street followed a year later, but still had one foot firmly planted in the Art Deco era. Its vertical thrust and winged

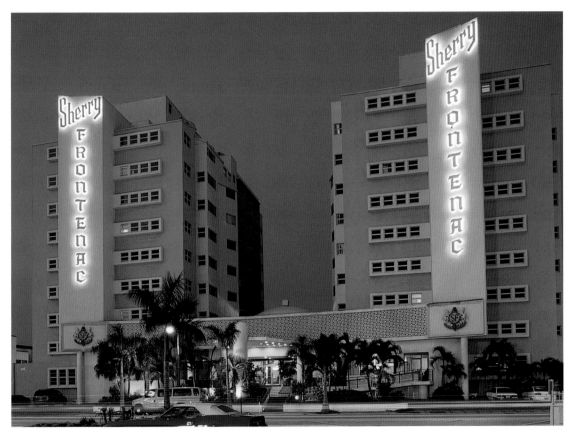

typical of the postwar style. Like the Sherry Frontenac, the Delano's floor plates are sawtoothed to provide ocean views, but Swartburg ingeniously used this bit of post-war functionalism for decorative effect on the street side.

Roy France established his primacy in the postwar pecking order with the open-ing of the Saxony in 1948. His design finally let go of ornamental flourishes like the Delano's winged finial and the Sherry Frontenac's nautical smokestacks in favor of bona fide Modernist details like continuous balconies and the sans serif neon sign on the roof, which would have met with the approval of International Style tastemakers Henry-Russell Hitchcock and Philip Johnson.

Built on the site of the Whitman estate across Thirty-third Street from France's Whitman Hotel, the Saxony was an immediate popular success and received the coveted Hotel of the Year award given by the Miami Beach Hotel Owners Association for an unprecedented three years in a row. The following year, on the other side of Thirty-second Street, hotel partners Ben Novack, Harry Mufson, and Harry Toffel, whose ambitions are writ large on Miami Beach's postwar landscape, felt robbed of

finial made a fine bookend to L. Murray Dixon's definitively Deco Grossinger Beach (now the Ritz Plaza) of 1940 across Seventeenth Street. The Delano's monumental entry canopy was also a complement to the canopy of Roy France's National Hotel of 1940 next door. The Delano completed South Beach's signature Deco skyline begun by the Ritz Plaza and the National before the war.

From the beach, however, the Delano reveals its split personality. The east facade is more in keeping with the International Style. Departing from the tripartite vertical thrust that greets the arriving visitor, the east facade is asymmetrical, breaking the mass into two rectangular volumes of different sizes, with balconies and generously glazed penthouses

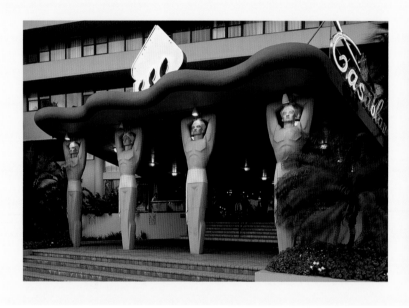

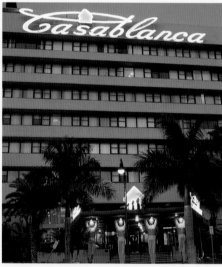

ROCK THE CASBAH (FAR LEFT): An Arabian Nights-themed porte cochere featuring giant genies supporting a woggled canopy greets arriving guests at Roy France's Casablanca of 1949, named for the film.

(LEFT) The showy entrance stands in contrast to the hotel's clean, International Style lines.

PASSAGE TO INDIA (OPPOSITE): A shy young couple sits amid the moderate splendors of Norman M. Giller's Bombay of 1951 (now the Golden Sands). MiMo elements included a woggled ceiling, cheesehole lights, and a wraparound, floor-to-ceiling glass curtain wall.

the 1949 award for their Sans Souci Hotel. The partners had hired France as architect for their hotel, but unimpressed by his designs, they called in a store-interior architect with a reputation as a "hotel doctor" for fixing other architect's mistakes by the name of Morris Lapidus. Lapidus's fix-up job on the Sans Souci became the springboard for his second career. While the exterior was France's and resembled his Casablanca of 1949, Lapidus put to work his extensive repertoire of interior effects. The Saxony's success set the stage for Miami Beach's most famous feud, which would be played out in the rivalry of the Fontainebleau and the Eden Roc hotels.

In France's Casablanca, named for the Humphrey Bogart film, the International Style collides head-on with Hollywood-themed kitsch. The tower is an austere International Style horizontal slab with ribbon windows and expressed stairwells, but what grabs the eye is the campy, Arabian Nights–style entrance, with four larger-than-life sashed and turbaned genies supporting a woggle-shaped canopy. Originally nude and anatomically stylized, the genies were clothed to curtail controversy. The hotel name is written on a two-dimensional

onion-domed minaret, lit up at night in exotic lapis-lazuli neon. This collision of styles, with no attempt to reconcile them, is part of what makes Modernism à la Miami Beach of interest to Post-Modernists.

Newer resort destinations like Las Vegas learned from the Miami Beach experience. There is in fact a genealogy of East Coast resorts. John Collins originally saw Miami Beach's potential as a resort because he was from New Jersey and was familiar with the success of Atlantic City and Coney Island, both of which were barrier islands in the Atlantic Ocean, like Miami Beach. When

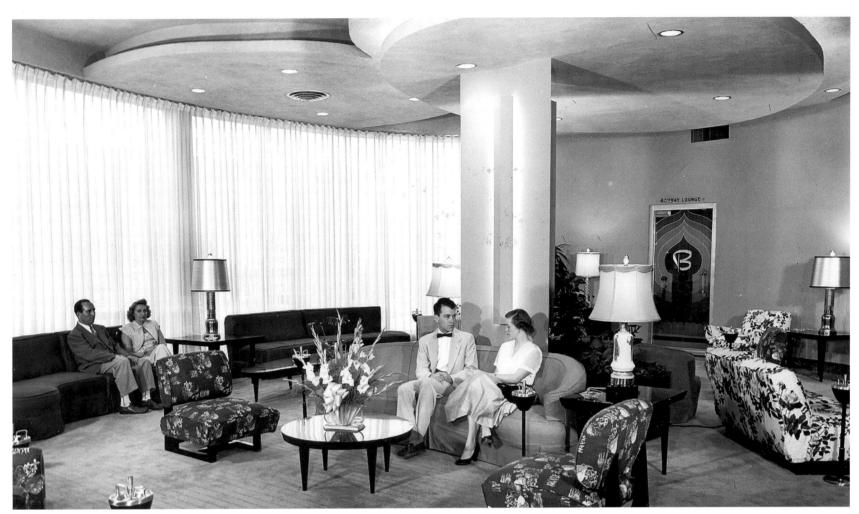

mobster Benjamin "Bugsy" Siegel looked for a model for his Flamingo Hotel and Casino in the Nevada desert, he turned to Miami Beach and its lavish resort hotels.

Even though automobile ownership skyrocketed after World War II, few architects thought about how to accommodate it. Norman M. Giller, always a low-key trendsetter, was the exception. His modestly scaled Golden Sands Hotel (originally the Bombay of 1951) at Sixty-ninth Street and Collins has outlasted many of its ritzier neighbors because it was the first hotel on the Beach to offer a parking garage. "When

we built the Golden Sands, we decided on our own to put in a certain amount of off-street parking," Giller recalls. "There was no regulation that you had to have it, so I think that had something to do with its success. In the Art Deco days we were in a Depression, so nobody was thinking about cars, because not too many people had them."

The Golden Sands, though redone, has many features of mid-1950s resorts in miniature: a curvilinear lobby with woggles, a pool, shops, a restaurant, and direct beach access. Vertical masonry louvers on the Collins Avenue facade cast colonnade-like shadows. Other than the innovative garage, "it's a basic facility, nothing luxurious about it," Giller says. "The people who stayed there were almost the same kind of people that stayed in motels."

The Lido Spa on the waterfront of Belle Isle along the Venetian Causeway, with its colonnade of gold anodized-aluminum screen panels camouflaging a blank facade, is Resort MiMo playing at Subtropical Modernism. Originally a Wrightian modern motel with a glass gable facade designed by Norman M. Giller in 1953, the property was radically altered into its current appearance by A. Herbert Mathes in 1960.

In its spa incarnation, the Lido was one of the last holdouts of the Borscht Belt on the Beach. For nearly forty years, it catered to a dedicated clientele of Jewish ladies of a certain age, complete with canasta, kosher meals, and the silken strains of the Hy Siegel Orchestra on Saturday nights. As former owner Chuck Edelstein, who brought the 2.5-acre property in 1963, once said, "Fifty goyish women in rooms, no problem; fifty Jews, everybody wants a room change!"

The Lido Spa's outstanding architectural features are its thin aluminum-mesh pilasters framed by thick horizontal cantilevers. At sunset, the pilasters catch the golden light and cast shadows against the stucco wall so that they seem to have the full volume of a Classical colonnade. The large illuminated sign of yellow letters on a green-mosaic tile background and the slight curve of the facade at the porte cochere provide a sense of arrival.

Perhaps no other architect defined the transition from Deco to MiMo as thoroughly as Albert Anis. Although not as prolific as Dixon and Hohauser in the 1930s, Anis helped define Miami Beach Deco with influential works like the Waldorf Towers,

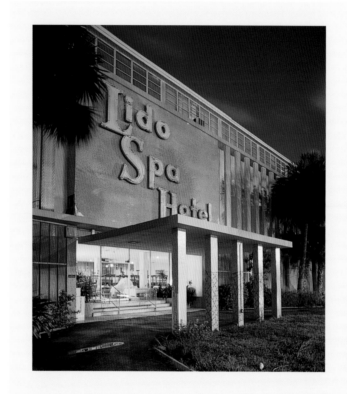

CAN WE GET A FOURTH FOR MAH-JONGG?: Situated on tree-lined Venetian Causeway, the Lido Spa Hotel was one of the last holdouts of Catskills culture in Miami Beach. Hardworking Jewish immigrants who had never taken a vacation were instructed in the ways of leisure by tumlers, or hired entertainers.

the Winterhaven, and the Bancroft. With his Shore Club in 1949, Anis gave up the finely sculpted and streamlined massing of Deco for ensembles of more abstract volumes. At the Shore Club, Anis took the eyebrow motif of the 1930s and began playing with it for purely decorative effect. In his hands, the simple eyebrow became a three-dimensional, sculptural focal point as it snaked around a stairwell. MiMo architects came to rely on the shadow-making qualities of the thin masonry cantilever as an ornamental staple.

One of Anis's most prominent commissions was the Biltmore Terrace of 1951 (now the *Happy Days*–themed Dezerland Hotel) on Miami Beach's northernmost lot bordering Surfside at Eighty-seventh Street. Anis's skill at interweaving volumes of varying sizes and shapes is evident in the undulating lobby that slides underneath the hotel towers.

The Dezerland's interior was also another opportunity for Morris Lapidus to transfer his expertise in designing dramatic store interiors to resort architecture. The slight angle at which the Dezerland's tower stands from the main superstructure signals Lapidus's inimitable manipulation of volumes and interior space. Arriving under the low-slung porte

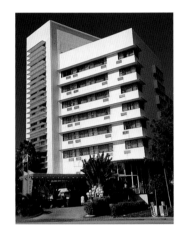

cochere that slices through the lobby's undulating glass wall, you clearly sense you are in for a wild ride. Intersecting, curving planes are clad in modern materials like polished red granite and fluted glass at the entrance.

The Lapidus signature is unmistakable. After slicing through the glass-walled lobby, the porte cochere intersects a cylindrical column, around which the glass wall wraps to form a prowlike feature. In a gesture that would see its full realization in the 1955 Eden Roc, Lapidus exploited the reception area for dramatic spatial effect. The volume of the reception area both forms the lobby space and partially hides it. The lobby reveals itself only once the visitor fully enters it. As at the Eden Roc, the lobby presents a circular array of options to the guest. Next to the reception desks stand the elevators, followed by the entry to the nightclub, and a gift shop. Opposite these are an undulating double-height glass wall and a wall panel punctuated by a grid of circular openings, in which globe-shaped birdcages were once set.

In the 1930s, beachfront hotels included long, gallery-like spaces that connected the front lobby with public spaces facing the beach. At the Dezerland, Lapidus turned the long connecting gallery into a procession of dynamic, rising and descending spaces emanating from the lobby. A generous expanse of glass opened onto the lush vegetation of the Altos del Mar neighborhood, where the North Shore Open Space Park stands today. The same devices Lapidus used to lure shoppers into and through long retail spaces were employed here, not the least of which is a multilayered ceiling exuding indirect light from behind floating woggles.

Lapidus appears again, along with Polevitzky and Grossman, when the Sirkin family developed the DiLido Hotel on a prime lot on the north side of Lincoln Road between

ART OF THE LOUVER (ABOVE): Fixed louvers on the facade of Albert Anis's Biltmore Terrace of 1951 (now the Dezerland) evoke the minimalist sensibility of a Donald Judd sculpture.

(LEFT) Louvers, eyebrows, and boxed windows impose a visual rhythm on the assembled masses of the hotel. The syncopated, multilevel interior was an early showpiece for Lapidus.

Collins Avenue and the ocean. Harry Sirkin hired Polevitzky in 1945 to design a mixed-use retail, office, and hotel project for the site. Polevitzky's stores and offices were built in 1950, but Grossman was brought in to design the hotel, with Lapidus, his former boss, as associate architect.

Expanded and transformed into a Ritz Carlton in 2004, the DiLido, which features an L-shaped footprint that faces both Collins and Lincoln Road, took its stylistic cues from the work of Le Corbusier and Niemeyer. The hotel room floors are supported on Corbusian pilotis above the set-back, double-height lobby. The allusions to Corbusier continue in the eggcrate design of the facades. Created by the exposed floor slabs and piers, the eggcrate expresses the structure while providing shade to the rooms, a feature of concern to Corbusier and Niemeyer in their warm-weather contexts.

At street level, Lapidus's playful architectural antics transport the DiLido back to Miami Beach from Corbu's Marseilles. On the Lincoln Road side, the volume of a meeting space intersects and slides beneath the projecting superstructure at an angle. An abstract mural, also reminiscent of Corbu, once camouflaged the volume of the meeting rooms and continued along the wall behind the pilotis supporting the superstructure.

On Collins, a provocatively curving, tonguelike porte cochere breaks out through the lobby's glass facade, and slides around the pilotis to shelter arriving automobiles. The entrances respond to the distinct character of each street: the Collins lobby contained the hotel reception area and elevators, while the Lincoln lobby provided small stores and a restaurant, as well as direct access to the meeting rooms. In between, changing levels, open mezzanines, and disappearing sight lines keep the patrons in constant motion.

The DiLido was the southernmost of the large postwar beachfront resorts. By 1953, Lincoln Road was already losing its fashionable status. The Fontainebleau opened less than two years later, completely shifting the economic epicenter of the city away from Lincoln Road and Dade Boulevard to the self-contained resorts to the north.

Lapidus's final role as a supporting player was at the Algiers, where he was paired with prolific Miami Beach Deco hotel designer Henry Hohauser. The hotel unfortunately fell victim to condo developers with their eye on the bottom line in the 1970s. Its striking, highly original design was pure Lapidus. From the street, it appeared as a collage of four distinct volumes. The hotel tower was defined by the taller elevator core and the emphatically horizontal south wing. Each row of windows was camouflaged behind four closely spaced, continuous masonry cantilevers, which exuded a cool, ultramodern detachment.

The hotel tower hovered above the undulating, glass-walled lobby, which in turn floated above a row of storefronts. Not content simply to curve the double-height glass walls, Lapidus canted them outward at the base and overlayed them with rhythmic piers that projected, mollusklike, above a parapet. A wedge-shaped, glass-enclosed volume, which housed a card room, projected out from the mass of the building at the second-story level to double as a porte cochere. Although Lapidus would soon become renowned for his larger hotels, none match the sheer bravura and originality of the Algiers.

While the Saxony ruled the Miami Beach hospitality industry, Ben Novack plotted his revenge with the patient cunning of a Renaissance prince. His plans would forever change the face of Miami Beach resorts.

By the end of the 1940s, there was an almost total build-out of hotels on the oceanfront lots of the Collins family's quondam Miami Beach Improvement Company subdivision all the way up to Forty-fourth Street. Carl Fisher's Indian Beach subdivision, consisting of enormous lots facing both the ocean and Indian Creek, began with the lavish Harvey Firestone estate at Forty-fourth Street. The Firestone family, looking to profit from the lot, appealed to the Florida Supreme Court for rezoning and won.

Waiting in the wings was Novack, who snapped up the lot upon rezoning. Novack led fellow hoteliers to believe that he was turning the Firestone estate into a park as a buffer between the hotels to the south and the stately mansions to the north. Conventional wisdom held that the Beach was overbuilt with hotel rooms and that the property was too far from shopping on Lincoln Road and nightclub entertainment on Dade Boulevard to succeed as a hotel.

Novack knocked Miami Beach for a loop when he announced that he was going to build a five-hundred-room hotel on the site. In keeping with the local tradition of using European place names to evoke a touch of class, Novack chose the name

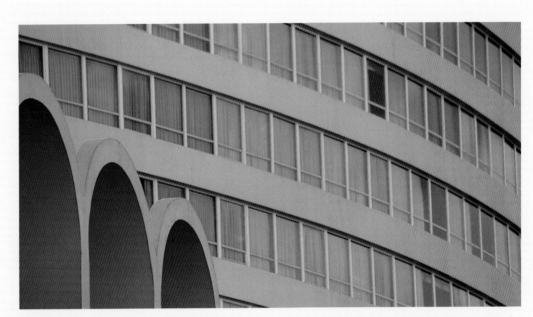

THROWING THEM A CURVE: Lapidus's curved layout for the Fontainebleau outraged the architectural establishment in 1954, but critics have now come full circle. The compressed arches at left were a later, harmonious addition by Herbert Mathes in 1958. The hotel's white spandrels interact magnificently with the tropical atmospherics.

Fontainebleau, after encountering it on a vacation in France. When pressed by reporters as to who the architect would be, he offered the first name that jumped to mind: Lapidus.

The Novack-Lapidus relationship is legendary for its ups and downs. The friction started when Novack, who sensed Lapidus's ambition to become known as a great architect, chiseled him down to a paltry fee of $80,000 to build the $12 million hotel. In December 1953 Novack also demanded that the architect have the hotel ready in just twelve months, in time for the 1954–55 winter tourist season. To meet the demand, Lapidus moved to Miami Beach and worked out of the Firestone estate as the hotel grew around it.

Perhaps the most colorful chapter in their relationship revolves around whether it was Lapidus or Novack who came up with the idea of the hotel's curved shape. Lapidus may

Sinatra *always* stayed at the Fontainebleau penthouse, nicknamed the Sinatra Suite. His routine was the same: he'd hang his tux in the shower to steam out the wrinkles, then sit around in his bathrobe doing crossword puzzles, trying not to speak so he could rest his voice. He'd vocalize, put on his pants with his shoes on so as not to mar the crease, and go on stage.

Maybe he'd have some laffs with Joe E. Lewis, the raspy-voiced comic he portrayed in the 1957 flick *The Joker Is Wild*. Then he'd hold the room in the palm of his hand, changing the mood to whatever he wanted, like a magician. Women held their breath, and even tough guys got teary eyed as he walked them down memory lane with that marvelous voice.

When Sinatra was in town, dames took their furs out of the freezer and their real rocks from the vault, and the customers duked the help fifty clams for anything—car keys, a highball, a towel. "It was yacht time and dress-up time in Miami Beach," columnist Earl Wilson wrote.

It was Frank's world; everybody else just lived in it. One night at the Eden Roc you might spot baseball manager Leo "The Lip" Durocher, socialite equestrienne Liz Whitney, Teamster boss Harold Gibbons, and CBS prexy James T. Aubrey,

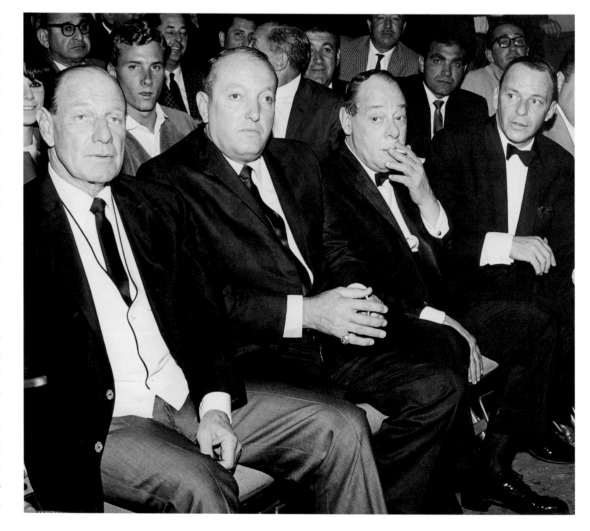

"the smiling cobra," the model for Jacqueline Susann's *Love Machine*, whose career Jackie Gleason would later destroy by inviting him along to an orgy at the Fontainebleau and then leaking it back to CBS.

In the early days, Frank might fall by the lounge at the Booker Terrace Motel in Overtown, Miami's black section, and jam into the smoke-filled wee hours in the racially mixed club. White hipsters like Tony Bennett grooved with Count Basie. Later on it was time for sordid sex play with hot-and-cold-running hookers and flowing Jack Daniel's (Gleason taught him to drink it) at the Sinatra Suite, until the sun came up or Frank lost his temper, which happened just as regularly.

When Sinatra invited a twenty-five-year-old German-Irish dish named Judy Campbell to Miami in 1960, hotel doors started swinging open and shut at the Fontainebleau as in a scene from *Così Fan Tutte*. Desi Arnaz had eyes to make it with her in his suite at the Diplomat up in Hollywood. Judy split before anything happened, but Sinatra blew his stack anyway in the Poodle Lounge the following night. The night after that, a jealous JFK barged into her room wearing nothing but a robe and slippers. Both Jack and Frank tried to inveigle her into three-ways at different times.

Frank introduced Judy to a smooth customer named Sam Flood, aka Momo Salvatore Giancana aka Sam Giancana, capo of the Chicago mob. Innocent Judy knew Flood as a businessman with gambling interests in Cuba and a "big man in the shrimp business," that is, until she became a go-between for the mob and the White House by sharing Giancana's and the president's beds. Sam helped deliver the crucial West Side vote in Chicago, Capone's old district, to crown Kennedy president. Giancana wore a sapphire friendship ring Frank gave him. Sinatra admired the boys for their juice, the power over life and death.

A farce of a darker sort went on behind closed doors in Sam's permanent suite at the Fontainebleau, where Sam had a sit-down with a handsome hood named Johnny Roselli and government spook Bob Maheu to clip that bearded bastard in Cuba for Uncle Sam. With the mentality of the Ivy League frat boys that they were, the CIA aimed to plant a powerful depilatory on Castro so that his beard fell out, then lace the dictator's cigars with botulinum toxin. One thing after another went wrong, much to Giancana's amusement and the government's chagrin.

The late 1960s found Sinatra at his most mobbed up and confused. In 1967, he brought his child bride Mia Farrow to the Beach on a *Death in Venice* trip. Frank was fifty, wearing one of his five-dozen custom rugs, his skin bronzed several shades darker than a cigar-store Indian as if he was coated in Man-Tan, his face gone jowly. Mia was twenty-three, younger than his daughter Nancy, the star of *Peyton Place*, and best known for getting her hair shorn like a boy's.

Earl Wilson reported, "Frank gave a sixty-fifth birthday party for Joe E. Lewis at Jilly's South in Miami Beach," run by Frank's refrigerator-sized goombah Jilly Rizzo. "It was the wettest party I ever attended. The little bride, Mia Farrow, was the hostess. At times she sat on Frank's knee."

Frank never went anywhere without a phalanx of bodyguards: Jilly, who was built like a middle linebacker, and torpedoes Ed Pucci and Andy "Banjo" Celentano. They looked like the freakin' Seventh Fleet passing by the cabanas.

Something was eating Sinatra: age, baby. That boozy Rat Pack shtick was getting as moth-eaten as his hairpieces. As if that hillbilly clyde, Presley, wasn't enough, now he had to deal with the Beatles. There's nothing sadder than an old swinger.

Frank's world.

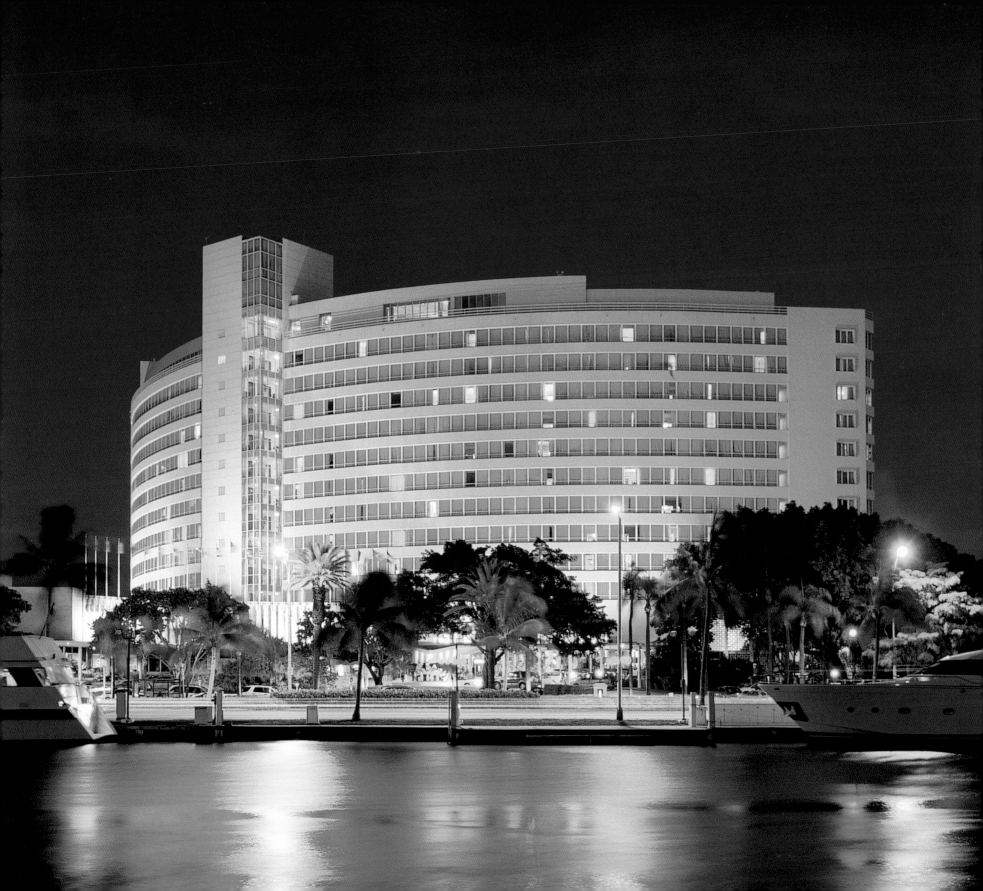

have had the last word; he claimed that the curve was due to his distaste of boring, interminably straight hotel corridors. However, it is likely that both men wanted the curve, but for different reasons.

There is little doubt that Novack, who suffered the humiliation of his Sans Souci's repeatedly being passed over for Hotel of the Year by the Saxony, built the Fontainebleau to settle the score. His quest to remain supreme was a deliberate calculation: he took the proven success formula of the Saxony and poured all the land and money he could into it. Unlike any Miami Beach hotel before it, the Saxony's facade curved inward. If a curve worked there, Novack must have reasoned, his Fontainebleau would also have to be curved. Serendipitously, Novack's ambitions and resources took flight through the imagination and flair of Lapidus to create one of the world's most distinctive modern buildings.

Lapidus met the deadline. When the Fontainebleau's doors opened to the public on December 20, 1954, it created a phenomenon that not only defined the city, but also changed the design of resort hotels around the world.

Although architectural purists couldn't see past the use of ornamentation and decorative flourishes, the Fontainebleau's interior spaces brought together in a revolutionary way Lapidus's lifelong interests in

TOO MUCH IS NEVER ENOUGH (OPPOSITE): The fabulous Fontainebleau, seen here reflected in Indian Creek, is one of the world's most recognizable modern buildings.

MAKE MINE MINK (ABOVE): A sunbather relaxes on the hotel's rooftop deck in a mink bikini.

(RIGHT) Morris and Mies at least agreed that God is in the details. Door handles adorned with the hotel's initial capital.

In February 1960, after a monthlong saturnalia of filming *Ocean's 11* by day and partying long into the night onstage in the Copa Room at the Sands in Vegas, the Rat Pack (sans Dean) moved their Summit shtick directly to the Fontainebleau. For $17.50 a pop, including drinks and dinner, the audience was treated to what looked like spontaneous, alcoholic mayhem. Actually it was cannily scripted, alcoholic mayhem, by the group's morose-looking teetotaler, Joey Bishop.

The same crew, plus Nancy Jr., was on hand to tape the "Welcome Home Elvis" TV special on the *The Frank Sinatra-Timex Show*. A few weeks after demobbing from the army's Thirty-second Armored Division in Germany, Sgt. Elvis Aaron Presley arrived at the Fontainebleau with his Memphis Mafia in tow.

"Where the heck are the sideburns?" Bishop goofed with Elvis. "In Germany!" the squared-away singer shot back.

Sinatra once had gone so far as to write an article in 1957 that rock 'n' roll "is phony and false, and sung, written, and played for the most part by cretinous goons." But in the broadcast on May 12, 1960, the singers switched roles. Elvis swung through "Witchcraft," while ol' blue eyes knocked out "Love Me Tender." Elvis took home an extraordinary $125,000 for six minutes of work. It would be Elvis's last TV performance until his comeback special eight years later.

theater set design, movement, and circulation with his mastery of modern engineering and construction methods. Aware that Novack's guests were more familiar with the movies than with architectural verities, Lapidus strove to create a movie-set experience that would make ordinary tourists feel like stars.

The famed "stairway to nowhere" in the lobby and the entrance to the nightclub are prime examples. The stairway to nowhere allowed hotel guests, on their way to dinner in their finest evening wear, to exit the elevators at the mezzanine level and descend to the lobby on a grand, curving staircase in full view of their fellow vacationers. To derive the maximum drama at the entrance of La Ronde Room nightclub, Lapidus choreographed arriving patrons to ascend two steps to a small platform so that they could see and be seen, before stepping down into the amphitheater-like space.

The most direct reference to the Fontainebleau's theme of French royalty was the parterre gardens. Lapidus turned the existing gardens of the Firestone estate into a French Baroque fantasy, making the palatial hotel a Versailles for Ben Novack as the Sun King. For the exterior of the nightclub, Lapidus commissioned a larger-than-life relief of Apollo, in a giant clamshell chariot pulled by dolphins, drawing the sun across the Florida sky. Upon close inspection, Apollo's head appears to be a likeness of Novack.

In keeping with the axial planning of French Baroque garden design, Lapidus juxtaposed a long north-south axis leading to elaborate fountains with a shorter east-west axis that led to an expansive pool deck. In another layer of French allusion, Lapidus terminated the view over the pool toward the ocean sky with a statue of La Normandie, as André LeNôtre had done with a statue of Hercules at Vaux-le-Vicomte outside Paris. Lapidus found the bronze statue, which once stood at the top of the grand staircase in the main dining room of the famous French liner, on one of his buying trips to New York for Fontainebleau furnishings. He bought it from an oblivious salvager for the cost of the metal. In a succinct summa of the world he created at the Fontainebleau, Lapidus framed La Normandie with a futuristic parabolic arch on the opposite side of the pool deck. Today, the statue stands in the lobby of the former Sorrento Hotel, now the Normandie wing of the Fontainebleau.

STAIRWAY TO NOWHERE: Lapidus was once lambasted for theatrical flourishes like this superfluous staircase from the lobby to the mezzanine, but he understood the underlying emotion of architecture. The stairs provided a runway for guests to descend to the lobby displaying their finest evening wear. Lapidus was a Post-Modernist ahead of his time: the futuristic stairs were a delightful contradiction to the mural of the ruins of the Roman forum, since removed.

BELLBOY AT THE FONTAINEBLEAU

The peak of Resort MiMo is preserved in Jerry Lewis's period gem *The Bellboy*, made entirely on location at the Fontainebleau in 1960. Flying out from Hollywood to do a gig at his favorite resort, Lewis had a "vision of a bellboy, the entire role played in pantomime, the character a symbol of protest against people who regard bellboys, elevator operators and, indeed, all other uniformed workers as faceless dummies," as he wrote in his autobiography.

After convincing owner Ben Novack to let him use the hotel as a location, Lewis stayed up for eight days straight, hallucinating forty vignettes that took place in and around the Fontainebleau lobby. The film was shot on a shoestring in black and white in twenty-six days.

Sean Levy, a Lewis biographer, notes: "A big Miami hotel in the wintertime *was* a Catskills hotel, just one that had flown south for the winter. The same northeastern Jews who vacationed in the mountains in the summer were now able to travel by plane to Miami in the winter. The trip by air from New York took about as much time as a drive to Loch Sheldrake. And where the traditional audiences went, the traditional entertainers followed."

Vaudeville lived, if only on a resuscitator, on the Beach, where there were more cornball acts—ventriloquists, lounge singers, trained poodles,

acrobats—than there were call girls, which is to say a lot. Jerry was glad to give his old Catskills buddies work. The Bellboy's cast of Milton Berle, Henny Youngman, Joey Adams, Jack Durant, Sonny Sands, Sammy Shore, Jimmy and Tillie Girard, Eddie Schaeffer, Harvey Stone, Lou Brown, Jack Keller, and Herkie Styles reads like names you try to discern on faded signed photos in Jewish delis.

Lenny Bruce was in town during the shoot and hung with Jerry, but was not invited. Lenny didn't dig the Fontainebleau scene, anyway; he'd rather stick with the schnorrers in South Beach.

The Bellboy features some wonderful period shtick. After six in the evening, guests in the 1960s didn't schlep around in T-shirts and flip-flops like overgrown children; they wore evening dress. In one bit, Stanley the bellboy comes out to take a flash picture of the full moon over the Fontainebleau. Pop! The landscape turns into full daylight. A moment later, a man in a white dinner jacket and a woman in a strapless evening gown scurry across the formal French gardens like enchanted mice at the stroke of midnight in Cinderella.

Guests watched television in a communal room off the lobby. A sign in the film reads, "This TV set is for the guests of the Fontainbleau [nobody could spell it right, nor owner Ben Novack's name either, for that matter]. If you're not registered here—DON'T LOOK!"

Lewis plays with the vast scale of the resort. The smart-aleck bell captain tells Stanley to set up chairs in the cavernous Napoleon Room; a quick cut, Stanley walks out whistling, there are chairs set up as far as the eye can see.

WEST OF EDEN: The slightly concave Collins Avenue front of the Eden Roc, seen here across Indian Creek, looks conservative compared with the radical glass curvature of the Fontainebleau, but shows Lapidus's great versatility. The green-glass mosaic panels to either side, shaded to represent depths of the ocean, were a widely copied detail.

In the biggest falling out since Martin left Lewis, Novack's partner Harry Mufson hired away Lapidus to design the Eden Roc on the lot next door. In response, the hotheaded Novack barred his ex-partner from ever setting foot in the Fontainebleau. He also tried to stop Lapidus from designing hotels, but relented when the architect said it meant taking away his livelihood.

At the Eden Roc, Lapidus set out to perfect the spatial and circulation ideas he first tested in the Fontainebleau, while toning down its stylistic delirium. On the surface, it seemed as if Lapidus was responding to the furor over the Fontainebleau's futuristic curve by borrowing from the more traditional facades of the Sherry Frontenac and the Saxony, two of the most successful hotels of the previous decade.

The west facade of the Eden Roc fuses the Sherry Frontenac's bilateral symmetry and nautical allusions with the Saxony's coolly understated, gentle curve and glass-walled rooftop terraces. The Sherry Frontenac's signage panels are evoked in the Eden Roc's full-height Italian glass-tile mosaic panels. Under Lapidus's sure hand, the Eden Roc's architectural alchemy is perhaps the pinnacle of Resort MiMo.

THE ARCHITECTURE OF EMOTION: MORRIS LAPIDUS

No great architect of the twentieth century has been more reviled or suffered more indignities during his career than Miami Beach's own Morris Lapidus. Lapidus was banished from the architectural establishment with the completion of his masterworks, the Fontainebleau and Eden Roc hotels of 1954 and 1955. He spent his entire working career in critical penumbra. It was only toward the end of his life, when he was in his eighties, that his genius for creating dynamic interior spaces and his theatrical showmanship were recognized by a new generation of Post-Modernists. His lavish designs appeared in the mainstream architectural press for the first time in half a century.

Lapidus possessed an imposing public persona with a bulletproof ego that may have concealed an artist's hurt from the misinterpretation of his work. A famous encounter that took place at the 1963 convention of the American Institute of Architects in his own hotel, the Americana in Bal Harbour, still rankled decades later. The theme of one panel was "A Quest for Quality in Architecture," and the speakers extemporized on how the Americana was the antithesis of their definition of quality.

From the podium, San Francisco architect Robert Anshen lambasted the Americana for being everything that was wrong with contemporary architecture. "This hotel is built of thin, cheap, improbable materials," he said of the Americana, whose central feature in the lobby was a double-height, glassed-in terrarium in the shape of an inverted cone open to the sky. "It is incompetent, uncomfortable, and a monument to vulgarity."

Impeccably dressed in a signature bowtie (one of his trademarks was incorporating a bowtie motif into his designs, like the black-and-white marble flooring of the Fontainebleau), Lapidus rose from the audience and took the microphone. "My name is Morris Lapidus. I am the architect who designed this hotel," he said, as the panel members looked for a hole to crawl into.

"I want to pose the question of this hotel, which is not an architectural masterpiece, but designed for people who come here for fun," he continued. "Yes, it is a cheap hotel. There is a quality in architecture from the camera view. But there is also the quality of human emotion. People want architecture to give them pleasure. They want human comfort, satisfaction, and warmth."

Anshen diplomatically conceded, "An atmosphere of carnival fun is the Americana's greatest attribute, and for this I congratulate you."

Carnival fun was always a major theme in Lapidus's work. One of his most vivid childhood memories growing up as a Russian Jewish immigrant on New York's Lower East Side in the first decade of the twentieth century was seeing the illuminated fairyland of Coney Island. "For the first time in my life, I experienced the excitement of electric light," he wrote in his second autobiography, *Too Much Is Never Enough*. "I never consciously tried to create a version of Coney Island in my architecture, but its wonders and beauties, as seen through the eyes of a child, are echoed in a good deal of my work."

Lapidus was an architecture student at Columbia University, where "in the early twenties we were still studying architecture as it had been taught a century before" at the Ecole des Beaux-Arts in Paris. "The first year's courses included History of Architecture, History of Ornament, Perspective, Shades and Shadows, and The Classic Orders," he wrote in his first autobiography, *Architecture: A Profession and a Business*. "We were initiated into the mysteries of grinding a stick of Chinese ink in a slate mortar, to make a wash which we used to render (tone) the carefully drawn base, column and entablature of the Orders." Schooled to recognize a thousand historical buildings at a glance, Lapidus didn't balk when his client Ben Novack told him he wanted "that modern kind of French Provincial" for the interior of the Fontainebleau. Novack's partner Harry Mufson's instructions to the architect for the Eden Roc were, "I don't care if it's Baroque or Brooklyn, just get me plenty of glamour and make sure it screams luxury!"

Lapidus was a figure of enormous contradictions: a Classically trained architect who embraced the latest technologies and styles of his era and mixed historicist period elements in a delirious mélange that anticipated Post-Modernism; an early admirer of Miesian minimalism who came to personify its antithesis; a Modernist pariah who showed his wounded vanity only by quoting at length from his critics; a uxorious husband

notorious for his epic outbursts with associates; a man working in a field that held Nature to be an eternal verity but who had the haimish touch of keeping plastic plants in his apartment; a Jew who waxed sentimentally about the joys of Christmas; and a fundamentally emotional designer in a rigorously rational profession. Lapidus was said to keep four bronze busts of himself, a sign of vanity, yes, but also of the perdurability of personality that allowed him to withstand half a century of obloquy.

Although best known for re-inventing the resort hotel, Lapidus designed everything from glass-walled office buildings to fire stations. He spent the early part of his career in the Depression designing stores with bold, Berlin-inspired graphics, subtle colors, and theatrical lighting effects, all of which he would put to use in his resorts. Later he became known as a "hotel doctor," redoing the designs of Miami Beach hotels. A critic at the University of Miami wrote that Lapidus was "an architect by training and a mob psychologist by choice," which Lapidus felt "summed up, in a few words, what I had tried to do throughout my career."

Lapidus had to invent his own vocabulary to describe his free-spirited forms: *woggles*, *beanpoles*, and *cheeseholes*. In combination with illuminated ceilings, a mix of historical references, a dramatic control of space, and an exquisite feel for color and materials, these forms were the makings of Lapidus luxury.

In a real sense, Lapidus may have been the last great Baroque architect. He had a Baroque

sensibility for guiding the viewer through contrasting experiences of space. For Lapidus, the journey was the thing. Lighting, color, and materials form a *Gesamtkunstwerk* to make even the uninitiated aware that architecture is a spatial experience. His feel for contrasts in volume and love of color and rich materials for their own sake had seldom been seen outside of Versailles and Bernini's Rome.

Lapidus was a master in using building forms as pure sculptural expression. Look at the sensuously wrapped balconies on his Seacoast East apartments or the abstract compositions formed by different views of the tray balconies of the Eden Roc. One of the most astounding aspects

of his work is the sheer fecundity of forms. As one critic noted, he never repeated himself; in countless variations of staircases, balustrades, and balconies, no two are exactly alike. The sheer force of creativity is overwhelming. One has the feeling that, as with Frank Lloyd Wright, he could simply shake the designs out of his sleeves.

To the end, Lapidus remained something of a quixotic figure, tilting at the windmills of the International Style. He championed emotion in the Cartesian world of postwar architecture. His insistence on his own woggled decorative vocabulary may have obscured his gifts as a manipulator of form and space.

Lapidus no doubt found great joy in his work. His love of craft is evident in his scrupulous attention to details, in the gorgeously sculpted balconies, the pulse-pounding interior vistas, and the sensuous handling of materials. A sophisticated whimsy permeates his work: Photographs of his renovated brownstone office at 249 East Forty-ninth Street in New York in the 1940s show that he incorporated a T-square for the front door handle. The door handles still in place on his Summit Hotel (now the Metropolitan) of 1962 in New York feature his bowtie motif. The shade structures on Lincoln Road are a conga line of the sorts of forms he loved to create. Emotion and delight are the keynote of his designs. Creating a "tangible emotional impact" in the beholder, he felt, was the ultimate goal of his self-styled "Architecture of Joy."

THE LAST DETAIL (TOP): The Eden Roc's initials on an elevator doorplate.

(ABOVE) The spite wall stands between the two Lapidus masterpieces.

(NEAR RIGHT) A rosewood column inside the Eden Roc.

(FAR RIGHT) The Eden Roc's lobby.

(OPPOSITE) The lolling canopy of the Seville.

In contrast to the experience of entering the Fontainebleau, where the widescreen lobby is instantly appreciable, one enters the Eden Roc through a vestibule space that is partially screened from the lobby by the volume of the reception area. A glimpse of the lobby around the reception space beckons the visitor inward. The moment of arrival is deliciously drawn out. Not until the arriving guest is afforded a carefully choreographed 270-degree view of the drum-shaped lobby space with a bar, a sunken lounge, picture windows facing on the ocean, and a staircase to nowhere does the elevator bank stand revealed. From the bar, the circulation of people through the lobby recalls the movement of figures in a delightfully elaborate mechanical clock.

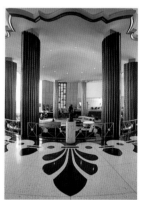

Lapidus exercised his prowess as a sculptor of building mass to shape the ocean facade, in contrast to the conservative street facade. Seen from the east, the T-shape plan is apparent, suggesting a nautical effect. The wrapped, continuous balconies appear to float, while the crisply creased parapets accent their horizontality. As in the Fontainebleau, the upper balconies are longer than those below, further emphasizing the horizontal thrust. As if winking to an accomplice in his architectural showmanship, Lapidus connected the two masonry wings of the Eden Roc with full-height panels of glass curtain wall. This was 1955 after all, and the sliver of curtain wall whispers "Lever House," Gordon Bunshaft's seminal glass jewel box of 1952 on Park Avenue in New York.

The success of the Eden Roc only further enraged Novack. He created one of the great architectural insults with the north wing of the Fontainebleau in 1959. Not only was the looming, fourteen-story "spite wall" built close to the property line so that it cast a shadow over the Eden Roc's pool in high season, but it is entirely windowless, except for Novack's penthouse apartment.

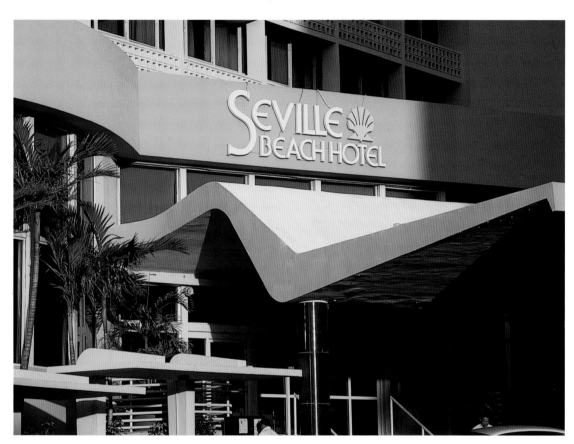

The first hotel to faithfully emulate Lapidus's winning formula was the Seville of 1955, by Lapidus protégé Melvin Grossman. Grossman began as an engineer working for Lapidus and then, after turning down an offer to become partners, struck out on his own to become Lapidus's biggest imitator. With the Seville, Resort MiMo becomes a distinct style, further refined and distilled by Grossman.

Built on the site of the former Pancoast Hotel, the Seville took full advantage of its prominent corner lot facing Collins Avenue and a plaza leading to the beach. Toward Collins, the hotel presents an urban edge, with a nightclub and meeting spaces perched over stores at the sidewalk level, which were once accessible through the lower lobby. Round cutouts in the awning above the terrace on the avenue recall Philip Goodwin and Edward Durell Stone's influential Museum of Modern Art in New York of 1939.

The hotel is a masterful synthesis of straight and curved lines. The rooms are housed in a ten-story superstructure with an eggcrate facade framing windows and recessed balconies with screen block parapets. The rooms, at twenty-four by fourteen feet, were among the era's largest, in contrast to tiny rooms in the old South Beach hotels that could barely accommodate a double bed.

The carnivalesque curved lines of the public spaces in the hotel's pedestal soften the International Style superstructure perched above. Grossman took the sober International Style elements of the grid facade and added pure postwar élan with an outrageous free-floating porte cochere that lolls out like a giant tongue. In its heyday, the underside of the canopy was carpeted with glowing lights, an invitation to forget your cares and abandon yourself to fantasy.

Resort MiMo architects realized that nothing had to be naturalistic about the landscaping. Exaggerated angles and sculptural shapes complete the sense of fantasy at the Seville. The staircase from the lobby

to the outdoor deck is narrow at the top, splaying out to a wide base, for a Mannerist Busby Berkeley effect. The round canopy of a circular towel booth near the pool is set on two pillars of unequal height, so that it is cocked at a jaunty angle, like the cap of an eager attendant. A spiral swirling ramp leads up to an observation deck surmounted by a pylon, and the now-unused diving tower makes a freestanding delta-wing-shaped sculpture.

The grand, block-long, sixteen-thousand-square-foot lobby still has a lot of MiMo panache, although the Spanish theme has been toned down. The marvelous period gold anodized-copper chandelier still hangs within the dome of what was once called the Matador Supper Club, originally decorated in deep red with a silhouette of a Spanish flamenco dancer.

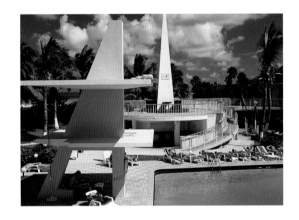

The former Castanet Lounge, a semicircular bar, was done up in red and black tones. Like the now nonfunctioning illuminated clock on the facade, the Seville is a gorgeous piece of 1950s real estate stopped in time.

Grossman reapplied this resort formula at the Deauville in 1957 on the site of the former McFadden Deauville Casino on Sixty-seventh Street and Collins in North Beach. In the same parti as the Seville, the Deauville's austerely Modernist superstructure hovers above a panoply of eye-catching architectural acrobatics responding to the automobile scale of the 1950s. The Deauville is as high, wide, and handsome as a 1957 Cadillac.

The operating metaphor for the Deauville's beachfront facade is a luxury liner, on the grandest scale since Hohauser's Sherry Frontenac. The Deauville's protective wings open to the beach, framing a view of patio and sky. The nautical feel is enhanced by rows of deck chairs angled toward the sun, crisp railings, and the bow of the oceanfront ballroom. Flags snap in the breeze and rows of palm trees provide a sense of the remote tropics. This is the best of both worlds—a cruise ship that carries its own desert island imagery with it. As clouds scud by on a moonlit night, you feel as if you are sailing dark, uncharted waters.

MUSEUM-QUALITY MIMO (ABOVE): The original gold anodized-copper chandelier still ornaments the former Matador Supper Club at the Seville.

ALL DECKED OUT (LEFT): A double-tiered diving deck, no longer in use, and a spiral observation deck form sculptural follies on the grounds of the Seville.

In front, the double-arched porte cochere resembles a spaceport, the architectural equivalent of Detroit's rocket fins and taillights. A curvilinear clerestory, like a rakish jet fighter canopy, adds an aerospace feel. The arc of the clerestory intersects seamlessly with the straight lines of the mullions in the glass lobby wall, brilliantly integrating curves into Modernism's grid. The lobby radiates with light from the floor-to-ceiling plate-glass windows. This is a joyous place, a holdover from a joyous era. The Beatles played live in the Napoleon Room, and if you listen closely, you can hear the reverb.

Norman M. Giller's Carillon Hotel tied with the Deauville one block south for the title of Hotel of the Year in 1957. Named after the developer Al Kaskell's niece Carol, the Carillon, like the Deauville, was built in anticipation of licensed casino gambling coming to Miami Beach. Although legalized gambling never did arrive on the Beach, the Carillon was the culmination of two trends in Miami Beach Modernist hotel architecture that began in the Deco period.

Restrained by shoestring Depression budgets, Dixon, Hohauser, and contemporaries could only hint at the extensive use of glass introduced by Bauhaus architects in

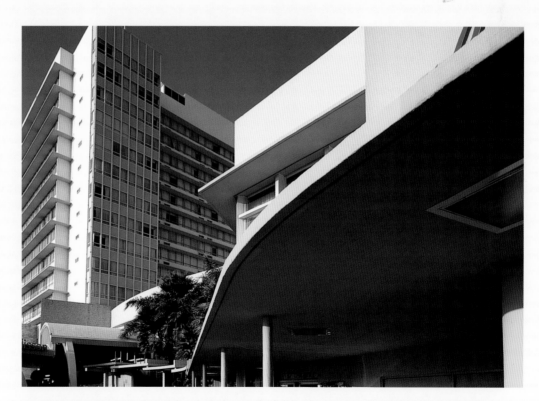

ARCHITECTURAL ACROBATICS: A swooping, stepped canopy leads to a space-age, barrel-hooped porte cochere below the Modernist grid of the Deauville's superstructure, designed by Lapidus protégé Melvin Grossman, who formalized the Miami Resort style.

A HARD DAY'S NIGHT AT THE DEAUVILLE

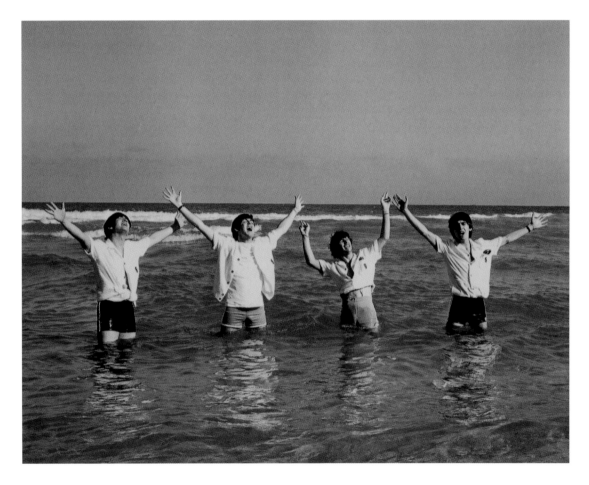

Whoever clipped Jack in Dallas—the mob, the company, Hoover, Hoffa, the Cubans, Texas oil barons, or a skinny nut with a mail-order rifle, any of a dozen parties the Kennedys in their arrogance had double-crossed and pissed off—after mourning their beloved president, Americans were ready for something new and fun to take their minds off it. The Beatles were it: they were irreverent, their hair

was longer even than Jack's, and when they harmonized on the high notes, their heads going like bobble dolls, there wasn't a dry seat in the house.

Beatlemania hit Miami Beach like a hurricane in 1964. Fresh from their first appearance on *The Ed Sullivan Show* and a live concert in the nation's capital, the four lads from Liverpool were flown into Miami International by a pilot wearing a

Beatle wig to be greeted by seven thousand screaming teenagers.

In a frenzy to reach their idols, fans broke a plate-glass door, ruined twenty-one glass jalousies, and tore up a dozen chairs, while a motorcade whisked the Beatles to the Deauville, where they barricaded themselves in a three-bedroom suite. John Lennon and his semisecret wife Cynthia shared a room, Paul McCartney and Ringo Starr bunked together, and somehow mouthy D.J. Murray the K wormed his way into being George Harrison's roommate, to the dismay of the "quiet Beatle."

Girls wrote "I love you, John" in the sand outside the hotel. Two girls even tried to have themselves mailed to the Beatles' suite in large parcels. The Maysles brothers documentary, *The Beatles: The First American Visit*, captures the pre-*Hard Day's Night* hysteria and the band members' enforced captivity, as Ringo beats a tattoo on miniature bongos and Paul feeds biscuits to seagulls midair off the balcony.

The Beatles rehearsed wearing newly purchased bathing suits and terry-cloth shirts with the hotel's insignia of a capital *D* incorporating a rook and three space-age fleurs-de-lis. They posed for pictures in the surf while Miami Beach matrons in rubber-petaled bathing caps bobbed in the background. They took in the nightclub acts—Don Rickles and the Coasters in the Mau Mau Club at the Deauville—and boogalooed to Hank Ballard at the Miami Peppermint Lounge on Seventy-ninth Street.

"Now, this was just the most brilliant place I'd ever been to," Ringo remembered. "There were two great things in Florida. One: I was taken to my first drive-in in a Lincoln Continental by two very nice young ladies. Two: a family lent us their boat and let me drive." The film was *Fun in Acapulco* with their hero, Elvis; Ringo promptly crashed the sixty-five-foot-long speedboat into a pier.

On the night of February 16, they donned their blue-silk suits with the rounded, black-velvet Beatle collars, and tore through a set of "All My Loving," "Twist and Shout," and "I Want to Hold Your Hand" in the Napoleon Room before a capacity crowd of 3,200. Never mind the teenagers—adults were clawing their way in. In the audience were heavyweight champs Joe Louis and Charles "Sonny" Liston, whose baleful glare later appeared on the cover of *Sgt. Pepper*. A TV audience of 75 million tuned in.

When it was over, amid that amazing high-pitched keening produced by a roomful of delirious adolescent girls, Ringo shook his pudding-bowl haircut for the sheer lark of it. The sweat glistened on Paul's boyish face. George smiled his alarming snaggle-toothed grin. John bowed with his Rickenbacker guitar strapped high across his torso, like a Latin troubadour.

America was theirs. The British imports of the Beatles and James Bond brought America out of its postassassination blues. Later that year, the card game in the opening of *Goldfinger* was shot at the Fontainebleau's pool deck. (Sean Connery's shots were actually filmed separately at Pinewood

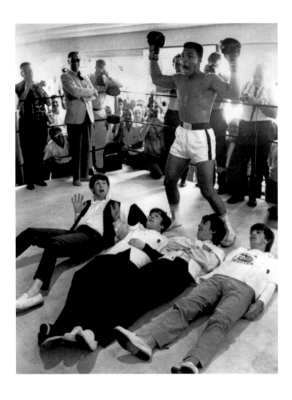

Studios in London, but the connection was made: Bond, the Beatles, and Miami Beach were the apotheosis of cool.)

In a publicity man's wet dream, the Beatles went to the Fifth Street Gym to clown around with Cassius Clay, who was training for his title fight with Liston in a few weeks.

Flashbulbs: Clay throwing a domino punch, all four Beatles grimacing; the Beatles knocked out on the canvas; Clay holding Ringo in the air. Inveterate punster John crooned, "Liston, do you want to know a secret?"

There is an openness and innocence to the photos of the Beatles in Miami and Flip Schulke's images of Clay as a fresh-faced kid, from a time before they learned to put up their guard

against the world. The Beatles would never again be able to mix freely with the public as they had in Miami Beach. Ali was on his way to becoming perhaps the most recognizable face on the planet.

For the four young men from grim, gray northern England, Miami Beach was a revelation. "Miami was like paradise," Paul said. "We had never been anywhere where there were palm trees."

When the Beatles arrived back in overcast London, BBC reporters asked what they had most liked about America:

GEORGE: I think I enjoyed the sun in Miami most of all. You know—healthy.
REPORTER: You're the healthy one of the four?
GEORGE: No, but the sun was sort of very healthy.
REPORTER: What did you most like about the trip, Ringo?
RINGO: Oh, I just loved all of it, you know. Especially Miami—the sun. I didn't know what it meant till I went over there.

the 1920s. The notable exceptions were the glass-walled lobbies of Polevitzky's Shelborne and Albion hotels, but other hotels made do with faux corner windows and generously glazed lobbies that contrasted with load-bearing walls of concrete block and stucco punctured by normal-sized window openings. The use of glass increased dramatically after the war. Robert M. Swartburg's Sorrento of 1948 was a sign of what was to come. Lapidus, of course, went all out with continuous window bands and a glass stair tower at the Fontainebleau.

However, no one had successfully imported the classic glass curtain wall to the Beach until Norman M. Giller did in the Carillon in 1957. Giller was the first architect in the Southeast to use flat-slab concrete construction. Because the concrete floor plates were thinner and lighter than standard wood flooring, no support beams were required. The relatively thin edge of the floor could abut the glass, without being hidden by spandrels or parapets, giving the curtain wall its finely detailed appearance. Giller hit upon the solution for economic reasons. In 1957, Miami Beach passed a height limitation of 150 feet, normally fifteen stories. Without the space wasted on floor beams, Giller was able to squeeze in an extra floor at the same cost while staying within the height limitation.

The Carillon, in fact, boasts a truer version of the glass curtain wall than New York's world-renowned Lever House of 1952. New York fire codes required masonry parapets at each floor, thus compromising the effect of floor-to-ceiling glass wall from the interior. Miami Beach had no such regulations, allowing guests in their rooms and passersby to marvel at the ultramodern transparency.

Concurrent with the increasing use of glass in Resort MiMo was the evolution of relief for decorative effect. What began as cheap, molded-stucco imitations of high-style Art Deco reliefs on the parapets and in vertical and horizontal courses on the faces of small 1930s hotels evolved after the war into relief work purely for harnessing Miami's abundant sunshine for decorative effect. The chevrons and stylized flora and fauna of Art Deco morphed into a language of rhythmic patterns unique to concrete block and stucco construction in South Florida.

The high point of abstract stucco relief can be found in the folded plane cladding of the Carillon's ballroom spaces, known as the accordion wall. Described by Giller as a marriage of Miami Beach vernacular with the striking image of the Air Force Academy Chapel in Colorado Springs by Walter Netsch, built from 1956 to 1962, the accordion wall brought delicate Deco reliefs of the 1930s into the automobile scale of the 1950s. As a sign of how pressing the need is for MiMo preservation, the original accordion wall was demolished during the writing of this book. The motif will be re-created by the firm of Arquitectonica in its reconstruction of the property as a twin-towered hotel-condo.

The folded plane of the accordion wall reappears as a canopy over the arrival area, extending from underneath the cantilevered, glass-walled superstructure. The canopy will be preserved in the reconstruction. In the original hotel, guests were greeted inside by a lavishly proportioned lobby with the customary stairway to nowhere. However, the Carillon's stairway led somewhere: rather than rising to the mezzanine, the stairs connected to a lower-level shopping concourse. The lobby was distinguished by

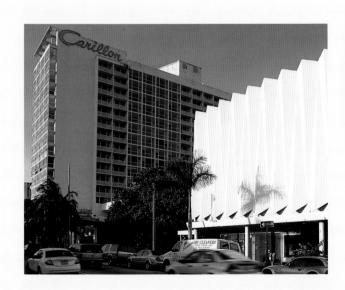

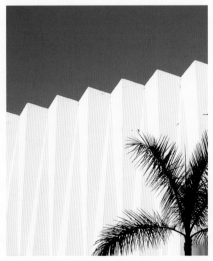

THE LAST RESORT (OPPOSITE): The Carillon, seen here before undergoing renovation, was the last major piece of unused oceanfront real estate in Miami Beach. Designed by Norman M. Giller in 1957, the hotel featured a finely detailed facade of floor-to-ceiling glass walls.

(FAR LEFT) The original concrete accordion wall as it stood in relation to the superstructure.

(LEFT) The boldly scaled accordion wall brought Deco relief into the automobile age.

an enormous, double-height lounge with plate-glass walls that provided views of the avenue, the pool deck, and the ocean. A carillon was planned for the tower on Collins Avenue, but never realized.

In contrast to the grand ambitions of other Collins Avenue resorts, the 1955 Swiss-chalet style Lucerne (now a Fairfield Marriott) by Carlos Schoeppl at the corner of Forty-first and Collins is a home away from home, that is, if you happen to live in a split-level ranch on the New Frontier. Use of natural stone and plate glass and the outsized details of the gabled facade and overscaled windows create an almost Post-Modern illusion of a big house, rather than a resort hotel.

The hotel exterior resembles a suburban house with Wrightian details. The six-story superstructure containing most of the rooms recedes behind the lobby and features an updated version of the sawtoothed plans of the Delano and the Sherry Frontenac, providing each room with both an ocean view and a terrace. The porte cochere is scaled down to home carport size by a low, red roman-brick parapet and scalloped clapboard eaves. Originally, the hotel name appeared in upbeat script on the blank red-brick exterior, which recalls a Wrightian pylon. The Wrightian-flavored interior, lined in white-marble brick, is filled with light. Although not original, the furnishings are in synch with the period. Brochures of the era referred to the crisp, chalet style as "Swiss modern."

The Lucerne played a pivotal role in New Frontier politics. While staying at the hotel, ex-Cuban president Carlos Prío Socarrás, who was ousted by Fulgencio Batista in 1952, plotted to overthrow the dictator by financing Fidel Castro's rebels. With the backing of Socarrás's group, Castro was able to buy the fifty-eight-foot yacht *Granma*, to make his famed landing with rebel forces in Oriente province in December 1956.

Al Kaskell also developed the monumentally modern seventeen-story, Spanish Baroque Doral Beach Hotel in 1964. Designed by Melvin Grossman, the Doral was strongly influenced by the clean-lined neoclassicism of the plans for Lincoln Center in New York. The name *Doral* was derived from the first letters of Kaskell's and his wife Doris's names.

The Doral's emphatic verticality, hierarchy, and compressed arches were a reflection of a new classicism entering Modernism in the early 1960s. In a dramatic flourish, waterfalls

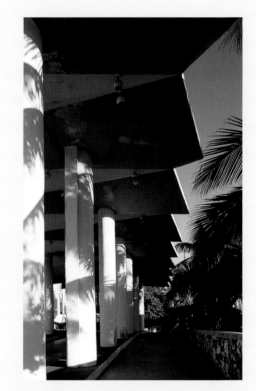

FINTASTIC VOYAGE: The fanlike creases of the Carillon's folded-plane concrete porte cochere echoed the visual rhythm of the accordion wall, and resembled a line of cars with tailfins.

spilled from the arched bays on either side of the entryway to a pool a half level below, where colorful koi fish swam amidst exotic vegetation. The pool rippled under the entry drive and stretched to the sidewalk. The basin is now filled in with landscaping.

Beneath the Classical overlay, Grossman relied on the latest Modernist vocabulary. The arched masonry bays of the pedestal stand on a separate plane from the dark curtain wall beyond. The tower's striking verticality is achieved through the use of black solar glass, the most recent innovation in window glass, sliced by piers clad in precast quartz stone. On the ocean side, gleaming piers rise full height directly from the pool deck in a dramatic, somewhat incongruous evocation of the High Modernism of midtown Manhattan, or perhaps a dream of New York from *The Best of Everything*, which had its world premiere on Lincoln Road in 1959, when Miami Beach was still Hollywood East.

In the lobby, the Doral's Spanish conquistador theme bursts upon the arriving guest with cinematic intensity. In keeping with the monumental exterior, the Doral featured the first symmetrical arrangement of interior public spaces since the Sherry Frontenac. The hotel was furnished with as many Spanish antiques as possible.

The Starlight Roof Supper Club on the seventeenth floor is Miami Beach's quintessential rooftop restaurant. Ten thousand miniature lightbulbs illuminate the ceiling, creating a shimmer that whispers of Sinatra backed by the Nelson Riddle Orchestra. The view from the Starlight, commanding the bend in the palisade of hotels and condos on Indian Creek, provides a wide-screen, urban backdrop befitting a 1960s spy caper.

For sheer epic glamour, the arrival area of the Doral Beach is unsurpassed. At sunset, beyond the lush, green horizon of Middle Beach, the last golden rays splash the languid river of Indian Creek and illuminate the gleaming quartz columns that rise from the white terrazzo pavement, making any tourist feel like a conquistador. Despite its up-to-the-minute luxury, the Doral never enjoyed the fame of the 1950s resorts. The era of fabulous Miami Beach

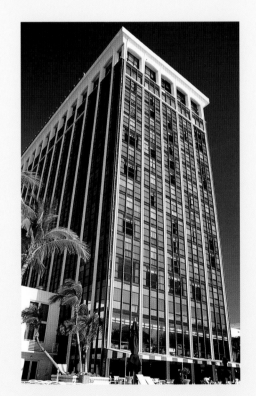

MANHATTAN MEETS MIAMI BEACH (ABOVE): The monumental facade of Melvin Grossman's Doral Beach Hotel rises straight from the ground like a midtown Manhattan office building.

(RIGHT) The mosaic elevator banks in the Doral are a tribute to the Eden Roc.

was drawing to a close. The last hurrah was Grossman's Hilton Plaza Hotel of 1967. By then, the Resort MiMo formula was exhausted and unredeemed by sheer scale or ostentation.

In a sense the resorts were victims of their own success. Hotels before the Fontainebleau were part of the lively urban environs of Miami Beach, but the big 1950s hotels brought about the decline of Lincoln Road and the nightclub scene. The Fontainebleau's remote location required that it provide a self-contained experience for guests. A lower-level shopping concourse with first-class furriers and jewelers made visits to Lincoln Road unnecessary. Venues like La Ronde Room drew the most popular performers and their audiences away from the clubs on Dade Boulevard and the Collins Canal.

Miami Beach, which thrived on planned obsolescence, was itself becoming obsolete. As Modernism fell out of fashion in the late 1960s, so too did the Miami Beach resort. Jet travel made exotic locales, like those evoked in the hotel themes, well within reach of the middle class. Tourists were no longer satisfied with Spanish-themed hotels like the Seville or Doral when they could see the real thing. As faith in Modernism gave way to the counterculture and back-to-nature movements, Miami Beach became an emblem of excess and degradation of the natural environment.

Norman Mailer caught Resort MiMo in its last, late flourishing in his book on the 1968 conventions, *Miami and the Siege of Chicago*. The excesses of modernity led him to ungate the Amazonian torrent of his prose in his description of the "white refrigerator" hotels along the Billion-Dollar Sandbar. The litany of names is a requiem for fallen heroes:

"For ten miles, from the Diplomat to the DiLido, above Hallandale Beach Boulevard down to Lincoln Mall, all the white refrigerators stood, piles of white refrigerators six and eight and twelve stories high, twenty stories high, shaped like sugar cubes and ice-cube trays on edge, like mosques and palaces, shaped like matched white luggage and portable radios, stereos, plastic compacts, and plastic rings, Moorish castles shaped like waffle irons, shaped like the baffle plates on white plastic electric heaters, and cylinders like Waring blenders, buildings looking like giant op art and pop art paintings, and sweet wedding cakes, cottons of kitsch and piles of dirty cotton stucco, yes, for ten miles the hotels for the delegates stood on the beach

side of Collins Avenue: the Eden Roc and the Fontainebleau (Press Headquarters), the DiLido and Delano, the Ivanhoe, Deauville, Sherry Frontenac and the Monte Carlo, the Cadillac, Caribbean and the Balmoral, the Lucerne, Hilton Plaza, Doral Beach, the Sorrento, Marco Polo, Casablanca, and Atlantis, the Hilyard Manor, Sans Souci, Algiers, Carillon, Seville, the Gaylord, the Shore Club, the Nautilus, Montmartre, and the Promenade, the Bal Harbour on North Bay Causeway, and the Twelve Caesars, the Regency and the Americana, the Diplomat, Versailles, Coronado, Sovereign, the Waldman (dig!), the Beau Rivage, the Crown Hotel, even Holiday Inn, all oases for technological man."

Mailer, like most of his contemporaries, disparaged the style that with the distance of time has come to be celebrated as Resort MiMo, but it is critical to realize that he was writing perceptively at the exact moment this self-satisfied, postwar Americanism started to rot from the inside, with the war in Vietnam and race riots in the streets. The dream, deferred for too many, exploded. Mailer read his fury into the architecture:

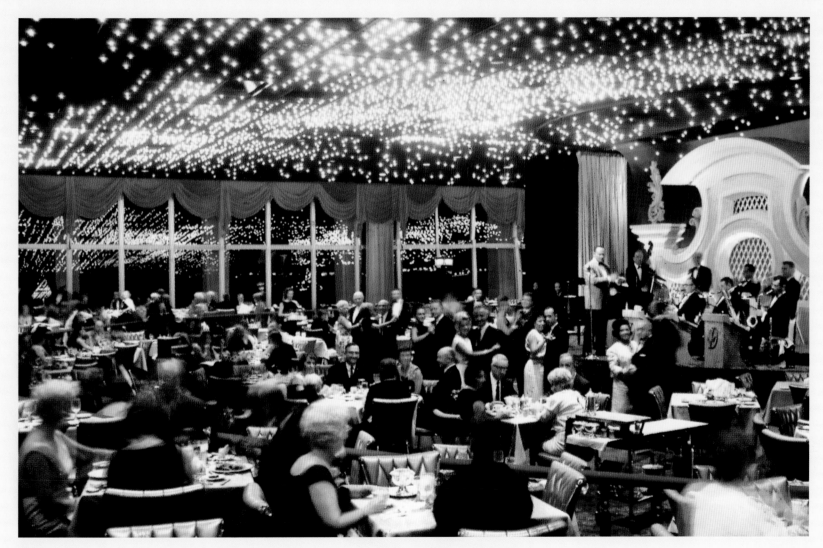

STARRY NIGHT: The Doral's Starlight Roof Supper Club, from a time when Miami Beach featured more stars than there are in heaven.

"The diadems like the Fontainebleau and the Eden Roc, the Doral Beach, the Hilton Plaza (head-quarters for Nixon), the Deauville (HQ for Reagan) or the Americana—Rockefeller and the New York State delegation's own ground—were lavish with interlockings, curves, vaults and runs of furnishings as intertwined as serpents in the roots of a mangrove tree. All the rivers of the very worst taste twisted down to the delta of each lobby in each grand Miami Beach hotel—rare was the central room which did not look like the lobby of a movie palace, imitation of late-Renaissance imitations of Greek and Roman statues, imitations of baroque and rococo and brothel Victorian and Art Nouveau and Bauhaus."

NECROLOGY
The Diplomat Hotel, 3555 South Ocean Drive, Hollywood, Norman M. Giller, 1957

Giller's pièce de résistance was razed to make way for a gargantuan convention hotel and condominiums because the underlying value of the land a dozen miles north of Miami Beach had surpassed the original value of the entire $23 million complex of a hotel, country club, motel, and golf course.

The resort remains Giller's favorite of his own designs. Materials from more than fifteen countries were used to construct the seven-story hotel, including Italian marble, Japanese tile for the gardens, and volcanic rock from Pompeii, in keeping with its international theme. The lobby was decorated in black, white, gold, and turquoise, and an adjacent lounge had black silk walls and a crimson ceiling illuminated by pencil spots. The grand staircase lobby was sheathed in gold anodized-aluminum railing.

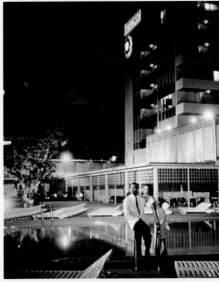

(ABOVE) The Diplomat epitomized the glamour of 1950s Gold Coast nightlife.

FIFTIES FLASH (OPPOSITE): Giller's hyperparaboloidal canopy for the Diplomat (demolished) took its cues from jet-age imagery, but the architect prefers to talk about its structure, counter-balanced on two concrete footings.

(LEFT) A rendering for the Diplomat, with the saucerlike dining pavilion at left.

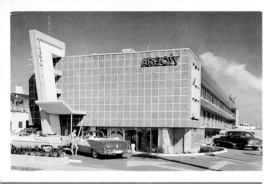

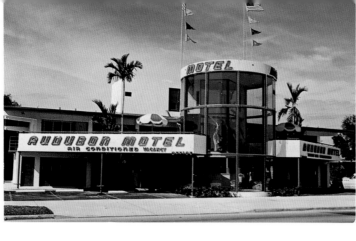

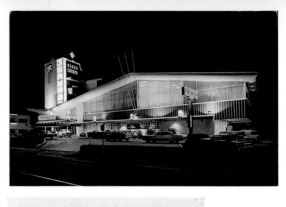

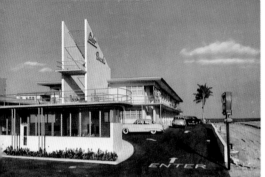

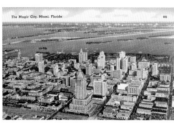

The Magic City, Miami, Florida

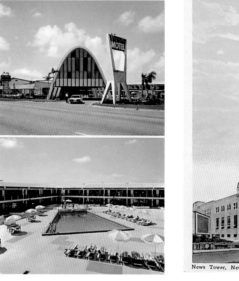

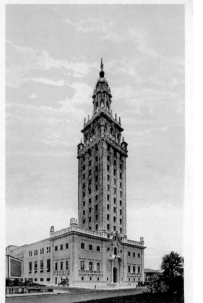

News Tower, New Home of Miami Daily News, Miami, Florida.

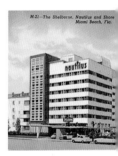

M-21—The Shelborne, Nautilus and Shore
Miami Beach, Fla.

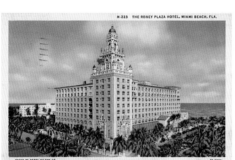

M-223 THE RONEY PLAZA HOTEL, MIAMI BEACH, FLA.

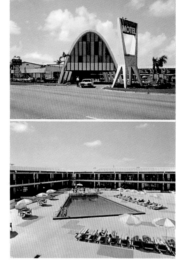

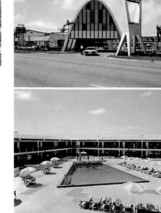

ADMIRAL VEE MOTEL

MIAMI, FLORIDA Upper Deck Swimming Pool

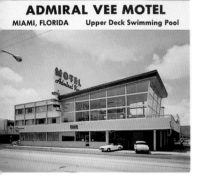

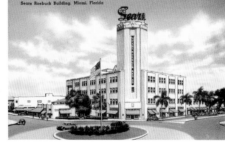

Sears Roebuck Building, Miami, Florida

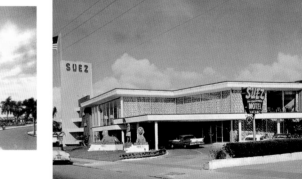

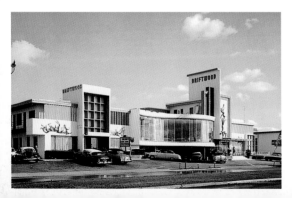

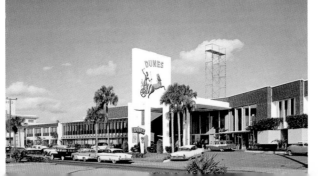

Centrally air-conditioned and heated, individually controlled. Free parking at your door. Beautifully
landscaped and uncramped spacious grounds. Sensible rates prevail at all times.

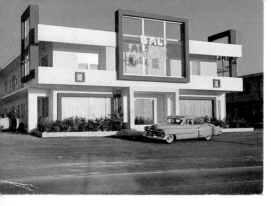

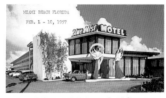

"The Maids of the Mist" beckon you to Fun-in-the-Sun

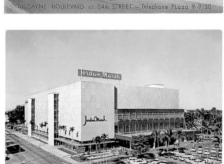

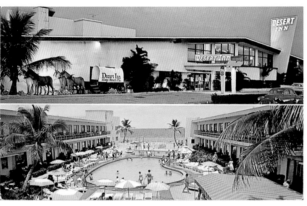

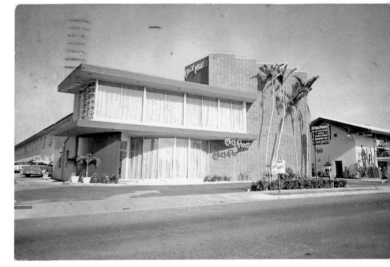

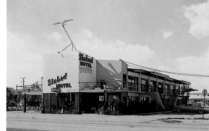

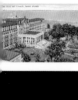

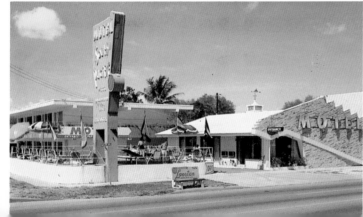

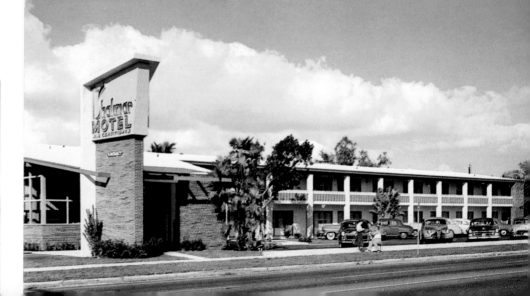

MOTEL MODERN

FOUR

When Frank Sinatra and Ava Gardner honeymooned at the Green Heron in Sunny Isles in the fall of 1951, they chose the motel because it was the only one on the remote stretch of sand north of Miami Beach. Less than a decade later, there were seventy-two motels with a total of 7,500 rooms on the strip, which became known as Motel Row. Large-scale motels catered to families that were not the jet set, treating them to an atmosphere of foreign locales and the amenities of the expensive resorts in Middle and North Beach at a moderate cost.

At one time or another, the motels included, alphabetically, the Argosy, Audubon, Aztec, Bali, Beachcomber, Blue Mist, Blue Seas, Caravan, Castaways, Chez Paree, Colonial Inn, Del-Ray, Desert Inn, Driftwood, Dunes, Fountainhead, Golden Gate, Kimberely, Lido Beach, Magic Isle, Mandalay, Monaco, Olympia, Rubaiyat, Safari, Sahara, Singapore, Tangiers, Tropicana, Voyager, and Waikiki. Although the motels invariably presented rakish modernistic sculptural compositions, these were overshadowed by all manner of exotic kitsch for curb appeal: wagon trains, Egyptian charioteers, miniature sphinxes, Arabs on camelback, Navajo thunderbirds.

As the city located at the end of the highway, at a time when nearly every man could feel himself a king of the road, every woman a queen, Miami raised motel design to an art form with two distinct variations: U.S. Highway 1 (Biscayne Boulevard locally) became lined with a procession of motor hotels geared to tourist-crammed station wagons; the strip of beach north of Bakers Haulover Park known as Sunny Isles was transformed into a themed resort wonderland. The elaborate themes of Motel Row imparted a sense of place to otherwise interchangeable motels on the featureless landscape, so that tourists came to look upon the motels as destinations in themselves and did not feel a need to see the rest of Miami Beach in order to have arrived.

MOTEL ROW

The popularity of the desert Southwest in the 1950s found vivid expression in the motels of Sunny Isles. The influence of Frank Lloyd Wright's Taliesin West pervaded residential architecture of the period. His desert retreat embodied the desires of the new consumer class after the Depression and World War II: informal living and ample leisure time. By contrast, the South Seas imagery may have reminded veterans of their time overseas or it may simply have fed a desire for escapist leisure, along with other desert and dune motifs of camels, pyramids, and Arabian nights.

Ocean Palm Motel, 15795 Collins Avenue, Norman M. Giller, 1951

Norman M. Giller quietly created an architectural revolution with one of the most-copied building types in America. His Ocean Palm Motel was the first two-story motel in the country, a building type that became so common it is virtually invisible in the built environment. The original motel still stands in an area rapidly giving ground to the hypertrophy of forty-story condominiums.

Giller, when told about this roundup of Sunny Isles motels, commented wryly, "You'd better move fast. They're scheduled to be destroyed in the next few years." He takes a matter-of-fact view of the impermanency of this legacy. The same economic pressures that led him to build two- and four-story motels are causing their rapid replacement.

Giller recalled that the idea for a two-story motel originated with a client's request. Collins Avenue had recently been moved 150 yards farther away from the ocean, opening up the land for 100-foot front lots backing on the ocean. The owner of the Ocean Palm was leasing what is now a multimillion dollar property for $6,000 a year.

"The owner came to me and said, 'That's just too much to build a one-story building. Do you think that people would walk upstairs?' I said, 'You know, with the Atlantic Ocean in your backyard, I think that those people would walk upstairs.' Sure enough, they built that thing and the first season they got back all their investment."

Along with its second story, the Ocean Palm's cantilevered catwalk is its most innovative feature. The catwalk and roof eaves cantilever outward without the use of supporting columns, providing an unbroken, panoramic ocean view. Looking out from your efficiency apartment at your own view of the ocean is as satisfying as the resort experience, on a modest scale. To support the balconies, Giller devised a system of turnbuckle steel rods braced to fixed concrete columns on the opposite side of the building forty feet away.

The motel was a small marvel of economy. Giller grouped the bathrooms for four guest rooms in one plumbing stack that was repeated on the second floor, so that eight bathrooms could be served by a single stack. The model was copied countless times.

The Ocean Palm is a version in embryo of grander motels to come along the Sunny Isles strip. There is a pocket-sized front office, which in later motels would be expanded to include impressive lobbies and public dining areas. The facade is quite

modest, with just a hint of MiMo touches like glass jalousies and framed slumped brick.

Dunes Motel, 17001 Collins Avenue, Melvin Grossman, 1955

Desert-themed motels did not follow any sort of logic, other than taking advantage of Miami's sand and sun. The Dunes was no doubt a result of the cross-pollination between the Miami and Las Vegas resort industries.

With its luxuriantly broad signage pylon sporting an Egyptian charioteer racing across the Sahara, the Dunes was among the largest, and yet one of the more restrained, motels on the strip. Perhaps the outsized pylon made any further attention grabbers unnecessary. The motel featured a double-height porte cochere and a handsomely executed sawtooth brick wall, which shielded the nightclub area. Beyond the dramatically proportioned lobby, the guest wings sprawled like two opposing E's in plan, with a pool deck in between.

Sahara Motel, 18335 Collins Avenue, Carlos Schoeppl, 1953

One of the finest homages on the strip to the spirit of Wright's Taliesin West is Carlos Schoeppl's Sahara. Schoeppl was adept at

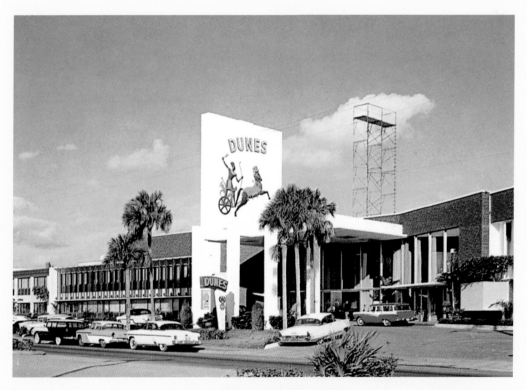

ROAD WARRIOR (ABOVE): Moderately priced motel resorts in Sunny Isles like the Dunes, seen here in its heyday with Populuxe two-tone cars parked in front, evoked exotic scenes and desert locales.

(OPPOSITE) The staggered piers of the modest Ocean Beach Resort motel echo the facade of the upscale Deauville.

Norman M. Giller was a quiet innovator in MiMo architecture long before Morris Lapidus moved to Miami Beach. Like Henry Hobson Richardson, he might have taken as his motto, "I'll plan anything a man wants, from a cathedral to a chicken coop." Giller has designed a remarkable range of buildings—nightclubs, hospitals, military bases, resorts, synagogues, banks, and apartments—and created one of the most widely imitated building types in the United States: the two-story motel.

Giller is also responsible for some of the most influential technical advances in the state. He was one of the first to introduce central air-conditioning to South Florida, through the back door in a sense. When he designed a local army base during the war, military regulations required heating for buildings, but there was no provision for air-conditioning, which was needed much more in South Florida. Giller found a system that had both heating and air-conditioning for the same cost and convinced the army to use it. He was the first to discover that PVC plumbing lasted longer than lead piping in the high water table of the coastal soil. He also introduced space-saving flat slab construction to the Southeast. In 1957 his practice was ranked by *Architectural Forum* as the tenth largest firm in the country by volume, with $101 million worth of projects under construction, even though he had only a fraction of the employees of major competitors like Skidmore, Owings & Merrill.

Giller believes that what is now identified as commercial MiMo architecture was not a conscious school of design. "Everybody was just designing what we called contemporary architecture of the time," Giller said as he sat behind his curvilinear desk-conference table in the penthouse of the office building he designed on Arthur Godfrey Road.

"When you're doing that, you're not saying, 'Gee,

I want to design a MiMo building or an Art Deco building.' It was not conceived of, 'This is going to be a MiMo building.' We may have said this is a streamline building, and you see a lot of stucco work in different forms and colors, but in the architect's mind at the time it was a contemporary building, and that's what he was thinking about."

Like many architects, Giller is quick to sketch out his ideas with a few pen strokes as he talks. He draws the cantilevered truss system he used for the balconies of the first two-story motel in America, the Ocean Palm in Sunny Isles. The cantilevers support the balconies without columns, so that the long, clean lines of the motel show through, a system adopted by countless others.

Giller's own office is vintage MiMo, from the 1950s-style starburst faceplate on the doorknob set at chest height to the turquoise upholstery of the chairs and his custom-made zigzag desk. On one wall is a wooden panel with the outline of the United States, which once opened at the push of a button to dazzle clients with slides of his latest project. Framed pictures on the wall showing Giller with John and Bobby Kennedy, Hubert Humphrey, and LBJ attest to his work building

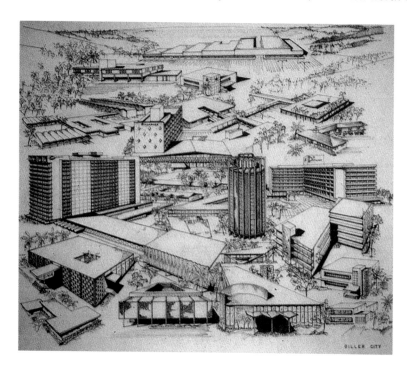

GILLER CITY

hundreds of schools, clinics, and hospitals throughout Latin America for the U.S. Agency for International Development in the 1960s.

Born in Jacksonville in 1918, Giller pieced together a patchwork education in architecture, including correspondence school, a stint in the navy, a semester at the University of Florida studying with Florida's first licensed female architect, Marion Manley, and finally a degree from the University of Florida in 1945.

In the early 1940s, he apprenticed for Henry Hohauser and Albert Anis. Giller recalls working in Anis's penthouse office at 420 Lincoln Road: "He lived in part of the facility and the other part was his office and the drafting room. I would sit there and the ocean was in the background. There were no buildings between Washington Avenue and the ocean, so it was a clear view and I would sit there half the time watching the ocean. At that time, the workload was starting to go down, because

the government was tightening up on the different kinds of materials that you could use," as a result of the war effort.

After the war, there was an explosion of pent-up demand for construction. "When I first opened my office, we had over one hundred clients. I was a brand-new architect," Giller marvels. "The phone would ring: I've got a piece of property and I want to build an apartment building, I want to build a house, or I want to build some stores. With one hundred projects, that first year was really overwhelming. I had seven men working on one board, because in those days we used a pencil and paper and a T-square and a triangle."

Giller's chief MiMo monument remains the Carillon Hotel, with its innovative glass curtain wall. His personal favorite of his own designs, the Diplomat Hotel in Hollywood, Florida, fell victim to relentless real-estate pressure. "It's an example of a ten-story hotel where the land got so valuable that they could afford to tear down a building worth millions of dollars," the architect said. He shows a blow-up of the Diplomat's hyperparabolic porte cochere with pride, but is unsentimental about the destruction of his legacy. "It's the economics that drives most of these buildings."

Giller feels that the new Miami is becoming too densely developed. "When we were building, we had a height restriction of 150 feet on the beach," he recalled. "I think they're just overcrowding the city, even though I had something to

do with that when I was on the design review board. I don't think anybody could have imagined the impact that it would have."

The new Miami Beach Chamber of Commerce, completed in 2001, is a fitting capstone to Giller's long career, not only because he designed it with his son and partner, Ira, but because it is a deliberately Post-Modern building that evokes and reinterprets MiMo for today. Because the building is raised on pilotis, you can get a direct feel of the building's irregular footprint by walking under it on the ground-level parking lot. Two right angles are connected by an undulating hypotenuse, which recalls one of Giller's earliest designs, the Copacabana nightclub of 1948 shaped like a grand piano. The first-floor visitors' center features an artfully sculpted terrazzo floor of marine motifs reminiscent of Deco hotels.

employing the highly popular Wrightian gable-cum-Swiss chalet motif. He designed a high-style Resort MiMo version in the Lucerne and a compact, urban version in his renovation of the Rowe Motel.

In the uncluttered setting of Sunny Isles, the Sahara allowed Schoeppl to convincingly evoke the sprawling horizontality and spacious-as-the-West interiors of Wright's Arizona idyll. Enormous, low-pitched gable roofs were a common feature on Motel Row, but the sculptural and dimensional qualities of the Sahara show a truer appreciation of Wright's work. Instead of just

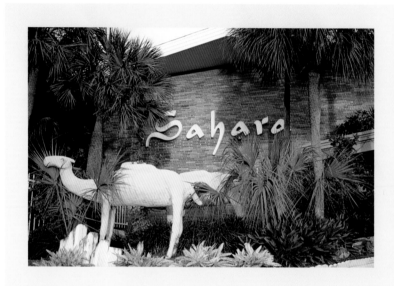

FROM THE SAHARA TO THE SOUTHWEST (BELOW, LEFT): Motel "elements," as they are called, like these biblical figures on the lawn of the Sahara, may have reminded weary travelers of Joseph and Mary's search for lodging.

(LEFT) Camels peek out from the palms in front of the Sahara's low-pitched roof.

(OPPOSITE) A rendering of Norman M. Giller's Thunderbird Motel of 1955 shows how closely the middle-class resorts of Sunny Isles were patterned after their pricey Miami Beach counterparts.

serving to call attention from the roadside, the motel's low-pitched roofs are composed as an assemblage, reminiscent of Wright's sprawling campsite in the desert. In contrast to the Dunes' high lobby, the wide, low lobby of the Sahara flows off in different directions, suggesting casual informality.

Thunderbird Motel, 18401 Collins Avenue, Norman M. Giller, 1955

At the other end of the spectrum from the Ocean Palm is Giller's four-story luxury motel that contains all the features of a high-end resort. With its large-scale Southwest Indian motif, the Thunderbird is Giller's favorite of the sixty or so motels his firm designed.

"This was going to be the king or queen of the whole area," Giller said, "which it really turned out to be. You now had a big lobby, a nice check-in place. We put a little wing back in there that was a restaurant. This is a far cry from the first motel five years earlier."

The central pylon with the thunderbird design and the long sloping roof were designed to disguise the height of the superstructure, which was set perpendicular to the street. "We didn't want it to look like four stories from the outside," Giller recalled, "because people may not relate to that as a motel. They'll think of that more as a hotel." In one of the touches that distinguishes the Thunderbird from a lower-echelon motel, the windows for the rooms are set on a sawtooth angle to give each privacy and an ocean view.

The frontage of the Thunderbird is two hundred feet, twice the standard lot, so Giller was able to design a curvilinear, double-height glass lobby with a balcony, two grand stair-

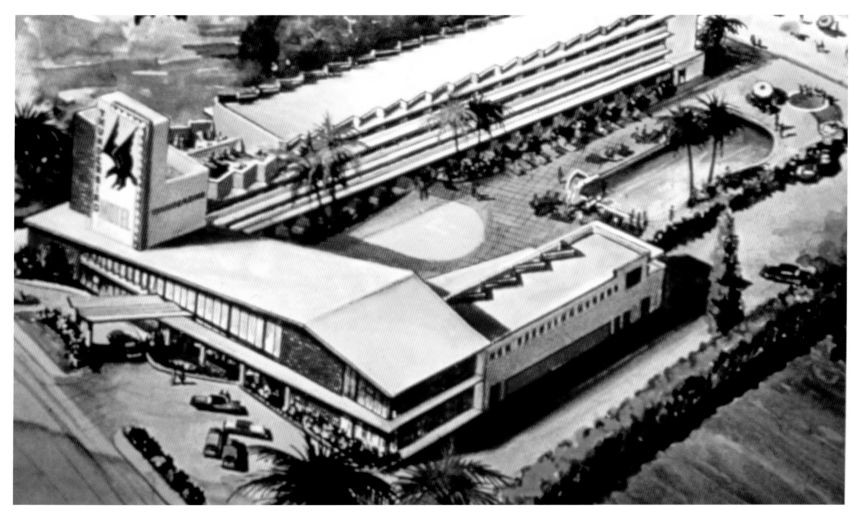

cases, and several planes of woggles. "The lobby has got a nice little curve to it, to give a little flair," Giller said. "We started with the curves when we did the Copacabana building on Dade Boulevard around 1948. The whole building was curved like a piano. Curves add a lot as far as design is concerned. I think it gives you a little bit of a change instead of all the square, rectangular corners."

Typical of its time, Motel Modern architecture embraced both nature and the automobile. The subtropical climate allowed MiMo design to fulfill the modern ideal of integration of interior and exterior blending. The Thunderbird's glass-walled lobby looks out directly on a landscaped garden with curvilinear paths and swaying palm trees, so it was only natural that these curves found their way into the lobby design.

"We did a number of very simple stores out on Southwest Eighth Street, but we used the curved corner and the concrete cantilevers out over the walkway," he said. "When you're doing that, you're not saying, Gee, I want to design a MiMo Building or an Art Deco Building. Maybe it is in the air. We were trying to give it a little extra flair."

At its height, the Thunderbird offered a pool, a snack bar, a first-class steakhouse, and two quaintly superannuated features, a TV room where guests could watch the novelty of television in a small auditorium-style space, and a room for playing cards, a major social activity in the 1950s.

The big motels were a demotic reflection of Resort MiMo. Newspaper ads for the Thunderbird announced rooms for $4 a night, with a quote from the sage of Miami Beach, Walter Winchell: "The Thunderbird calls itself a motel. It is more like a palace."

The economic renaissance of Miami Beach touched off by the Art Deco preservation movement of the late 1970s has driven up the value of the land where many of the small hotels and motels of the 1950s were built. Nowhere is this more apparent than in Sunny Isles. In just a few years, nearly all of the motels have disappeared, many already replaced by equally outlandish mega-high-rise condominiums. The days are numbered for the few that remain. In some small way, the motels' brash spirit is carried on in the new towers that appear straight out of a science-fiction movie. One can easily imagine spaceships zooming around and between their sculpted, sky-piercing forms.

THE MOTELS OF MIMO BOULEVARD

The lots along Biscayne Boulevard were smaller and more urban than those on the beach in Sunny Isles, so the boulevard motels were smaller and catered to the overnight trade rather than serving as longer-stay destinations. Although the motels were nowhere near the water, many made full use of maritime connotations, with names like the Sinbad and the South Pacific, just like the landlocked enclaves of Miami Shores and the city of North Miami Beach.

Sinbad Motel, 6150 Biscayne Boulevard, architect unknown, 1953

The Sinbad has been denuded of most of its original character, but its prowlike projection pointing toward the boulevard and its perpendicular orientation in the middle of the lot seem to indicate that this was once Sinbad's boat. The four-pointed, three-dimensional star that once adorned the tip of the prow found its way onto the cover of REM's *Automatic for the People* album, which was recorded at Criteria Studios in North Miami. A Motel Modern motif runs through the album's artwork.

Shalimar Motel, 6200 Biscayne Boulevard, Edwin Reeder, 1950

The Shalimar Motel is distinguished by its homelike shed roof. The popular Sammy Walsh's restaurant once stood opposite the reception facing the corner of Biscayne and Sixty-second Street. Along with the South Pacific next door and the Sinbad Motel to the south, the Shalimar formed a thematic group evoking sea adventures and exotic locales.

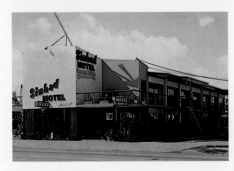

NIGHT AND DAY (TOP): Giller designed his motels to attract tourists when illuminated at night. Plate-glass walls serve as show windows for the lobby interiors.

(ABOVE) Fashionably functional, the Sinbad lets its sunny surroundings do most of the work.

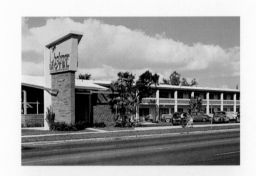

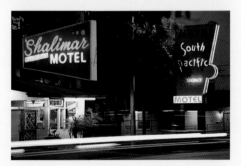

THEN (TOP): A shed roof and stone pylon gave the Shalimar a modern domestic feel.

NOW (ABOVE): The neon signs of the Shalimar and the South Pacific beckon a new wave of urban explorers.

Like the Lucerne Hotel in Miami Beach, the Shalimar presents itself as an overscaled house. The U-shaped structure, with two exaggerated extended sloping eaves at either end, looks like a cutaway of a gable-roofed house. The eaves form the embracing symbol of a house, framing a two-story motel balcony that is divided into ten bays by cinderblock columns.

The south wing supports a white, roman-brick pylon with a billboard for the motel's name. A beanpole screen is set in a niche, and a similar cutout space leads to the interior. Opposite there is a small, clapboard-covered office near the street, surmounted by a suspended, delta-wing-shaped sign for the motel with script letters on a corrugated-metal background.

The north wing once served as a porte cochere entered from Sixty-third Street, which unfortunately has been boarded up for security reasons in the marginal neighborhood. The wing plays variations on the symbolism of roof as house. The solid-looking north facade is foiled by the porte cochere, which cuts a void into the wall and reveals the roof to be just a connector of two separate volumes.

In a startling gesture, the next section of the building is set in, but the A-line of the roof runs without a break over a blank space, revealing the roofs as a symbol or sign, because it does not necessarily need to cover enclosed space to fulfill the visual function of shelter. The building subverts the idea of what is outside and what is inside, and how much information is needed to represent the idea of house—is it a fully enclosed structure, the void covered by a roof in the middle, or just a column of air with a background of a wall and a slanted roof, like an archetypal child's drawing of a house? The domestic theme is heightened by the use of common materials like clapboard, brick, cinderblock, and shingle.

South Pacific Motel, 6300 Biscayne Boulevard, architect unknown, 1953

The South Pacific is an example of the decorated shed from Robert Venturi and Denise Scott Brown's *Learning from Las Vegas*, but with an exclamation point. The volume of the small one-story lobby was exploited to create maximum visual impact with minimal materials. The edge of the low-pitched roof seems to dissolve into stacks of synthetic stone that look as if they are toppling over. A zigzag lightning-bolt-shaped cornice turns the entire facade into

a dynamic deictic arrow directing the eye to the reception office. Multicolored bubbles on the South Pacific's sign still manage to light up the night and, along with the signs of the Shalimar and the Sinbad, present a tarnished glimmer of the boulevard's first heyday.

Vagabond Motel, 7301 Biscayne Boulevard, Robert M. Swartburg, 1953

The Vagabond, the most outlandish motel on the Biscayne strip, was designed to entice motorists from every angle. To this day, the sirens waving from a stone grotto at the northwest corner have the power to turn on brake lights. From the south, a signage pylon erupts into the night sky, trailing a shower of twinkling, multicolored stars.

The lobby, reception area, and back-office space form a collage of volumes and planes clad in glass, stucco, and crab orchard stone. Swartburg would explore this collage concept fully in his trio of apartment buildings on Bay Drive in Normandy Isle.

With its winglike canopy stretched over four structural elements that evoke a sci-fi spaceship, the porte cochere speaks eloquently of flight and of the future as it looked in the 1950s. As if these visual acrobatics were not enough, the motel also

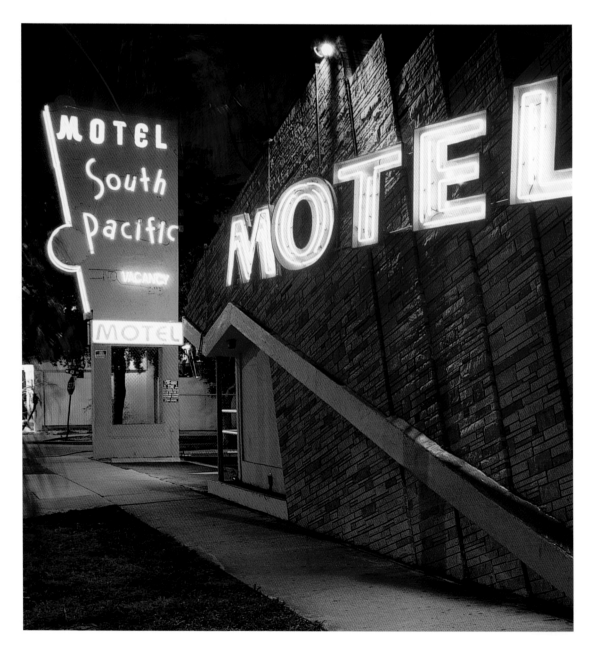

offers the most expansive court on the boulevard, featuring a spacious, raised pool deck to tantalize the weary family that might not have been convinced by sea nymphs, twinkling stars, and Buck Rogers references.

MIAMI BEACH MOTELS

Creek Motel (originally Motel Ankara), 2360 Collins Avenue, Reiff & Feldman, 1954

Graciously situated on a slip of Indian Creek, Reiff & Feldman's motel seamlessly blends Wrightian elements and pure 1950s flash. The central element is a radically cantilevered, raked delta-wing roof, perched as lightly as a paper airplane atop a triangular glass lobby.

The interior and exterior blending, central to subtropical architecture, is brashly realized. A single concrete slab forms the porte cochere and the ceiling of the lobby, separated only by a glass membrane. The cantilevered canopy defines an outdoor space almost equal in volume to the interior lobby space, and is pierced by a pylon set like a tent peg at the far corner, as if to keep the whole thing from taking off.

The lines of the building are delightfully thought out. The lower, fieldstone half of the lobby's window wall angles outward to frame the entrance steps. Unfortunately, one of the wittiest details was removed in a recent renovation: a bench in the lobby that paralleled the angle of the wall no longer has the appearance of extending through the window wall to the covered porch outside.

Two clean-lined wings anchored by slumped-brick pylons frame the grounds against a curvilinear mooring dock on Indian Creek. The aesthetically satisfying combination of curves and sharply angled lines is pure MiMo, especially when viewed from the bowed footbridge on Twenty-third Street.

The roofline's acute angles are a keynote for the whole structure, from the crimped shape of the sign atop the pylon at the north end to the kinked geometry of the pool and planters. A floating staircase with concrete railings forms a zigzag sculptural shape that is thoroughly integrated with the signage pylon. The staircase has the minimalist integrity of a Tony Smith sculpture, playing off the perspectives of right angles against unexpectedly skewed angles, as in the bottom flight of stairs. With

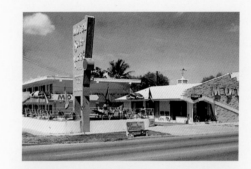

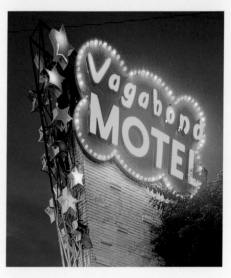

LEARNING FROM MIAMI: Biscayne Boulevard motels are a Miami version of the Las Vegas strip.

(TOP) The facade's domino effect was even stronger before the glass lobby was enclosed so that the wall seemed to have no support.

(ABOVE) The Vagabond's star-spangled pylon.

(OPPOSITE) The South Pacific facade appears to topple, making the whole building a directional arrow.

ROWE HOUSE: The remodeling of the Rowe Motel (now a Super 8) integrated a structure meant for the open road into the urban fabric of Miami Beach by overlaying the archetypal glass gable and intersecting pylon on a 1930s hotel.

its openwork lattice breezeway, the stairwell expresses modern aspects of openness, penetrability, transparency, and clarity of construction.

The motel shows how well suited Frank Lloyd Wright's design elements are to Modernist vernacular architecture and why they were embraced by architects and the public in the 1950s. The stone pylons hark back to Wright's Fallingwater of 1937, while the all-glass architecture seems as appropriate as a jalousied Florida room in the subtropics.

The motel made a brief but exciting cameo with its original signage during a high-speed boat chase scene in *Murph the Surf* starring Robert Conrad in 1974, a travelogue of late MiMo-era condos along Indian Creek.

Rowe Motel, 6600 Collins Avenue, David Ellis, 1939; Carlos Schoeppl, 1956

To keep up with ultramodern resorts like the Deauville and Carillon across Collins Avenue on the beach side, Carlos Schoeppl gave the landlocked prewar Rowe Hotel a MiMo makeover that transformed it into an up-to-date motel, where guests could park within steps of their room and enjoy the equally accessible pool deck.

It is a measure of the popularity of motels in the 1950s that such a relatively simple makeover was expected to make the inn competitive with the all-inclusive beachfront resorts. By applying a sprawling glass gable to the stucco box of the old hotel, Schoeppl transformed it into a minicelebration of the wide-open spaces of the American heartland, within North Beach's compactly urban scale.

In the rear, sliding glass doors were cut into the walls, and exterior catwalks were added to complete the transformation. A new L-shaped addition stretched to the back of the lot to create the feel of a motel out on the open road, instead of in the midst of urban Miami Beach.

Queen Elizabeth Hotel Apartments, 6630 Indian Creek Drive, Melvin Grossman, 1952

Originally built as a combination motel and apartment building with underground parking and a pool with a bayside view, the Queen Elizabeth's two double-story wings are set at an angle to the street facade, creating a constant play of zigzags where one expects right angles.

A leitmotif is formed by the Z patterns and backward Z's of the metal railings. The motif is repeated throughout: in the jagged fringe of the floating stairways, the hollow squares in the railings that become acutely angled rhomboids in the sharply raked

banisters, the irregularly shaped canopy that projects at an odd angle, and the sharply angled front office. The dynamic zigzags contrast with the long horizontals of the facade, which were a simple visual shorthand that signified "ultramodern" to the arriving vacationer.

The best feature is the rear balcony, which frames a view of the bay like a Cinemascope screen. By the poolside, with the exaggerated image of a chalet-style house behind you, it is possible to imagine that you have found your place in the sun, at least for the moment.

International Inn, 2301 Normandy Drive, Normandy Isle, Melvin Grossman, 1956

Gazing out at Biscayne Bay and the lights of North Bay Village at sunset from the plate-glass mezzanine of the International Inn conjures up the glamorous Miami Beach of Murph the Surf. The transparent lounge becomes a spectacular double-height conning tower above the geometric pool deck, which lies moored to the shoreline like a mini aircraft carrier.

Far from the madding crowds of Collins Avenue, and within walking distance of nowhere, the International Inn, unlike the in-town Rowe Motel is a true creature of the automobile culture. It is conveniently located at the east end of the North Bay Causeway that connects Miami Beach and Hialeah Race Track. The restaurants, nightclubs, and kiddie pleasure domes that once lined the causeway in North Bay Village were popular destinations in the 1950s and 1960s.

Modernist principles of clarity of structure and transparency are put to stunning use in this jet-age motel. Two concrete slabs appear to float on large sheets of glass, supported by a central concrete stairwell. The ultramodernity of the glass box was pushed even further by the building's trapezoidal plan. Rather than being rectangular, the lines of the building open outward to the main facade overlooking the bay. The floor-to-ceiling plate-glass walls in the front and rear are also canted, emphasizing the upward sweep of the roof. The motel's voluminous, glass-enclosed lobby and mezzanine space, topped with a shed roof, serve as the signage for this denizen of the roadside.

Inside, the low-ceilinged reception area gives way to the sweeping curve of the mezzanine balcony and the soaring double-height lounge space. The sudden transition from a compressed to an open space is an effect whose lineage can be traced from Grossman's mentor Lapidus, back to Frank Lloyd Wright, all the way to Bernini in the Baroque era.

The International Inn's original fixtures are nearly intact: a chandelier so big that it is almost Post-Modern in scale and a floating staircase that winds above a miniature grotto, set against a wall clad in unusual zebra-striped mosaic tile. This Populuxe palace cries out to be taken over by a sympathetic entrepreneur and turned into a retro-hip lounge.

IN A CLASS BY ITSELF

Hampton House (originally Booker Terrace Motel and Apartments), 4240 Northwest Twenty-seventh Avenue, Miami, R. K. Friese, 1953

In the 1950s, as Miami's African-American community spread north and westward from Overtown, and African-American tourists desired the same postwar amenities as whites, the Hampton House motel, an equivalent of those on Biscayne Boulevard, opened on Twenty-seventh Avenue in the Brownsville section.

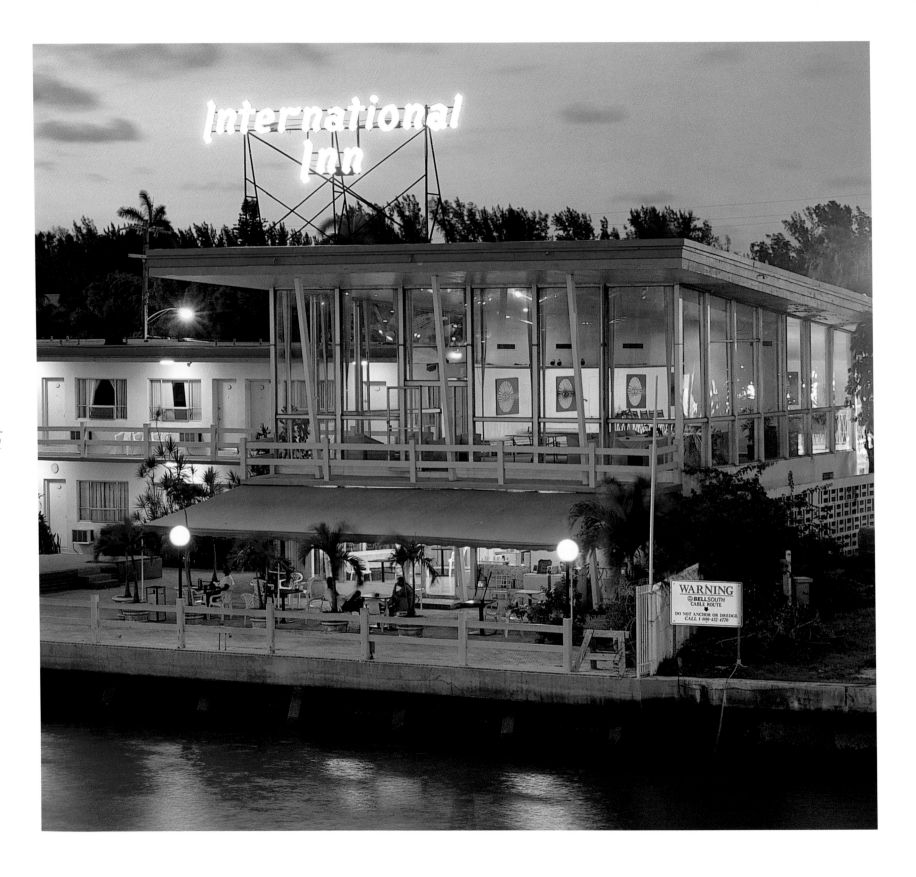

The Hampton House, however, was no mere motel. Paralleling events in Miami Beach, it became a political, cultural, and social center for the African-American elite, where the rich and famous stayed, played, and mingled with middle-class tourists in the quest for fun in the sun. Muhammad Ali, the Reverend Martin Luther King Jr., and Malcolm X stayed there. King, who gave an early version of his "I Have a Dream Speech" at the Hampton House, often stayed in room fifty-one, after holding press conferences in the lobby.

The Hampton House replaced the hotels of Overtown as the venue where entertainers like Count Basie, Josephine Baker, Ella Fitzgerald, Sammy Davis Jr., Patti LaBelle, and Aretha Franklin gigged after playing the whites-only hotels of Miami Beach.

After the mid-1960s, the Hampton House fell into decline. As of this writing, the vacant building is a shell of its former self. The grounds are covered with weeds, and trees grow through holes in the roof. In 2003, community activists and local preservationists, led by the African-American Committee of Dade Heritage Trust, secured a reprieve from the wrecking ball, and the site was granted historic designation.

Plans have been made to purchase and restore the Hampton House to its MiMo heyday. Historic components, such as the lobby, patio, courtyard, and hotel rooms once occupied by Ali and King, will be preserved. The first floor will be dedicated mainly to the historic tourist attraction, while the top-floor office space is planned to be a business support center to attract African-American professionals to the area.

NECROLOGY

Driftwood Motel, 17121 Collins Avenue, Sunny Isles, Norman M. Giller, 1952

The Driftwood is one of the mounting MiMo casualties of the tide of development along Sunny Isles' Motel Row. The U-shaped two- and three-story motel presented an unusually sophisticated facade to attract motorists. An undulating plate-glass S curve united the two wings whose street facades employed varying sculptural effects and relief patterns forming an exquisitely balanced abstract composition meant to be "read" at cruising speed. The variety and free-form nature of the pure compositional forms gave a surprising depth and texture to the facade when played upon by the sun.

The Driftwood was built in two separate stages, but when it was completed, it made a seamless whole. A two-story motel was originally built on the north side of the lot. When the three-story wing to the south—which provided a new main entrance and lobby—was completed, Giller added an undulating second-level bridge to unify the ensemble.

The composition of the street facade was a sculptural tour de force. Starting at the south end, a thick, overhanging cornice that capped a band of vertical louvers drew the eye across a panel featuring an actual piece of driftwood. The ensemble was crowned by a thin, intersecting signage pylon. The central mass rested lightly on the plate-glass lobby. An eggcratelike panel on the north wing balanced a similar treatment on the south wing. The undulating glass wall of the second-level bridge swung outward and back from the juncture of the signage pylon and the entry canopy. The S curve made the eye sweep across the whole visual feast, searching for rhymes and echoes. At night, the masonry elements receded and the glass pavilion, illuminated from within, emerged, beckoning weary motorists with a vision of a clean, well-lighted place.

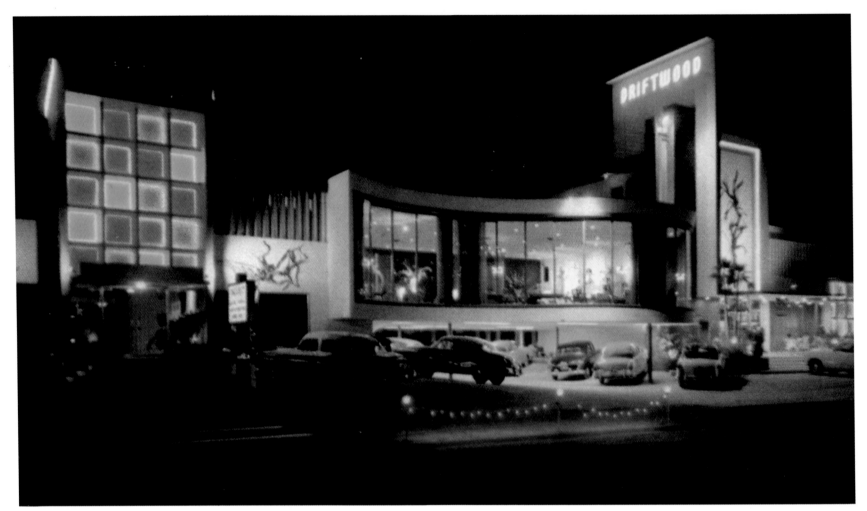

Giller even considered the relative "temperatures" and textures of the building materials. "We used a lot of roman brick in this particular building," Giller said. "It's a long, sixteen-inch brick, and it makes a nice design. You get a deep cut in the joints. It gives you a nice warm texture, which counterbalances the slick glass. Glass is a very hard material, as opposed to brick being a warmer material. Glass is a colder material."

The Driftwood was a MiMo landmark, but Giller is a realist and is relatively sanguine about the disappearance of Motel Row. "I think they'll eventually all go because of economics."

Castaways Island Hotel, 16400 Collins Avenue, Sunny Isles, Charles F. McKirahan, 1958

Designed to resemble a shipwreck in its own private lagoon, the island hotel addition to the Castaways Motel was the most phantasmagoric creation on Motel Row. Sited on the inland side of Collins Avenue, the sprawling complex was a definitive Motel Row mélange, featuring a Shinto Temple Dining Room side by side with a Tahitian Cocktail Lounge and a subterranean Shipwreck Bar.

"This triumph of crazy-quilt design is the Castaways, where almost anyone in a Hawaiian shirt might be mistaken for a bellhop," journalist Harold Mehling wrote in 1960, before there was a theoretical framework to explain complexity and contradiction in architectural style. "The Castaways is *sort of*. It would be sort of Japanese Religious if it weren't sort of South Pacific Carefree or sort of All-Oriental Mishmash. A guest who likes his atmosphere in large, gooey chunks may dine under the tinkling spell of the Shinto Temple Room and then drink under the passion-flower influences of the Tahitian

Cocktail Lounge. But if he should drink too much before strolling out to inspect the motel's architecture, he might quit drinking forever. The problem, however, is not D.T.s. It is that the Castaways' designers madcapped the place by angling its roof sections sharply, faking in non-functional points, and slanting its edges steeply."

With its hyperparabolically pointed Papuan peaked gables, the Castaways Island Hotel was a splendid example of the ambivalent motives of the cult of tiki to combine an advanced future with an uncomplicated past. The Castaways' teahouse lobby with its double hyperbolic roof was a forerunner of Charles F. McKirahan's stellar American Motor Inn, covered in the Fort Lauderdale chapter.

Suez Motel, 18215 Collins Avenue, Sunny Isles, Norman M. Giller, circa 1954

Sunny Isles no longer has room for old-fashioned road warriors like the Suez, which was demolished as this book was being written. One day it was there, and the next it looked as if it had been hit by Hurricane Andrew.

The Suez was an artifact from a time when families loaded into cars to make the hegira south without hotel reservations and stopped at the first lodging that enticed their road-bleary eyes. In the days before motel chains regulated the options, motel owners resorted to all manner of visual gimmicks. Three-dimensional "elements," as they are called in the trade, appealed to station wagons full of impatient kids.

The Suez's element was a single-story pyramid that pierced the entry canopy, flanked by two somewhat rough-hewn sphinxes staring enigmatically in either direction along Collins Avenue. A minisarcophagus of a female mummy, who resembled a Miami Beach matron in a head wrap with kohl-rimmed eyes and a muumuu, nestled in one wall.

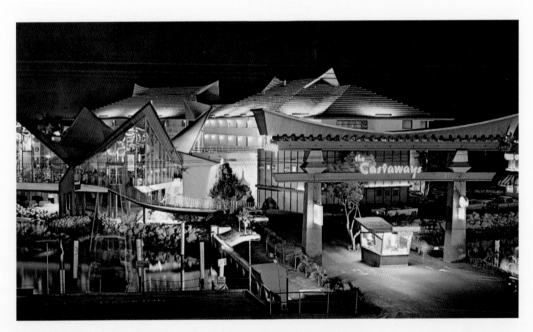

(ABOVE) Charles F. McKirahan's Castaways Island Hotel (demolished) was a phantasmagoric complex of pan-Pacific themes.

MIMO MEMORIES (OPPOSITE): Giller's Driftwood (recently demolished) was a rhapsody of flowing geometric forms, including a concrete lattice panel, a suspended, glass-walled S-curve mezzanine bridge, and a wafer pylon.

BAY WATCH (PREVIOUS SPREAD): Interior lights from the canted, two-story glass viewing lounge of Melvin Grossman's International Inn of 1958 shimmer on the water of Biscayne Bay at sunset.

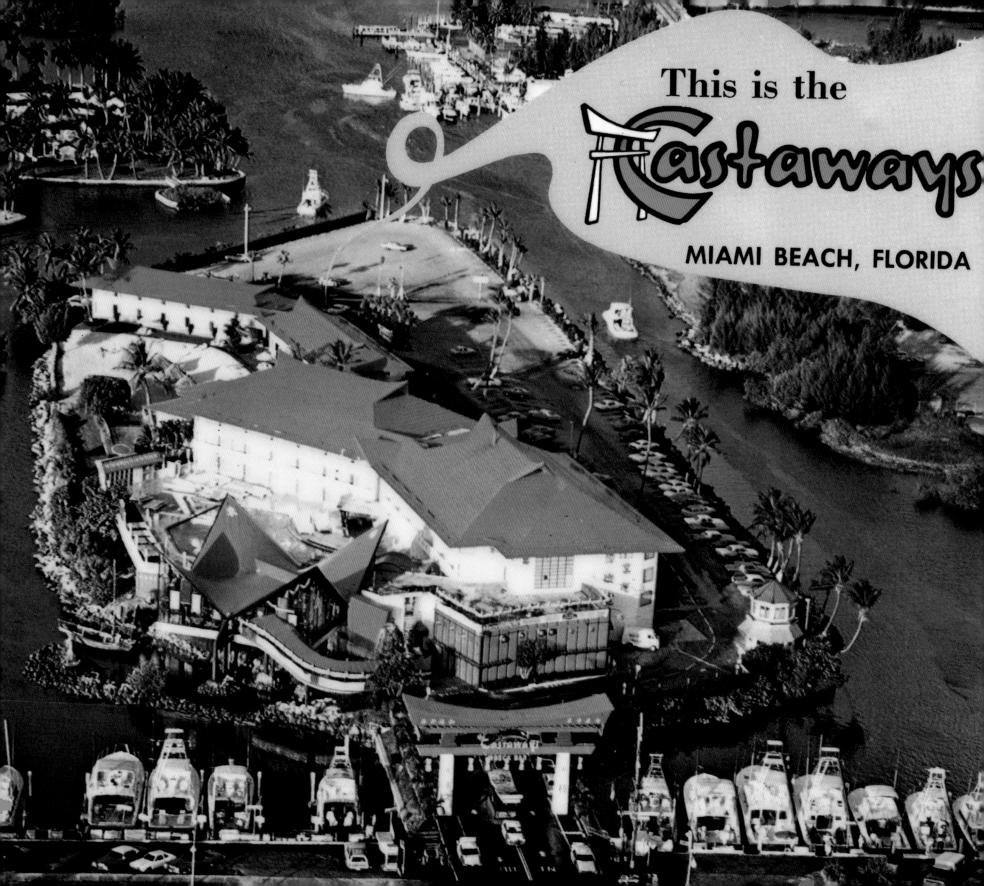

This is the **Castaways**

MIAMI BEACH, FLORIDA

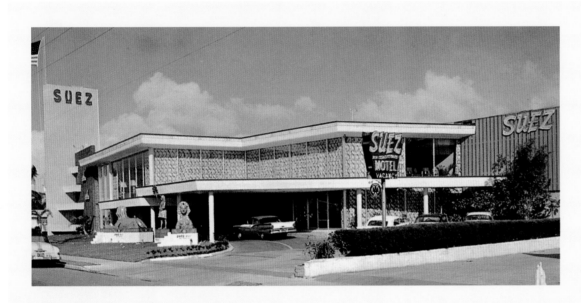

OUTCAST OF THE ISLES (OPPOSITE): Charles F. McKirahan's Castaways Island Hotel (demolished), a pop delirium of Polynesian pavilions set in its own lagoon, was famous for its subterranean Shipwreck Bar.

LITTLE EGYPT (LEFT): Giller's Suez (demolished) featured a pharaoh and two miniature sphinxes.

Schlockmeister Herschell Gordon Lewis, who graduated from making "naturist" nudie flicks to become the "godfather of gore," shot the unsavory little cheapie *Blood Feast* in four days, mainly in and around the Suez Motel in Sunny Isles in 1963. The miniature-golf-scaled sphinx in front of the motel was used to stand in for the real thing. The auteur Lewis believed that hiring professional talent was a waste of money. He said of his lead actress, Connie Mason, Miss June of 1963: "She never knew a line. Not ever." The story climaxes at the Miami Beach City Dump, where the film belongs.

Set at an angle to the road, the building's whole facade served as a sign to draw in the traveler. The tall signage pylon with the motel's name was pierced with dartlike cascading water basins that drew the eye along the facade to the entry. The overall layout was typical: a shallow lobby was dominated by a staircase leading to a mezzanine that bridged an entry to the pool deck, which was framed by two perpendicular wings of rooms.

Like the iconic winking neon cowboy in Las Vegas' Glitter Gulch, 1950s motel kitsch is becoming a colorful relic. In the pell-mell to provide luxury living, developers are eradicating the playfulness that made Miami Beach an attraction to begin with. Developer Gil Dezer has plans to open a sign graveyard to preserve this legacy.

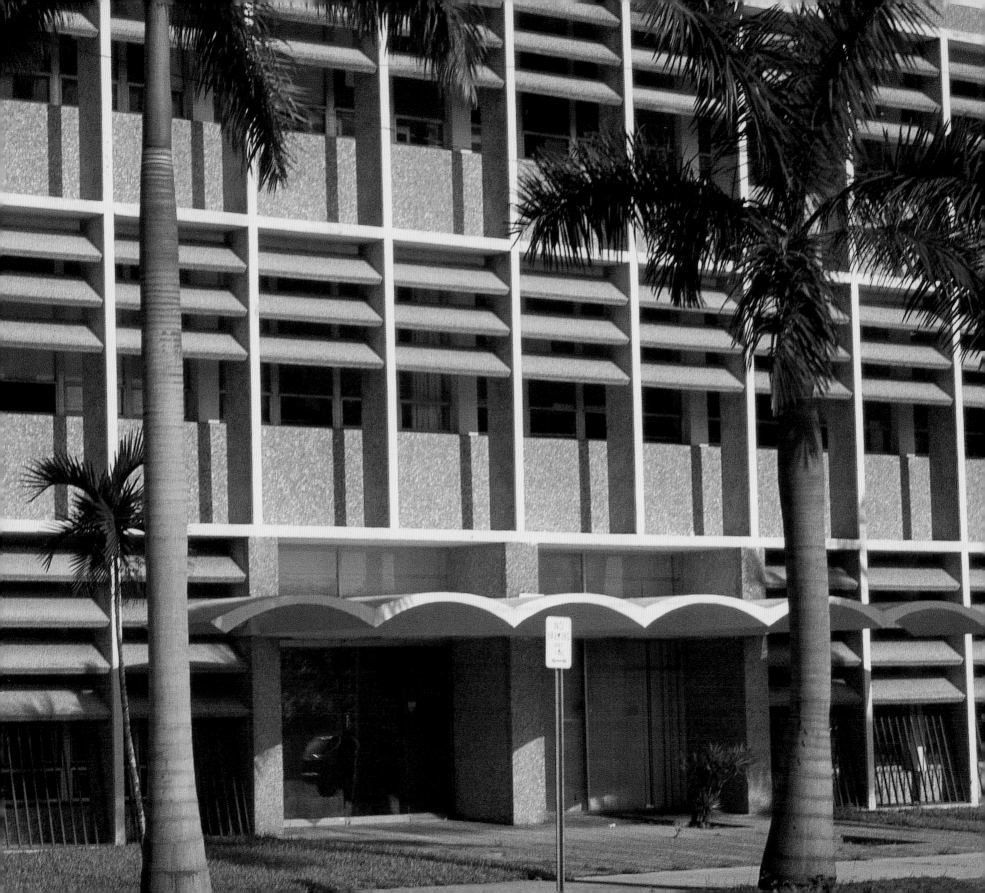

FIVE

Since so much of Miami was formed in a short period of post–World War II expansion, the city features whole corridors, neighborhoods, commercial nodes, and campuses of MiMo architecture. Whereas many older cities have an occasional landmark or pocket of modern buildings, modern became the Miami vernacular, rendering an entire cityscape in its image. The city had little in the way of an autochthonous architectural tradition to begin with, so MiMo rushed in to fill the void, creating whole galaxies and constellations.

These dense concentrations are the result of several fortuitous circumstances. Whole tracts like Biscayne Boulevard owed their existence to suburban expansion, and were developed in a single, stylistically consistent era. The ever-expanding suburbs then left these areas behind. The neighborhoods slipped into a condition of benign neglect, the next best thing to active preservation, because little new construction or renovation was undertaken.

MIMO METROPOLIS: DOWNTOWN MIAMI

Despite the centrifugal forces of suburbanization that threatened downtown Miami's primacy after World War II, the postwar boom led to a sizable wave of office construction that added a MiMo layer to downtown's 1920s and 1930s architecture.

Burdines, 2 East Flagler Street, Robertson & Weber, 1936; annex, 1946

The expansion of the International Style Burdines department store by the team of E. L. Robertson and J. R. Weber was the first major construction downtown following the war. The architects spanned Miami Avenue with a tri-level glass bridge to connect with a new annex, clad in Indiana limestone, and covered the addition to the existing store in Keystone to match the 1936 construction.

During the Christmas season in the 1950s, an illuminated, thirty-foot-tall Santa, complete with a tree and a sackful of gifts, waved to shoppers from the bridge over Miami Avenue. Burdines' lunch counter, like many other Southern establishments, was the scene of sit-ins during the civil rights movement in the 1960s.

Ainsley Building (now Foremost Building), 14 Northeast First Avenue, Morris Lapidus, 1952

The Ainsley Building was the first new office building to rise in downtown since the end of World War II. The fifteen-story office tower at the corner of Flagler Street and Northeast First Avenue displays the distinctive combination of International Style and sculptural invention that would make Lapidus a popular success. An exquisitely detailed glass curtain wall faces east, but is dazzlingly offset by voluminous, horizontal concrete cantilevers on the Flagler facade. The cantilevers serve as shading devices, but their robust masonry forms make a cool sculptural statement above the visual cacophony of the shopping street.

The ends of the cantilevers wrap around the tower corner, and the lowest continues along the Northeast First Avenue

facade, providing a base for the glass curtain wall. The brooding horizontality of the Flagler facade echoed the facade of the contemporary Algiers Hotel, which Lapidus worked on with Henry Hohauser.

The main entrance on Northeast First Avenue is marked by a grouping of intersecting planes. Polished granite frames the window wall of the lobby, while a projecting, upward-tilting canopy pierces the glass to continue the lobby ceiling. A Keystone-clad wall separates the composition from the adjoining building. A glass-walled rooftop penthouse affords expansive views of downtown in three directions.

Perhaps because of Lapidus's selective memory, he left the Ainsley out of the saga of his life. According to his self-created legend, recognition as an architect escaped him until he was accidentally selected by Ben Novack to design the Fontainebleau in 1954.

Ingraham Parking Garage, 225 Southeast Second Street, Steward & Skinner, 1946
150 Southeast Third Avenue (originally Pan American Bank), Carl Blohm and Charles Nieder, 1951

The first major postwar building constructed on the site of Henry Flagler's original Royal Palm Hotel was, appropriately enough, a parking garage. The garage was built for office workers in the Ingraham Building of 1926, a block to the north. The style is Streamline Moderne, but the garage served as the foundation of a remarkable MiMo ensemble along three blocks of Southeast Second Street as the 1950s and 1960s progressed.

The vertically divided, four-story facade of the old Pan American Bank contrasts with the garage's horizontality, but the buildings share a similar height, massing, and prominent rounded corner. Built to serve the new automobile culture, the bank featured such up-to-date conveniences as a through-block "auto tunnel" with four "auto teller's windows." The bank is subdued in design, but its presence marked the beginning of Miami's ascendancy to the role of business capital of Latin America.

Americas Center, 150 Southeast Second Avenue, Morris Lapidus, 1966

Lapidus's second downtown office building is notable for its use of sun grilles years after they had fallen out of favor. At a time when reflective thermal glass was quickly making

sun grilles passé, the Americas Center sports one of South Florida's most rigorously modern grilles. Don Seidler, a longtime Lapidus associate, explains that high-profile buildings traditionally featured customized grilles and that Lapidus found the design challenge irresistible, even when grilles were no longer necessary.

On the building's main facade facing Northeast Second Avenue, the sun grilles form a kind of exoskeleton, cantilevered two feet from the surface glass. The detailing of the sun protection system is striking because its functionalist design probably would have passed muster with leading figures of the International Style, had they found themselves designing an office building in Miami in the mid-1950s. The balance of machine precision and handsome proportions is a high point in Lapidus's wide-ranging oeuvre.

The rear facade, facing west over blocks of two-story buildings, displays the Lapidus touch with narrow vertical stairwell windows that create a rhythmic, op-art effect. The relatively opaque stairwell bisects the rear facade of continuous window bands. Like the Ainsley Building, the Americas Center is crowned by a glass-walled penthouse set back from the main facades and capped with a folded-plane parapet.

A half block south of the Americas Center stands a tangle of ramps from Interstate 95 that disgorge directly into a sea of parking lots on the former grounds of the Royal Palm Hotel. The ramps were designed to connect the highway with a convention center that was never built. Their construction, circa 1960, obliterated acres of downtown real estate and created a path of blight between downtown and the river.

Miami Parking System Garage No. 2, 70 Southwest First Street, architect unknown, 1966

While the ramps of the Interstate look more like a mistake with every passing year, the quasi-public Garage No. 2 that stands alongside the on-ramp to I-95 North is a happier reminder of the period.

To the passing motorist, the floating vertical strips of gold anodized aluminum form starkly Modernist abstract patterns on the garage's exterior. The gold anodized aluminum is complemented by the rose-colored, terra-cotta cladding of the stairwells. At street level, the base is clad in mirror-smooth, salt-and-pepper granite. The garage, featured in a Lenny Kravitz

video, exemplifies how clever design transforms limited materials and prosaic buildings.

100 North Biscayne Boulevard, Rader Associates, 1964

Ambitious developer Jose Ferré planned thirty-story 100 North Biscayne Boulevard to be Miami's tallest building and the first Modernist tower to combine office and residential uses. The tower far exceeded the eighteen-story 100 South Biscayne Boulevard of 1958 and even topped the landmark Dade County Courthouse of 1926 by sixteen feet.

Like the 1963 Bacardi USA building, the building's dark glass curtain wall facing the boulevard made use of reflective thermal glass, which did not need to be shielded from the direct rays of the sun. Also like Bacardi USA, the curtain wall is sliced by continuous marble-clad piers rising the full height, while the narrower north and south facades are nearly solid masonry. In a cost-cutting measure, the west facade has masonry spandrel panels and bare concrete piers.

In a visionary attempt at transforming downtown into a twenty-four-hour neighborhood, the top nine stories were built as apartments, served by a separate elevator

lobby. While the luxury apartments managed to attract some prominent Miamians, the idea was too far ahead of its time, and the apartments were later converted into offices.

Dupont Plaza Center, 300 Biscayne Boulevard Way, Petersen & Shuflin, 1957

The dashing, low-slung lines, continuous curtain walls, and narrow, shiplike massing of the fourteen-story Dupont Plaza Center are the result of an ambitious vision to serve all the needs of the architectural and construction industries of South Florida under one roof in an "Architectural Industries Center." The original plan was simply an expansion of the Architects' Samples Bureau in Miami, but grew to become a regional headquarters for architects and contractors, including a three-hundred-room hotel for visiting executives as well as offices and exhibition space for construction products.

Shifting real-estate patterns left the Dupont Plaza isolated from the downtown core. The tract of vacant land between the tower and downtown, a remnant from the grounds of the Royal Palm Hotel, decreased in value as suburban addresses became more desirable. Even the building boom of Miami's roaring 1980s only managed to fill up two additional blocks. A downtown building boom at the time of this writing has driven up the property value, leaving the Dupont Plaza's days numbered.

The suburban address that would give rise to a second downtown during the 1970s and 1980s was Brickell Avenue, on the south side of the river from downtown.

The 550 Building, 550 Brickell Avenue, Robert Law Weed, 1952

When the six-story 550 Building went up in the early 1950s, the surrounding neighborhood consisted of lavish mansions under a thick, green mantle of indigenous vegetation. The 550 Building formed the nucleus of a second downtown of offices, hotels, and residential towers that arose in the 1970s and 1980s.

The 550 Building draws its aesthetic appeal from the sculptural quality created by the slight increase in size of each successively higher office floor, the entire mass of which is cantilevered over the glass-enclosed, ground-level retail and lobby spaces. The subtle, inverted-pyramid effect was made possible by a precedent-setting use of precast concrete wall construction. As part of its original look, 550 sported fixed vertical and operable horizontal metal louvers at each of its evenly spaced punctured window openings.

Weed reserved the visual drama for the rear of the building. Here the elevator and stair towers appear as a discrete rectangular volume clad in stucco with fine full-height, vertical corrugation offset by narrow horizontal vents at each floor. Even though this was the rear, it faced the parking lot, which took on greater importance in the 1950s. Convenient on-site parking was a major part of the appeal of Brickell Avenue's mansion-sized lots, so the facade facing the parking lot could not be an afterthought. On the west facade, Weed struck a balance of minimalism and MiMo visual appeal that still looks fresh today.

While it must have seemed an uncouth intruder when it first appeared in the leafy environs of Brickell Avenue in the early 1950s, the 550 Building now recedes into the background among the gleaming glass towers of Bank of America, Suntrust, Northern Trust Bank, and a growing legion of others. Several years ago, in order to stay competitive in the office-leasing game, the building was renovated, staying true to

Weed's minimalist sensibility. The original system of fixed and operable metal sun louvers was removed, but the integrity of the composition is still evident.

Many relatively small-scale MiMo office buildings on Brickell have already disappeared into oblivion because of real-estate pressures, and the 550, because of its modest size by current standards, is ripe for redevelopment. The next wave of development undoubtedly will take this gem and the Dupont Plaza along with it.

100 South Biscayne Boulevard (originally First National Bank), Weed-Johnson Associates, 1957

First National, the oldest and most prestigious bank in Miami, chose a block-length site on Biscayne Boulevard across from Bayfront Park for its new eighteen-story headquarters, the tallest building in Miami at the time. With a big bankroll, First National brought the first classic Modernist pedestal and superstructure office building to Miami.

The three-story base contained the bank offices and teller lobby, ground-level stores, and the city's first built-in, multilevel parking garage, which could accommodate 650 cars. The base supports a fifteen-story

office tower with rooftop conference spaces, dining room, and an open-air terrace. First National outdid its nearby rival, the Pan American Bank, with a through-block "auto tunnel" offering twelve drive-in tellers rather than four.

Among First National's distinctions were two completely different types of sun protection devices. The punctured north and south sides of the pedestal were faced with blue grillwork in an anodized-aluminum frame, supported on shallow cantilevers at each floor level. The grilles continued across the open parking levels to serve as railings. On the tower, the shades took the form of balcony-like overhangs, cast as one unit with the cement wall slabs.

Perhaps because the site was considered relatively remote from the downtown core in its day, the base facing Biscayne Boulevard was clad in a sheer, monolithic wall of polished Georgia granite, with only the bank name in metal letters for adornment.

When it was completed, First National Bank stood alone as a sublime Subtropical Modernist statement, aloof from downtown. But by the end of the 1960s, it was dwarfed by the thirty-eight-story One Biscayne Tower and the thirty-two-story First Federal Tower, which rose from a single block to the north. Under a new name, First National built the fifty-five-story Southeast Financial Center a block to the south and vacated the old building in the mid-1980s. At more than three times the 1957 building's height, the new tower literally overshadows its predecessor.

MIMO'S MAIN STREET: BISCAYNE BOULEVARD

Before the rise of Brickell Avenue, Biscayne Boulevard was Miami's prestigious suburban address. A string of stylish Subtropical Modern office buildings lined the street side by side with colorful motels. The strip fell into a long period of desuetude during the 1970s, but the renaissance of Miami Beach across the bay makes its revival imminent, perhaps at the cost of some MiMo gems.

1900 Biscayne Boulevard (originally D. R. Meade Company), Pancoast, Ferendino, Skeels & Burnham, 1959

The tidy, two-story, block-long 1900 Biscayne office building combines basic MiMo elements of a projecting concrete-framed facade and sun grilles to create a sophisticated interchange

between structure and image. The building clearly distinguishes between function (structural, or load-bearing, elements) and form (visual and symbolic elements).

The facade presents an intriguing dialogue between structure and symbol. The aluminum mullions create an illusion of being structural because they pierce the cornice, but are revealed to be purely decorative because they stop before touching the ground. At the same time, the structural nature of the white concrete piers is exaggerated by the heavy, and actually nonfunctional, base that links the columns. Thus the applied symbol of the mullions appears structural, while the genuinely structural element of the columns takes on an exaggeratedly symbolic form.

Bacardi USA, 2100 Biscayne Boulevard, Enrique Gutierrez, 1963; Ignacio Carerra-Justiz, 1973 (addition)

In the firmament of star-quality MiMo buildings that line Biscayne Boulevard, the Bacardi USA building is a supernova. Simply put, it is the Seagram Building of the Southlands.

Designed by Enrique Gutierrez of Sacmag International, based in Puerto Rico, the headquarters for Bacardi USA is a jewel

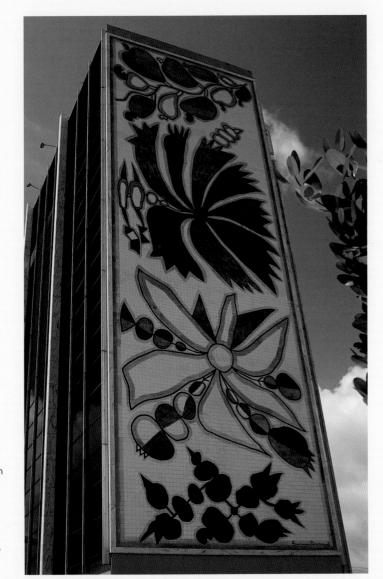

SKETCHES OF SPAIN: For Enrique Gutierrez's superb Bacardi USA building of 1963, the Brazilian-Irish artist Francisco Brennand used thousands of azulejos, traditional blue-and-white glazed tiles from Spain, to create these exuberant mosaics of plant forms. The mosaics evoke the company's origins in Xiches, Spain, and make an elegant contrast to the glass curtain facade.

of Latin American–flavored Modernist architecture, creating something new in the fusion, much the way Latin percussion affected the meter of American jazz in the 1950s.

The eight-story, reinforced-concrete tower, set off on a 102-by-183-foot lot, is a sharp Modernist composition, echoing the United Nations Secretariat and Mies's Crown Hall and Seagram. Like the U.N., designed in 1953 by a team of International Style architects including Le Corbusier and Oscar Niemeyer and led by Wallace K. Harrison, the Bacardi is a slab of glass bookended by masonry facades. The structure is suspended from enormous trusses like Mies's Crown Hall of 1950–56 in Chicago. There are many parallels to Mies's Seagram Building of 1958: the tower is raised on pilotis set on a plinth, and the main glass curtain wall with anodized-aluminum mullions is a direct tribute to Mies's design.

Each Modernist element is interpreted in a Latin American idiom. The plinth is not composed of Mies's preferred material of verd antique marble, with its connotations of a Classical Greek past, but instead is clad in Spanish blue-glazed tile. Mies's plinth is Greek in its proportions, while the base of the Bacardi, especially with the cenotaph-like addition by Ignacio Carerra-Justiz of Coral Gables in 1973, evokes a Meso-American ball court. A future archaeologist who stumbles upon this platform painted with a giant version of the Bacardi logo might conclude this was a temple belonging to a cult that worshiped bats.

While Mies relies on attention to the details of construction for visual interest, Gutierrez is flamboyantly and unapologetically decorative, splashing the north and south facades with murals done in *azulejos*, or traditional Spanish blue-and-white glazed ceramic tiles, by the Brazilian artist Francisco Brennand. Each mural consists of twenty-eight thousand six-inch-square tiles depicting plant forms framed in a marble border. The tiles are a reference to the origins of the Bacardi family in Xiches, Spain.

The complex combines the clarity of International Style construction with the chthonic mysteries of pre-Columbian temples. In its original state, the building was even more breath-taking, because the ground-floor walls are of plate glass, which let light flood through below the mass of the building. The view is now obstructed by fabric that shields the collection of the Bacardi Museum, which is open to visitors by appointment.

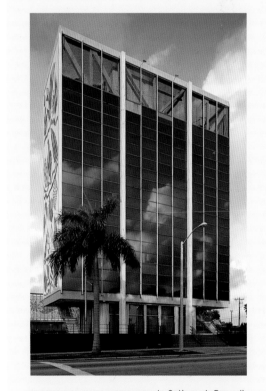

SEAGRAM OF THE SOUTHLANDS: In Gutierrez's Bacardi USA Building, a Miesian glass curtain wall is suspended from trusses attached to thick, overlayed piers covered in marble. Space-age floating staircases descend from either side. The plinth is faced in blue-glazed tile, a Latin American reference, rather than the Classical verd antique marble of Mies's Seagram Building.

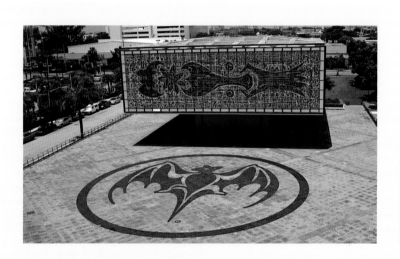

BAT SIGNAL: The Bacardi logo is emblazoned on the courtyard of the complex, which evokes a Meso-American ball court. Translucent, inch-thick glass mosaic covers the windowless, doorless rear administration pavilion, entered through an underground parking garage.

The construction techniques are as transparent as an X-ray. Four heroically scaled marble piers, measuring thirty by fourteen inches and reaching one hundred and eighteen feet tall, support a truss, eighty-one feet long and thirty-two feet wide. The floor plates are suspended on cables from the truss, dispensing with interior columns and allowing for a maximum of floor space: twenty-six thousand square feet of office space. A top-floor dining room offers commanding views of the bay and the city.

But certain mysteries present themselves: how do you enter the building? The main door is reached indirectly at the side. Two floating staircases descend tantalizingly from the second story, like retractable ladders from a spaceship. The forty-seven-foot-tall monolith in the rear has no doors at all.

Employees enter through a ramp in the side of the plaza that leads to an underground parking garage, rare in Miami with its high water table. The sixty-five-car garage was engineered to the specifications of a swimming pool, but for the opposite reason: to keep water *out*.

The rear tower, which looks purely ornamental, actually contains two floors for administrative and accounting offices. The only entrance is via an elevator from the garage. Set on a central concrete core clad in red-glazed brick, the upper floors cantilever

out twenty-four feet. The walls are composed of one-inch-thick hammered-glass "tapestries" designed to withstand hurricane-force gales. The tapestries were designed and manufactured in Chartres, France, by Gabriel and Jacques Loire, from an original painting by German artist Johannes M. Dietz. The cantilevered floors are hung from the roof by tensor rods connected to a crisscrossing system of beams that transfers the load to the concrete core and down to the foundation.

On a flawless Miami day, the tower, with its blue-white walls and reflective glass facade, seems to merge wholly with the environment. Together, the tower and addition take up less than 20 percent of the plaza, creating an exhilarating modern sculpture with a Latin American flavor.

TechnoMarine Building, 2919 Biscayne Boulevard, architect unknown, 1965

The three-story TechnoMarine Building stands out because of its delightful confectionary facade of white screen block. As airy as spun sugar, the upper two stories of screen block define the image of the building. Narrow windows are virtually invisible behind the projecting screen.

A dynamic tension between MiMo-style curves and the straight Modernist module is expressed in the pattern of the screen-block panels. Thick, sine-curve-like waves are superimposed on a receding grid. The end panels are unframed, allowing the screen-block panels to intersect, emphasizing the curved lines.

The screen-block entablature is supported by eight projecting piers. Four of the bays are filled in with gray tile, and three have a plate-glass skin. The bays are surmounted by a cantilevered, arched belt course. The grid of mortar lines on the gray tile field resembles graph paper, echoing the building's underlying modular structure. Suspended, compressed arches overlap the rectilinear undergridding.

5220 Biscayne Boulevard (originally Maule Building),
Pancoast, Ferendino, Skeels & Burnham, 1954

The facade of the headquarters of Maule Industries, which manufactured masonry building materials, is a showcase for the structural and decorative versatility of concrete.

"A good deal of this new Mid-Twentieth Century forward-looking is represented in planning Maule Industries' central office building," *Florida Architecture* noted about the building in 1956, "which is designed to serve as main showroom, both exterior and interior, for the mammoth concern's products."

The facade plays off the contrasting, sculptural qualities of concrete: heavy against light, thick against thin, and the material's dense, structural nature versus its airy, plastic properties. The brise-soleils of concrete, the very product the company was promoting, give the facade a sense of dynamism: the entire facade resembles a set of giant louvers. As in many MiMo buildings, the symbolic and structural elements are thoroughly integrated.

The appearance of the facade changes radically depending on your vantage point. The three-story building is organized by a projecting eggcrate divided into twenty bays. Brise-soleils consisting of three cement louvers clad in brown aggregate run along each level, appearing as uninterrupted horizontal lines spanning the bays. Behind the louvers are banded windows separated by spandrels clad in light blue mosaic tile.

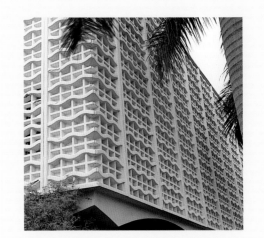

CORAL CONFECTION: A facade of delicate screen-block tracery conceals the narrow windows of the TechnoMarine Building, with wavelike patterns overlaying a Modernist grid.

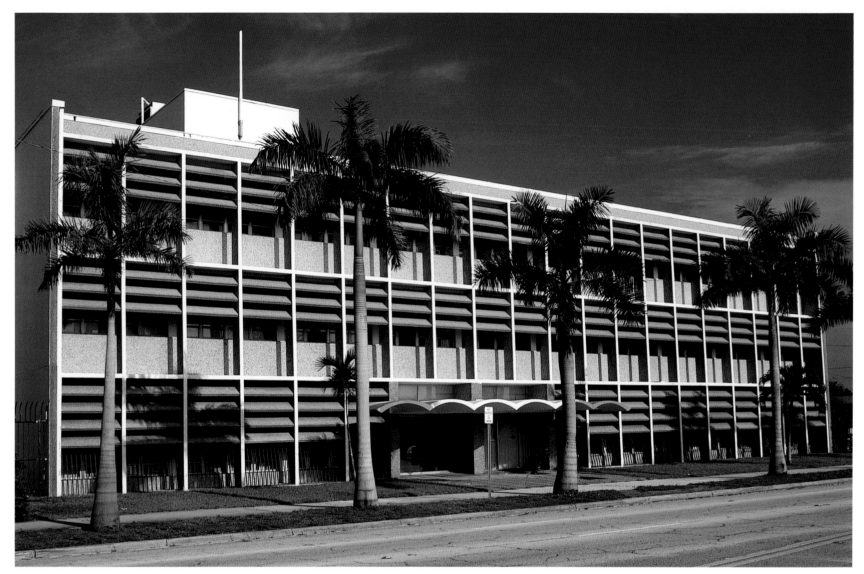

Viewed head-on, the bays form a framework for the louvers, which float like suspended panels between the piers. But as you gaze up or down, or from side to side, the quality of openness is in constant flux. The farthest bays appear to be solid stone, dominated by the depth of the piers. The angled louvers may appear shut, with no spaces between them, like the drawn shades of venetian blinds. The facade ripples with the play of open and closed space.

Concrete is explored in its heavy, structural nature as a building material and its simultaneous lightness as a decorative material. Although the eggcrate looks solid, it is not structural. This dual nature is expressed by the depth of the piers contrasted with their wafer-thin edges. Likewise, the louvers look ponderous when seen at angle, but reveal themselves to be remarkably thin planes when viewed head-on. The thick concrete columns flanking the entrance are twice the width of the structural steel beams, to show off the lithic quality of the material.

The cantilevered, compressed-arch concrete canopy, as weightless as a pen stroke, is a casual coup-de-grace, a purely decorative accent, and a light counterpoint to the serious minimalist geometries of the facade. In the rear, which served as the main entry for arrival by car, a four-story el conceals the elevator core behind a screen-block wall.

The company name once adorned the el and canopy in large capitals.

MiMo architecture was designed to work with sun. The changing angle of the sun brings out new layers of complexity in the facade, painting the tips of the brise-soleils with light and throwing additional patterns of shadow across the recesses.

5600 Biscayne Boulevard, Robert Law Weed, 1954

If you can find complete aesthetic satis-faction in a tire showroom, this is the one. Robert Law Weed's glass, steel, and concrete shed is a gem of structural expression combined with an overlay of space-age symbolism.

Architects like Weed combined high and vernacular Modernism for heightened visual effects. The building's structure is clearly expressed: steel beams support a truss of exposed I-beams topped by a corrugated metal roof. The double-height interior is enveloped by plate-glass walls framed by aluminum piers and mullions. Structural beams project beyond the aluminum sheathing to support the roof truss.

In a sophisticated balance of solids and voids, the concrete-enveloped mass in the rear of the building offsets the vast open space defined beneath the curved concrete eave in front. The balance of solids and voids is elegantly minimalist. The solid mass at the rear of the building balances the vast open space of the front, defined by the bow-curved concrete roof. In a nod to Wright's Johnson Wax Building of 1939, the plate-glass windows extend as a clerestory between the solid walls and the roof of the rear volume, so that the roof appears to float.

MUSIQUE CONCRETE (OPPOSITE): The cement-louvered facade of the Maule Building is a striking minimalist gesture that serves as an advertisement for the products of the former building-materials company.

OFF THE GRID (RIGHT): The serious formalism of the Maule's facade is offset by a skipping of compressed arches on a canti-levered canopy.

Each function is expressed in the ex-terior: the projecting eave protects the cus-tomer arriving by car, the glass box volume displays the showroom goods, the clerestory allows light into the back office, and the garage in the rear is enveloped by an opaque concrete mass. The palette of mate-rials is easily identified: glass, stainless steel, steel roof truss, corrugated metal roof, exterior steel columns, terrazzo floor, and concrete roof with a white soffit.

Weed applied symbolism to enhance the visual dynamism of the structure. The footprint of the glass box is trapezoidal, in conformance with the site on a traffic island in the middle of Biscayne Boulevard, but at the same time emphasizing the automobile-oriented building's sense of forward motion.

The building rewards close scrutiny, from its sculptural interplay of curves and planes to details such as the minimalist floating staircase in the rear, where each step is individually cantilevered from the wall without a riser for the ultimate in transparency. Lit from within at night, the structure becomes immaterial.

In an adapted re-use that shows MiMo's versatility, the former tire showroom now houses a pizzeria and carwash.

MIMO CROSSROADS: SEVENTY-NINTH AND BISCAYNE

In the 1950s and 1960s, the intersection of Seventy-ninth Street and Biscayne Boulevard emerged as a new suburban downtown. An extraordinary constellation of automobile-oriented buildings arose, which nevertheless formed a thriving, nearly urban center.

FLIGHTS OF FANCY: Sculptural floating staircases and overhead pedestrian walkways are some of the MiMo delights of Biscayne Plaza Shopping Center, built in 1953.

Biscayne Plaza Shopping Center, 7900 Biscayne Boulevard, Robert Fitch Smith, 1953

Miami's first classic suburban strip shopping center, Biscayne Plaza is an example of the golden age of automobile-oriented architecture. Its developers announced that they wanted to "utilize the site's unusual advantages to the utmost and especially intrigue the crowds coming from four directions."

The developers used futuristic concepts, such as second-story bridges connecting the three main wings, to entice shoppers. The bridges did not actually serve as a means of interior circulation but, like stage sets, were meant to dazzle motorists that passed beneath them, as if they were navigating through a city of the future.

The bridges, in fact, contained rentable space. One was occupied by Arthur Murray, a chain of dance studios that employed architectural theatrics in many of its Miami locations. The studio on Forty-first Street in Miami Beach featured a retractable roof for dancing under the stars; the one on Lincoln Road featured a double-height, glass-enclosed dance studio.

In the plaza's northeast corner, a prowlike, double-height, glass-enclosed space once housed a bank. The ensemble of the glass bank space and the adjacent futuristic bridge and its elegantly proportioned concrete stairway still make a sharp Modernist statement.

The plaza employs urban elements that maintain a human scale. The eastern wing is built up to the sidewalk of Biscayne Boulevard and contains a significant amount of office space above the shops.

Admiral Vee Motel, 8000 Biscayne Boulevard, Maurice Weintraub, 1957

The intersection's pièce de résistance is the Admiral Vee Motel, named for a famous racehorse. Currently housing a photography studio, the former motel occupies a lot at Eightieth and Biscayne, surrounded on two sides by the shopping center, but is separated from it by a very unsuburban alleyway. In order to shoehorn in the typical motel program of easy parking and a swimming pool, the Admiral Vee was built upward to three stories, becoming in effect an urban motel.

Its unusual vertical plan is employed to maximum effect. An enormous trapezoidal fin, visible for blocks in either direction,

projects outward over the sidewalk. The unheard-of second-story pool above the parking lot and the second-level lounge with double-height, canted glass walls, like an airport control tower, were calling cards for the motel.

Completing the scene, across the boulevard from the Admiral Vee was the Tower Restaurant with its attention-getting turret finial. The tower, with a pagoda attached to the finial, now houses a Chinese restaurant. Next to it stands a small office building reminiscent of Frank Lloyd Wright's 1948 Morris Gift Shop in San Francisco, and beyond it a store that approaches the corner of Eightieth Street in a series of intersecting planes and volumes of glass, masonry, and roman brick.

8101 Biscayne Boulevard (originally Miami National Bank), Smith & Korach, 1956

Smith & Korach designed the newly chartered Miami National Bank at Eighty-first and Biscayne with the same system of operable metal louvers the firm used for its Medical Arts Building at 1680 Meridian Avenue in Miami Beach. Several years later, another architect designed an expansion next door with vertical louvers that automatically followed the sun's trajectory. Other features included a carillon and a rooftop digital time and temperature sign, very space-age for its analog era.

U.S. Citizenship and Immigration Services Building (originally Gulf American Building), 7880 Biscayne Boulevard, architect unknown, 1962

For many years Miami's most prominent office tower outside downtown, the Gulf American Building established Seventy-ninth and Biscayne as the new suburban downtown, far from the old, congested city center at the foot of the boulevard. The office tower is a high point in the use of sun grilles. Rather than just being used in bands to screen the upper parts of windows, the metal grilles stretch in unbroken planes the full height of the building on all four sides. They entirely masked the windows of the tower and created a striking effect before the current beige paint was applied. Taking full advantage of its strategic location, the tower originally boasted a digital news zipper on the roof. The two-story pedestal, with double-height glass walls, reinforced the intersection's big-city aspirations.

Gulf American was entangled in some shady real-estate dealings in 1967, and the building was taken over by the federal Immigration and Naturalization Service. The rooftop digital sign was removed and the glass lobby was covered over. In its current state, the rows of sun grilles give the tower a fortresslike quality. Demonstrators use the parking lot of the shopping center across Seventy-ninth Street to protest Miami's perennial immigration issues.

The boulevard's steep economic decline was most acutely felt at the intersection of Seventy-ninth and Biscayne. Less than a decade after Biscayne Plaza was completed, the next generation of shopping centers arrived—inward-facing, covered malls surrounded by acres of parking. Strip shopping centers like Biscayne Plaza were no longer the latest and the best. Biscayne Plaza managed to keep some measure of respectability through the 1970s, but never fully recovered from the McDuffie race riots in 1980 that decimated much of what had become Miami's inner-city business districts.

In the late 1980s, the plaza was updated with a few superficial Post-Modern touches, which fortunately did not compromise the original design. The lounge space of

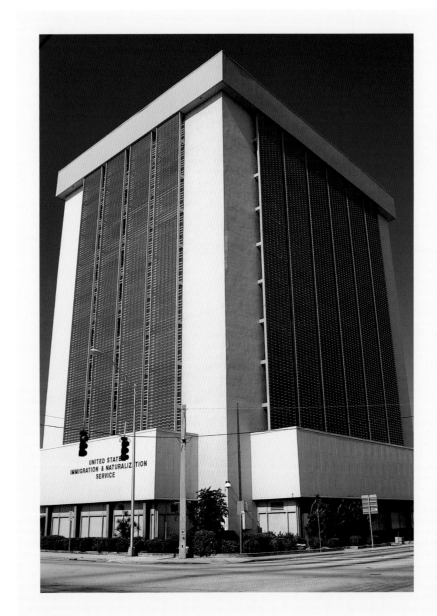

HOT OFF THE GRILLE: All four sides of the freestanding former Gulf American tower are covered in metal sun grilles, used to protect windows from tropical sunlight before the advent of thermal glass.

the Admiral Vee became a beauty school, and its soaring double-height glass walls were painted over with advertisements. For a while, like many other boulevard motels, it served as a brothel. However, since the 1990s, the Admiral Vee has been the home of Glas Haus studios, a photo production facility. The lounge functions as a studio bathed in natural light, and the adjacent elevated pool deck serves as an outdoor studio. Still, the renaissance of the boulevard will take time to gather sufficient strength to reclaim this tarnished MiMo wonderland.

AMERICA'S FIRST MODERN CAMPUS: THE UNIVERSITY OF MIAMI
Coral Gables
The University of Miami is such a dense constellation of first-rate MiMo and Modernist buildings by Robert M. Little, Robert Law Weed, Marion Manley, Wahl Snyder, Morris Lapidus, and others that it is worthy of a monograph of its own. Only the highlights can be touched upon here.

The history of the university, like that of many places in Florida, is the story of an individual's dreams pitted against nature. The far-sighted George Merrick knew a university would set his 1924 development of Coral Gables apart from other boom-time development schemes. From the outset he donated 160 acres of property in the Riviera section as a campus for the newly chartered school. The fund-raising campaign's slogan was "Keep the world coming to Florida. Build the University of Miami."

Merrick was a futurist in an old-fashioned way; he just didn't know what form the future was going to take. Modern ideas often appear cloaked in the trappings of the past, as if to disguise their startling newness from the creators. Coral Gables itself—a rationally planned suburban community designed around the automobile with gridded streets intersected by flowing lanes ideal for motoring—was completely a product of the twentieth century, yet was disguised in the red-tile-roofed Mediterranean Revival style to give it a semblance of history. Merrick's utopian plan of a picturesque city in a garden blended the City Beautiful Movement and emergent American suburbia.

The original architects' vision for the university was Mediterranean Revival, in keeping with the city's theme. The steel for the Merrick Building, the school's first building, was supposed to be clad in Spanish-style stucco and red tile roofs, but the great hurricane of

September 18, 1926, intervened, halting construction and delaying the opening classes. The first classes were held less than a month later in a converted hotel, the Anastasia. Classrooms were partitioned with makeshift plasterboard, which led to the school's early nickname, "the cardboard college." The Merrick Building stood bare until 1949 and was known as the "Skeleton Building" until it was finished in a postwar Modernist style.

Memorial Classroom Building,
Robert Law Weed and Marion Manley, 1948
The university expanded dramatically after the war to keep pace with the influx of students going to college on the GI Bill. The utilitarian, yet elegant three-story slab of the Memorial Classroom Building clearly expresses its purpose: acres of classroom space. Identical classrooms are lined up like cabins on a converted troop ship. Despite its size, the structure is remarkably open and airy, combining structural expression with a strong visual presence that responds to its subtropical environment.

Fixed louvers run the length of each open gallery, providing shelter from sun and rain. What would otherwise be monotonous

vistas are enlivened by the simple expedient of tilting the louvers: visually dynamic perspectives are created by exaggerating the vanishing points of the long horizontal lines. Corrugated metal siding, a common industrial material added later, accentuates the effect of disappearing sight lines.

The entire structure is an experience in varying degrees of spatial enclosure, an effect only partially marred by the necessary addition of elevator shafts to make the floors fully accessible. A central volume connecting two long wings is sheathed in crab orchard stone, enveloping a soaring, double-height, open lobby sheltering broad stairways and pedestrian bridges. The western portion, open to the sides, sports a stellar Mondrianesque grille of aluminum bars and colored panels.

The massive-looking exterior stone wall itself seems to float in space, supported on a single, rotund column. A verandah faced in Miami oolite projects from the facade. The use of oolite and multi-hued Tennessee crab orchard stone was planned as a visual keynote for campus buildings but was abandoned after the 1950s.

Pick Music Library, Robert M. Little, 1961

Something was in the air, so to speak, when this saucer-shaped library was constructed. Flying-saucer-shaped buildings were popping up like crop circles around the country, from the Space Needle in Seattle and the Capitol Records Building in Hollywood to the Pepsi-Cola Bottling pavilion and the Pick Music Library in Miami.

An axiom of science fiction, at least until the 1960s, was that the future will be the opposite of whatever is current. If people live and work in square buildings today, they will have round buildings in the future. Round houses made perfect huts for the Global Village.

The structure of the Pick Music Library is simplicity itself, subordinated to a strong visual symbolism of outer-space imagery. Twelve pitched steel beams radiate from a central concrete-block stack. The beams run straight through the plate-glass clerestory, supporting a light, circular cantilevered roof. The circular infill wall is made of alternating bands of stacked cement bricks and plate glass in standard storefront aluminum frames.

The reason for the space-age imagery was that an audiovisual library was seen as a forward-looking addition to the campus. The Jules Verne theme is realized in small details: The beams, which extend out like spider legs, end in concrete podlike feet. The bolt heads that attach the beams to the central heating and ventilation core are boldly exposed, like comic-book drawings of rocketships from the 1950s. This style of rivet-headed realism was abandoned in later science fiction.

In period photographs, when the few bookshelves were set against the concrete infill, the entire structure was much more open and filled with light. Unfortunately, most High Modernist buildings look better sparsely furnished, and the overstuffed Pick Music Library would look better without so many books. The Pick is on the endangered list of university buildings, but administrators are missing a prime opportunity if they do not clear out the books and convert the space into a café. It's trendier than anything Starbucks could conceive.

School of Architecture, Marion Manley, 1947; retrofit, Jan Hochstim, 1985

Originally designed as a housing compound for returning vets, the six low buildings that

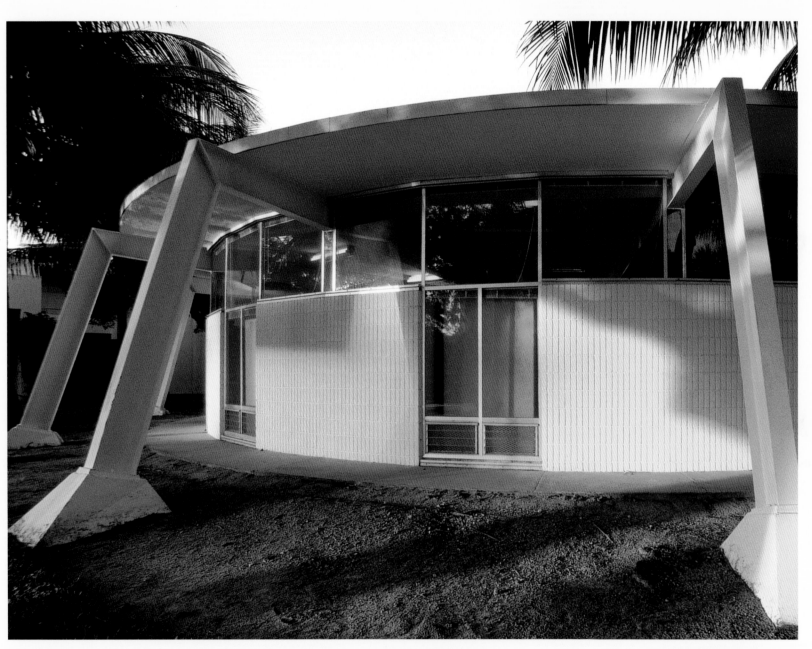

WAR OF THE WORLDS: The University of Miami's Pick Music Library seems inspired by the works of H. G. Wells and Jules Verne. Robert M. Little used unorthodox construction techniques and simple materials to create a memorable design.

comprise the School of Architecture are as intimately scaled as a day school in Germany or Switzerland. Manley was influenced by the Bauhaus precepts taught by Walter Gropius at Harvard. The two main four-story pavilions that form the primary studio space, now unified by a Keystone-paved courtyard overarched by oaks, are not remarkable at first blush, but there is a certain concinnity of proportions that creates a comfortable scale, from the open stairwells to the transparency of the buildings. The fenestration allows for cross-ventilation and ample studio illumination from both sides. Simple elements—pipe railings, doors, and window frames—are articulated in bright Mondrianesque primaries.

McArthur School of Engineering Building, Wahl Snyder, 1959

The five-story engineering building features one of the most ornate applications of screen block in all of South Florida. Four stories of rippling sculptural screen block are piled on a base of simple concrete block with a frosted-glass clerestory. The biomorphic structure looks as if it had grown organically, like a gigantic exoskeleton or a coral reef.

REEFS OF ACADEME: A detail of the rippling screen-block facade of the McArthur School of Engineering.

The building's surface, which projects out slightly from the inner glass sheath, lends itself to many forms of perception. Open breezeways bisect the wings, allowing the texture to be experienced up close. Daylight shines through the open corners, creating Gaudíesque shadows. The windows reflect glimpses of the sky. As the light changes, the bonelike screen stands out sharply against the darker glass. At twilight, electric lights glow mysteriously from within, like some hidden form of aquatic life. At night, the illuminated rooms reveal unexpected depths.

The screen-block-clad wing is set off by the taller west wing covered in a full-height metal grille made of diagonally cut cylinders. Originally gold anodized aluminum, the grille is now disguised by the university's current mauve look.

West Laboratory School, Robert M. Little, 1955

The West Laboratory School, a teaching school that is part of the university, is a classic, baby-boom-vintage grade school, from the cheery optimism of its light-filled, jalousie-walled classrooms to the opaque panels of bright, Jackson Pollock orange. Structural forms are expressed forthrightly with a bit of whimsy: giant concrete X's support the canopy over the main entrance.

The school represents a pitch of perfection in the use of jalousies, because they are extended to make up the principal envelope of the space. The spare design of glass walls covered by a thin roof with long, cantilevered eaves is where Subtropical Modernism most closely meets the Miesian aesthetic of *beinahe nichts*: "almost nothing."

A concrete waffle ceiling cantilevers six feet from the jalousie walls to provide a sheltered walkway around the perimeter of each individual pavilion. The pavilions, which contain multiple classrooms, are linked by covered walkways. The clarity of design and simplicity of construction expressed the progressive hopes of the era for a better society.

Wesley Foundation, Donald Rowell, 1952

The main building of the Methodist Wesley Foundation is a two-story adaptation of the Motel Modern style, replete with beanpoles and abstractly patterned geometric railings. In a wonderful synthesis of styles, the railing supports an aluminum cross that pierces the balcony, at once a symbol of the transcendence of the cross and a Modernist expression of intersecting planes. A floating staircase is cantilevered directly from the wall without supports, using Modernist technology to express the idea of an ethereal stairway to heaven.

A reading room, set at an oblique angle to the main structure, has many domestic features, including a pylon of striated crab orchard stone and a delta-wing-shaped planter. The entrance is framed by an asymmetric portico with an eyebrow set on an acute angle and a wing-shaped patio of white pebbled concrete.

SIX

Just beyond the fabulous resorts and glittering condos of Miami Beach lie commercial districts and entire neighborhoods of MiMo buildings that look almost untouched by time. Districts like Normandy Isle and tiny, insular Park View Island were developed almost at a single stroke after the war, and then were left behind by progress after the 1960s. In some neighborhoods, the SUVs in the driveways are the only give-away that you have not been transported back into the early 1950s.

WORKINGMAN'S MIMO: GILBERT M. FEIN NEIGHBORHOOD CONSERVATION DISTRICT

The proposed Gilbert M. Fein Neighborhood Conservation District is a true rarity in Miami Beach: two city blocks of low-rise housing directly on the bay. "The villas form the only enclave of its type remaining in the South Beach area," according to the proposal prepared by the City of Miami Beach Planning Department in 2002.

The stylistically similar, two-story apartments that line both sides of the cul-de-sacs of Lincoln Terrace and Sixteenth Street west of Bay Road were almost entirely designed by Fein in two phases, 1950 and 1956.

"That was the early period, and we were building them as fast as we could, getting them in there," Fein said about the buildings in one of his last interviews. "Each one took about three months to build. They were concrete block, and you had reinforced concrete-block columns every twenty to thirty feet tied into a cross beam, all stucco decoration. At that time, the Federal Housing Authority had their small finance loans, and all the veterans were buying little houses, and the builders couldn't put them up fast enough."

Most of the units were two bedrooms and one bath, joined in a four-unit building. "We put them up one block at a time. You'd start at one end of the street and go down the other end. Most of the popular builders in Miami did just that," Fein said. "All of the buildings

are two stories because when you have three stories, you had to use concrete instead of wood floor, and you had to put an elevator in, and it became much more expensive."

Fein's innovation was to provide access to the second-floor apartments via an exterior balcony and stairs, rather than an interior stairway. "The idea was new at the time. Most of the older buildings had a center hallway," he noted. "The apartments had no cross ventilation. So I came across the idea of an outside balcony. That was rare. There was a roof over the balcony, so your second floor was covered, and your first floor was covered."

The long buildings abut the street and are entered in the middle through a common courtyard. The street facades are simple, Modernist compositions with a nearly flat, slightly cantilevered roof and four sets of jalousied windows, organized by varied arrangements of belt courses and checkerboard patterns in painted stucco. The balcony railings in particular evidence some eye-catching abstract designs of circles and diagonals, forming patterned shadows on the balconies.

The buildings that frame the bay on Sixteenth Street are among the more stylish entries. The curved wing of 1445 Sixteenth Street follows the shape of the cul-de-sac, for a Cineramic effect. The tall, angular building on the water at 1491 Lincoln Terrace on the water's edge was designed by Igor B. Polevitzky in 1950. The enclave is a delightfully preserved time capsule among a forest of high-rises..

MIMO MINIMETROPOLIS: SEVENTEENTH AND MERIDIAN

In this twentieth-century subtropical resort city, it's not surprising that a golf course served as the nucleus of Miami Beach's civic center. The Municipal Golf Course north of Lincoln Road became the City Center area after World War II, as the growing resort required new and larger public facilities to keep pace with the rising bed count.

The first step was the construction of Seventeenth Street, across what had been the golf course, from Washington to Meridian Avenue in 1947. The same year, the newly prominent intersection of Seventeenth and Washington became the site of the imposing Miami Beach Jewish Center, later Temple Emanu-El. While the original synagogue was done in the Moorish style, the later addition is pure MiMo. In 1967, Morris Lapidus employed mosaic tile

MIMO FOR THE MASSES (ABOVE): Whole neighborhoods of Miami Beach, like the Gilbert M. Fein district, were built in a cohesive style because of the rush to provide housing after the war.

SUN SIGN (OPPOSITE): Lettering on the Burdines store of 1953 is as upbeat as the era itself.

and screen block on the social hall addition, facing Washington Avenue to the north, to emulate the Moorish decoration of the original temple in MiMo materials.

The Miami Beach Auditorium, which opened across Washington Avenue the following year, is notable as the collaboration of three of Miami Beach's most successful prewar architects: L. Murray Dixon, Henry Hohauser, and Russell Pancoast. In 1974 Lapidus oversaw the renovation of the auditorium into a performing arts theater. When Jackie Gleason died in 1987, the Theater of the Performing Arts, where he taped his popular television show in the 1960s was renamed for him.

Three landmarks at the intersection of Seventeenth Street and Meridian Avenue—Burdines, 777 Seventeenth Street and Lapidus's 1688 Meridian Avenue—form the core of a full 360-degree MiMo cityscape.

Burdines, 1675 Seventeenth Street, Robert Law Weed, 1953

Like many buildings of the early 1950s, the upscale department store Burdines, which moved its Miami Beach store from Lincoln and Meridian to a new building at Seventeenth and Meridian in 1953, is both

modern and urbane. The new store was a machine for shopping. Eye-catching neon script signage spelled out the store's name and the words "Sunshine Fashions," to draw in motorists cruising Seventeenth Street and Meridian Avenue. While undeniably adapted to the scale of the automobile, the store retained an urban character because its wraparound cantilevered canopy protects pedestrians from sun and rain in the manner of the arcades of South Florida's early vernacular commercial buildings. The canopies, which also served to store roll-down hurricane shutters, were customary in Burdines stores of the period.

Raymond Loewy's interior for the store was a whimsical delight, featuring an undulating cove ceiling that spanned the ground floor from entrance to entrance. In a depiction of the Gulf Stream, the cove was covered with a mural of marine imagery: Caribbean-blue mermaids, starfish, seashells, and waving seaweed fronds. Four delicate chandeliers with

opalescent seashell decorations lent sparkle to the scheme, while two gold metallic Sputnik pendant lamps drew the eye to escalators in the center of the floor. Off to the sides of the main aisle, the ceiling curved down to an intimate height of eleven feet, sheltering individual departments, which were designed as a series of small, open shops.

The store survived nearly intact until the 1990s, when the aerodynamic fluted-metal cladding around the edge of the wraparound canopy was removed and the white terrazzo main floor was covered in the same polished, beige aggregate marble tile used in suburban Burdines stores. In the unkindest cut of all, semicircles were gouged in the canopy of the Meridian Avenue entrance to accommodate PVC palm trees, the architectural trademark of the chain's current architectural identity.

777 Seventeenth Street, Gilbert M. Fein, 1959

Across the street from Burdines, the 777 Seventeenth Street office building makes a high-style MiMo statement, with its travertine-clad elevator tower, intricate metal grilles, and butter-colored mosaic tile spandrels. Its massing and continuous cantilevered canopy make it a set with Burdines.

Meridian Office Building, 1688 Meridian Avenue, Morris Lapidus, 1961

With the Meridian, Lapidus married the glass curtain wall, designed for temperate climates, with sun-protection devices that were part of the local, Subtropical Modern vernacular. The north facade sports one of the finest interpretations of curtain wall construction in South Florida. The east facade, however, faced the morning sun and required sun protection. In order to suspend finely detailed custom-designed sun grilles over the east facade, Lapidus designed a masonry "harness" of sorts from which to project masonry eyebrows from the curtain wall. The sun grilles were then suspended from these applied eyebrows.

The bank entrance on the ground floor was signaled by an outlandish folded canopy. Visitors are still greeted with the sight of a starburst chandelier in the main lobby. The lobby walls are clad in glossy rectangular mosaic tiles in shades of blue. The double-height south wall was covered in the same masonry relief tile used in Lapidus's Summit Hotel on Lexington Avenue in New York.

The view from the intersection of Seventh Street and Convention Center Drive is an exceptional constellation of Modernist architecture: to the east, the corridor of Seventeenth Street is terminated by the striking ensemble of the finialed Deco towers of the Ritz Plaza, Delano, and National hotels. A turn of 180 degrees brings into view the equally striking MiMo ensemble of Seventeenth and Meridian, framed by the handsome horizontal lines of city hall and the Lincoln Road Parking Garage. Smith & Korach's adjacent Medical Arts Building of 1957 reinforces the MiMo theme, while the Lincoln Road Parking Garage and Miami Beach City Hall, both from the 1970s, express directions local Modernism took after the MiMo period.

CONDO CANYON AND THE MIMO PALISADES

The cumbrous, yet crisply lined condominiums north of the Wyndham Hotel are often referred to as Condo Canyon. But a distinction must be made between Condo Canyon, which stretches from Fifty-fifth Street to Fifty-eighth Street in a nearly continuous canyon of twelve- to fourteen-story condominiums lining both sides of Collins Avenue, and the Palisades, south of Fifty-fifth Street to Forty-seventh Street, where the avenue hugs the banks of Indian Creek and the high-rises stand only to the east.

The Canyon and the Palisades together have become symbols of the overdevelopment of Florida's beaches. The condominiums were built on the lots of what had been lavish 1920s estates, platted by Carl Fisher. When the zoning was changed to high-rise, multifamily residential, no one bothered to adjust the balance of public to private land. In Condo Canyon, no allowance was made for public access to the beach, nor was any thought given to public access to Indian Creek between Fifty-fifth and Sixty-fifth Streets.

In contrast, Collins Avenue along the Palisades blends New York's Central Park West and Philadelphia's Kelly Drive with MiMo glamour. The canyon effect was averted because the line of buildings is only on one side of the avenue and because the buildings are relieved by two open swaths of public land containing beachfront parking lots and a fire station. The lots are deeper here and the buildings older, giving the Palisades more variety in massing, siting, materials, and color. The curve of the avenue is reflected in the broad concave curve of the Palisades, in contrast to the overwhelming linearity of Condo Canyon. Lastly, the wide swath of Indian Creek waterway provides an appropriate setting for the sumptuously high-style MiMo designs.

The Executive House, 4925 Collins Avenue, Robert M. Swartburg, 1959

The Canyon and Palisades got their start with the Executive House condominium, designed by Robert M. Swartburg, who had earlier contributed the Delano and Sorrento hotels. The Executive House displays the sophisticated Modernist flair seen in Swartburg's previous beachfront towers and throughout his work. While the Executive House relies heavily on traditional Miami Beach masonry construction, the crisp detailing of its fenestration, the full-height vertical banks of screen block to either side of the entry, and the aerodynamic porte cochere are concise expressions of its time and place. The X-shaped plan simultaneously provides maximal views for the units and creates exterior visual interest. The vertical tower massing allows for views of the sky over the ocean from the street. The condominium's pleasing proportions were rarely equaled in the area's subsequent build-out.

Crystal House, 5055 Collins Avenue, Morris Lapidus, 1960

As the name implies, the main facade of Lapidus's magnificent Crystal House appears as a shimmering glass curtain wall. The curtain wall's handsome proportions and the facade's slightly horizontal, rectangular shape exhibit Lapidus's elegant way with massing. The Crystal House was his response to a client request for something displaying the style of Mies van der Rohe, his nemesis.

Ever one to turn irritation into a pearl, Lapidus seized on the required curtain wall theme like a set designer creating a stage set for a Bauhaus performance, transforming the Crystal House's glass facade into a backdrop out of *Breakfast at Tiffany's*. The look was Miesian, but this was Lapidus's show to direct. Having proved his proficiency in curtain-wall design in the Ainsley and 1688 Meridian office buildings, Lapidus yanked the conceit of the Miesian box into the lighthearted realm of his own resorts. His flagrant disregard for Miesian minimalism begins with a prominent, compressed-arch porte cochere thumbing its spritely nose at the facade's uninterrupted rectilinearity.

In keeping with the Miesian theme, the spare lobby originally had a sitting area appointed, fittingly, with Mies's Barcelona chairs. Beyond the lobby, the visitor proceeds rearward to the garden and pool areas. The garden is in the French Baroque style similar to the original Fontainebleau garden. The showstopper here is the glass-enclosed, drum-shaped pool lounge, topped by a folded-plane roof that provides a memorable contrast with the rest of the scheme.

Seen from poolside, Lapidus's superficial application of the curtain wall stands revealed. The simple slab suggested from Collins is in fact a sprawling T-shaped affair. The mass appears as a masonry solid, to which glass curtain walls have been appliquéd on each facade, like mere wallpaper.

The Mimosa, 4747 Collins Avenue, Melvin Grossman, 1962

Melvin Grossman made a quintessentially Miami Beach statement with the Mimosa by elevating the humble prewar Miami Beach elements of cement block, stucco, punctured openings, and continuous eyebrows into high style. Grossman simply stretched that skin, using superior and more precise construction methods, over the much larger massing of a high-rise condominium. As in the Crystal House, a prominent, rhythmic porte cochere provides a foil for the spare lines of the tower. Grossman would explore this formula fully in his Imperial House a few years later.

Carriage Club, 5005 Collins Avenue, McKay & Gibbs, 1964

The big-city proportions of the Carriage Club are a far cry from the quaint beachfront Surfcomber and Seacomber hotels on Collins between Seventeenth and Eighteenth Streets, designed by the same firm in 1948. The great length and height of the Carriage Club facade, set parallel and close to the avenue, recall the monumentality of residential buildings of New York's Upper West Side.

Seacoast East, 5151 Collins Avenue, Morris Lapidus, 1961

The four-leaf-clover footprint of Lapidus's residential complex is a masterful synthesis of curves and straight lines. In *Architecture: A Profession and a Business*, Lapidus recalled that he arrived at the unusual shape out of practical considerations:

"A client of our office had acquired a piece of oceanfront property on Miami Beach. This property was located between two of his own apartment houses, one of which my office had designed. Our clients brought several problems to us. First and foremost, he wanted as many apartment units as he could safely incorporate into the proposed structure. The land cost was extremely high, and there was a limit to the rent he could charge. Secondly, he wanted to leave sufficient air or space between his two existing buildings and the proposed new structure. If he were to build too close to his buildings on the north and the south sides, he would be hurting himself, and would probably lose tenants. Lastly—and this would pertain only to this area—he wanted to make sure that the new apartment house did not cast a shadow on the pool deck and beach of his buildings to the north, nor did he want the new building to shade its own pool deck area and beach."

The final version features a rectilinear central section whose four wings have rounded, bull-nosed ends, two on the

LANSKYLAND

While the show-biz Chairman of the Board boozed and brawled at the Fontainebleau, the underworld chairman of the board, Meyer Lansky decided to relocate from his modest concrete-block bungalow at 612 Hibiscus Drive in Hallandale to Miami Beach in 1969 to be closer to his investments. The diminutive gangland boss and his doll-like wife, Teddy, moved into a condo in the shiny-new Seasons South (now the Carriage Club South) at 5001 Collins Avenue. No one had to worry about locking their doors anymore.

Even before the war, Lansky had a finger in all the action in South Florida, from carpet joints, or private casinos, to legitimate hotels. He owned so many spots along Highway A1A north of Miami that the strip was called Lanskyland.

Every hotel on the beach had its own bookie. After the war, illegal gambling was a $40 million industry in South Florida, until Senator Estes Kefauver broke up the racket in 1950. By then, smart money like Lansky's had gone legit by moving from casinos into businesses like resorts. Late in life, Lansky lamented that he hadn't set out to make a legitimate living in the first place; it would have been so much easier.

Life at home with the Lanskys in Hallandale was simple, like *The Sopranos* with matzo balls instead of pasta. Meyer entertained wearing a suit with a breast-pocket handkerchief, and white

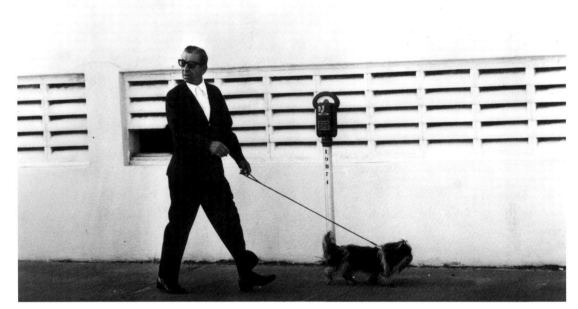

socks and bedroom slippers. Chopped liver was served in cut crystal, and seltzer in silver siphons.

In her memoir, *Wedded to Crime: My Life in the Jewish Mafia*, Sandy Sadowsky, who was married to a good-looking ganef, wrote that she met all the racket guys' wives at Meyer's: "This is Neddie from Boston. Yetta from Cincinnati. Ruchel from Detroit. Malka from New Jersey." Otherwise known for his icy composure, Meyer cursed out the help in Yiddish for infractions like taking too long to clear the soup.

Lansky spent his time like any other retired *alte kocker*–collecting Social Security, kibitzing at the old Wolfie's on the corner of Twentieth and Collins, reading books from the Miami Beach Public Library across the street, walking his shih tzu on Collins Avenue, or going to the track at the Hollywood Kennel Club.

As Nobelist and Surfside resident Isaac Bashevis Singer put it, "Even an old gangster like Meyer Lansky needs a place to retire."

avenue side and two facing the ocean. The facade is distinguished by continuous tray balconies sensuously wrapped around the half-cylindrical ends. Lapidus shows off his understanding of sculptural form: the linear balconies of the central section form a composition of straight lines like those of a Donald Judd sculpture; the curved, wrapped continuous balconies that extend slightly onto the wings anticipate the rounded ends, while the continuous balconies that wrap the bull-nosed wings end bluntly, reversing the visual flow. All the elements conspire to give the facade a rippling, flowing dynamism.

Lapidus was a total designer. His attention to detail can be seen in the beachside pavilions, which have a bit of the jaunty, surreal air of the sets for the 1960s cult television show *The Prisoner*. There are two tentlike pavilions formed of poured concrete. One tent even suggests pleats of canvas suspended from poles. The circular motif of the main tower wing carries right into the spiral of the changing cabana. The landscaping, too, reveals Lapidus's interest in staging and dynamic spatial composition. The rolling landscaping artfully conceals an aboveground parking garage. Curving

pathways lead to a garden of rectilinear pylons, echoing the dynamic of curves and straight lines in the facade.

The interior provides residents with all the deluxe trappings of a Lapidus resort. Rich, wood-paneled columns terminate in luxurious red-velvet round banquettes. There are delicious contrasts of space between the panoramic lobby and the small, self-contained mailbox area, which is lit by an oversized chandelier. An indoor fountain that combines dark wood and colored tile looks out on the pool deck.

The Alexander, 5225 Collins Avenue, Charles F. McKirahan, 1962

Fort Lauderdale modern master Charles F. McKirahan made the most of the limited visibility of this narrow slab set perpendicular to the street by covering the Collins facade in a full-height abstract painted stucco relief reminiscent of Polynesian art. McKirahan's other major contribution in Miami was the legendary Castaways Island Hotel in Sunny Isles. Perhaps both buildings were inspired by the time McKirahan spent in the South Pacific after World War II.

Imperial House, 5255 Collins Avenue, Melvin Grossman, 1961

As in the Mimosa, Grossman wrapped the tower in a skin of masonry and continuous eyebrows, but here the massing is curvilinear, no doubt to capitalize on the popularity of the Fontainebleau, while full-height tile mosaics recall the Eden Roc. Full-height banks of screen block complete the range of textures.

Entering the Imperial House is a memorable experience. As you slip out of the sun's glare under a low, unassuming porte cochere, water walls of undulating blue porcelain tile appear on either side of the entry. A gentle cascade trickles over the surface into a tile-lined basin, spanned by a bridge that connects the curbside to the entryway. Round openings in the porte cochere allow sunlight to illuminate the cascading water. The bridge features a finely detailed, gold anodized-aluminum balustrade.

The Imperial House's gentle curve provides a segue between the wall of buildings to the south and the open space of a public parking lot to the north. The effect is especially striking when seen in motion from the north by car on Collins or by boat on Indian Creek.

Oceanside Plaza, 5555 Collins Avenue, Morris Lapidus, 1967

The sheer size and close proximity to the street of Oceanside Plaza's horizontal fourteen-story slabs recall the dense, apartment-lined streets of West End Avenue or Park Avenue in New York. The bull-nosed corners and wrapped balconies reappear from Lapidus's Seacoast East.

5600 Collins Avenue, Melvin Grossman, 1967

The first condominium to be built on the Indian Creek side of Collins features a generous, lushly landscaped setback with an expansive pool deck occupying the north side of the lot, opening onto Indian Creek and the afternoon sun. A wide front setback allows for the most grandly proportioned porte cochere in the canyon, providing a dramatic sense of arrival and departure in an urban setting.

The interior is palatial Miami Beach Baroque. The regal lobby opens to a double-height compressed archway providing a view of Indian Creek and the treetops beyond. The billiard room has the proportions of a salon in a seventeenth-century palace.

Marlborough House, 5775 Collins Avenue, Giller, Payne & Waxman, 1963

The Marlborough House was the first tower in Condo Canyon, but its vertical massing, set perpendicular to the shoreline, was closer in appearance to the 1959 Executive House than to its massive, wall-like neighbors that followed in the 1960s. Also similar to the Executive House, the Marlborough House features full-height panels of screen block while a butterfly roof smartly caps its elevator tower.

THE BEST IS YET TO COME: NORTH BEACH

North Beach, which comprises a swath of the main island of Miami Beach from Sixty-third Street to the borderline with Surfside at Eighty-seventh Terrace and five adjacent island communities—Biscayne Beach, Biscayne Point, Stillwater Drive, Park View Island, and the MiMo-bejewelled Normandy Isle—is truly a product of the postwar era.

At its suburban heart of Eighty-first Street and Abbot Avenue stand four gas stations and a parking lot, evidence of the increasing dominance of the automobile at the time the area developed. The centrally located gas stations notwithstanding, the area is characterized by high residential density, a pleasant scale, beguiling MiMo architecture, a wealth of public open space, and miles of waterfront. All that's lacking is a human-scaled commercial core.

On the main island, the North Shore area, with its neat, square blocks of one- and two-story apartment motels, seems townlike, compared with city-scaled South Beach. East-west streets provide vistas of the leafy North Shore Open Space Park along the beach, while the narrower front setbacks are often landscaped with river rock, in the manner of beach communities. Standing like a MiMo sentinel at the north end of the park, the Dezerland Hotel marks the north border of Miami Beach. South of the park lies the Altos del Mar neighborhood, Miami Beach's only oceanfront neighborhood of single-family houses.

The strip of land between Seventy-second and Seventy-fifth Streets, owned by the federal government until 1921 and undeveloped until 1940, was the location of the Biscayne House of Refuge of 1876, the earliest known dwelling occupied by settlers of European descent in what is now Miami

Beach. Stretching from the ocean to the bay, the tract includes Ocean Terrace, a remnant of a road that once lined the beach all the way south to Forty-sixth Street. The road frustrated Carl Fisher's plans to sell his enormous beach side lots as "oceanfront." North Beach was incorporated into the City of Miami Beach in 1924 so that Fisher, with his political clout, could extirpate the road except for the two blocks that remain today.

The area south of Seventy-first Street, with its mix of large oceanfront resort hotels, high-rise condos, and ubiquitous two-story apartment motels, recalls the dense, urban character of lower Middle Beach. Tucked into the confluence of several waterways lies little Park View Island. Gilbert M. Fein designed most of the apartment motels on the island, giving it a strong MiMo unity.

Normandy Isle and its sister island Normandy Shores were the result of Greater Miami's penchant for City Beautiful suburban developments in the 1920s, along with Coral Gables, Miami Springs, Miami Shores, and Opa-locka. Although Normandy Isle saw some development in the 1920s and 1930s, it was built out mainly after the war.

A MODERN CITY BEAUTIFUL: NORMANDY ISLE

Perhaps because it is a separate island from the rest of North Beach and its founders maintained quality control for many years, Normandy Isle possesses a bounty of high-quality MiMo architecture.

Developer Henri Levy, a French Jew who moved to Miami Beach from Cincinnati in 1922 when one of his daughters needed warm weather for health reasons, was captivated by Miami Beach and caught the development fever rampant in the 1920s. The entrepreneurial Levy was drawn to the magnetic force of developer Carl Fisher. In 1923 Levy purchased land from Fisher, but Fisher would not associate with him because he was Jewish. Fisher's rejection only gave Levy greater impetus to leave his mark on the area.

In 1925, Levy's most ambitious scheme, Normandy Isle, began to take shape on a mangrove island to the west of his Normandy Beach South subdivision. Normandy Isle is distinct as the only example of the City Beautiful Movement in Miami Beach. Like Gaul, the island is divided in three parts. The east and west thirds, Ocean View and Miami View, consist of apartment districts centered around commercial areas, with the single-family detached residential Trouville section in the middle. While the west commercial area, not fully platted until 1939, has yet to become a focused business district, the east side became the site of a plaza with a prominent fountain dedicated to Levy.

While the buying and selling of land was brisk in North Beach before the real-estate collapse of 1926, there was relatively little development. The area's distance from the hub of Lincoln Road discouraged development until after the war. These factors would set the stage for North Beach and the three sister communities to the north to be developed almost exclusively in the MiMo era.

Deco Palm Apartments,
6930 Rue Versailles, Gilbert M. Fein, 1958

The Deco Palm Apartments are a variation on Gilbert Fein's personal favorite of his own designs. The overall scheme of the multiple-unit two-story structure is of a giant chalet-style house, but the design was arrived at experimentally, rather than deliberately. "Somebody came along with two lots, and I said, 'Well, why not take this building and tie it together, so that it looks like a first-class

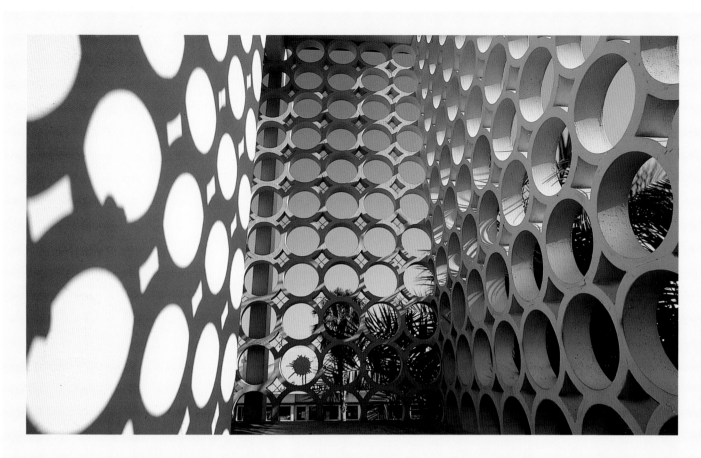

SHADOW PLAY: The circular screen-block facade of the Union Planters Bank on Normandy Isle enlivens a blank wall with an extraordinary play of light and shadow, a sculpture that interacts with the changing position of the sun.

apartment building," Fein recalled. "We extended the roof slightly and built a bridge across.

"The buildings didn't have much landscaping," Fein recalled. "In those days we just had a minimum setback, which everybody complied with. Rather than individual buildings, which would look bad, the thing I like about the double building is that you have a grass patio area in the center."

The Deco Palm also has overscaled planter boxes that further serve the illusion of unified house front. "They were very, very popular," Fein said. "We couldn't have too much landscaping at the ground level because of the entrances and so forth, but we put a planter at the upper level."

Union Planters Bank, 1133 Normandy Drive, Francis Hoffman, 1958

The two-story Union Planters Bank synthesizes Modernist and Classical forms. The main facade of screen block consisting of concrete circles forms a modern-day, abstract frieze, a tribute to the same fusion of Classical Greek and modern styles in Edward Durell Stone's U.S. Embassy in New Delhi of 1958. Protruding pillars divide the facade into the Classical ideal of five bays. A forecourt is composed of polished oval pebbles pressed into concrete.

The Classical grid is offset by a Modernist asymmetry. The void under the cantilevered balcony on the east end is offset by the opaque volume on the west. Seen from the side, the projecting second floor is counterbalanced by the visual weight of the recessed but solid first floor.

The screen block imparts a sense of lightness and permeability to the whole structure. Open circles meet at the corners without moldings, accentuating the effect. In lieu of Classical sculptural reliefs, the screen block creates abstract patterns of light and shadow. The ethereal effect is heightened by the recessed walls below and the floating staircase that adorns the west side..

As much of a MiMo landmark as the apartments he designed, Gilbert M. Fein died in early 2003 at the age of 83. This is one of his last interviews.

Born in Brooklyn, New York, Gilbert M. Fein got his degree in architecture from New York University in 1942, and like many vets moved to Florida after the war. "I came here for a two-week vacation in 1948," the architect said about Miami. "I left New York mainly because there was no housing. After coming down here and seeing what was going on and the possibilities, which I didn't have in New York, I decided to stay."

Fein's first job in 1948 was working in Norman M. Giller's office. "Norman was doing two-story apartment buildings, mainly low-cost Federal Housing Authority residences," Fein recalled. "That time was the beginning of air-conditioning. Finally, they came out with window units, and I talked Norman into getting one for the drafting room. What a difference it made." In his autobiography, *An Adventure in Architecture*, Giller wrote that before air-conditioning the architects had to use beach towels on their drafting boards to keep their blueprints dry because the air was so humid and the architects were perspiring so freely.

Fein left Giller's office after a year to hang his own shingle in the burgeoning postwar housing market. He designed more buildings than he could keep track of. The log of building permits issued by the City of Miami Beach shows that he built seventy-nine apartment buildings from 1949 to 1971, in styles variously described as garden style, postwar

Mediterranean Deco, postwar modern and International. Most of the courtyard apartment buildings in the postwar community of Normandy Isle, if not actually built by Fein, reflect his style.

A fire destroyed most of Fein's records and documents. His last office was in a modest building on Biscayne Boulevard, where he kept rolled-up blueprints in plastic garbage bags. One lens of his eyeglasses was covered with Scotch tape because of an unsuccessful cataract operation, but he continued to sketch plans for an outside draftsman.

At its peak in the early 1970s, his office of fifteen draftsmen was awarded the commission to build the new Miami Beach convention hall for the 1972 Republican National Convention. Fein said of Lapidus, who also competed for the project, "Morris, of course, when he heard I had the project for the convention hall, screamed and yelled."

Designing the convention hall was Fein's favorite period in his career, even though the end result was marred by the involvement of too many architects. The mayor of Miami Beach at the time, Elliott Roosevelt, showed Fein an inch-thick proposal detailing the requirements for the site. The convention was the first to be broadcast in color, and the networks wanted certain colors, as well as sufficient room and air-conditioning. Fein set out to design the basic shell, supported by seventy-foot-long trusses. "The conference hall you see now is the result of three different architects and three different ideas," Fein said of the building that was

swallowed up by subsequent expansions on Washington Avenue and Eighteenth Street. "The teams could not agree even on basics like the orientation of the building."

The original plan was to make the main entrance face west, but "the second architect supported facing Washington Avenue," Fein said, still with a trace of indignation. "They tried that, but nobody provided buses, or parking, or transportation, or anything. Traffic was horrible. So they went out to another architect who had everything facing west again. Now the other side was still there, but it wasn't used. Then they built a bridge across.

"The job I appreciated most wasn't architecture, it was social," Fein said about putting the plan together. "I had the FBI coming up to the office, I had each broadcasting network, and they each had something they wanted to do. The night before the convention we were testing out the acoustics. I was up at the front of the stand, talking, like Nixon."

6881 Bay Drive, Robert M. Swartburg, 1948

Bayside Apartments, 910 Bay Drive, Robert M. Swartburg, 1951

960 Bay Drive, Robert M. Swartburg, 1951

Swartburg's trio of apartment-hotels are a timeline of the transition from Deco to MiMo. The facade of the earliest, at 6881 Bay Drive, seems to be a snapshot of Deco elements evolving into MiMo. Eyebrows look as if they are caught in midstretch around windows. Deco symmetry breaks down into a looser composition, and the porthole at the entry looks as if it is about to be swept away in the tide of change.

The Bayside Apartments a block away are a dynamic stabilelike assemblage of planes and volumes à la Kandinsky. The building at 960 Bay Drive is a MiMo crescendo of intersecting planes of corrugated stucco and screen block topped by a towering crab orchard stone pylon.

HIGHLIGHTS OF NORMANDY SHORES

350 South Shore Drive, Gilbert M. Fein and Morton Fellman, 1954

With its latticework grid uniting two wings, 350 South Shore Drive is typical of Fein's double-wing garden court apartment motels. "The Federal Housing Authority wanted different houses to get some variation and roof changes, anything to make it look different," Fein said. "You drive by now of course, and you see they're all very similar."

Hearkening back to Tropical Deco compositions in stucco, Fein's apartment houses exhibit complicated schemes of frames within frames and overlapping planes. Smooth stucco is but one surface, providing a foil for other textures. Fein says that framing the windows with a protruding edge was an extension of the Art Deco style. "It started out as an eyebrow," he said, "but then they decided they were going to stick it out as a decorative feature."

275–301 South Shore Drive, Gilbert M. Fein, 1953,

125–35 North Shore Drive, Gilbert M. Fein, 1953

Like military jets off an assembly line, these mass-produced apartments are variations on the theme of the iconic delta wing. The facade of 275–301 South Shore Drive frames a grass court with a central palm tree and the Normandy Shores Golf Course beyond. Fein said the plan was inspired by Mediterranean homes in which the individual rooms connect through an exterior passageway in an enclosed courtyard.

Fein resisted interpretation of his work, but the most compelling aspect is its often overt symbolism. In contrast to the prevailing aesthetic of structural expression, Fein chose to emphasize decorative or purely symbolic elements, like the thickly articulated but structurally unnecessary eaves and delta angles.

Fein himself is not sure of the origin of the ubiquitous flying-wing angles: "Somebody thought of it, and everybody copied it," he said. "It was a way of breaking up the front, breaking up the flatness of the whole thing." Heavy cornices connote shelter, but Fein dismissed the symbolism. "It was something different, a little more modern, a little more interesting than just a plain piece of wood slapped on the edge."

Most of the people who lived in Fein's low-cost apartments were "the average person who had a job down here, the working man," Fein said. "Young families came down here to settle. A lot of the

fellows were here on basic training, and they came back here with sand in their shoes. You've heard the expression."

THREE MIMO SISTERS: SURFSIDE, BAL HARBOUR, AND BAY HARBOR ISLANDS
As a result of development efforts by the Tatum brothers and Henri Levy, the town of Surfside was the first of the three sisters to become incorporated in 1935. Development did not begin in earnest until after the war. The Surfside Business District on Harding Avenue, between Ninety-fourth and Ninety-sixth Streets, presents a fine collection of MiMo storefronts.

Many of the Surfside's oceanfront MiMo hostelries are being supplanted by condominium towers, but the western side of Collins Avenue still is lined with a cohesive row of charming, two-story MiMo apartments. Surfside's MiMo gem is the beachfront Community Center on Collins Avenue at Ninety-third Street.

BAL HARBOUR
Bal Harbour began as a project of the Detroit-based Miami Beach Heights Corporation in the 1920s. In the 1930s, a team led by Robert Graham was hired to produce a development plan, but the entry of the United States into World War II put construction on hold, and Graham leased the land to the U.S. Army Air Corps. A German prisoner of war camp was once located on the site of the ritzy Bal Harbour Shops.

After the war, the air corps barracks were converted into apartments that housed the twenty-five registered male voters required by Florida state laws for incorporation. In August 1946, Graham and the voters incorporated the town of Bal Harbour. In a considerable leap from the early suburban planning ideas of the Tatums in North Beach and Surfside, Graham's plan designated areas for residential, civic, commercial, and hotel development, a central greensward affording a view of the bay from Collins Avenue, and distinctive curving streets.

Brownstone Apartments, 10178 Collins Avenue, Roy France & Son, 1950
This assemblage of small-scale apartments around a verdant lawn is one of the freshest examples of what MiMo has to offer to contemporary architects. The imaginative composition of abstract, human-scaled designs could be a template for the New Urbanism as practiced by Robert A. M. Stern or Elizabeth Plater-Zyberk at the University of Miami. It offers individuality, creativity, and community while looking as up-to-date as today's newspaper. This is heaven.

BAY HARBOR ISLANDS
Bay Harbor Islands, the last of the three sisters, was incorporated by Shepard Broad in 1947. Two years earlier, Broad, a lawyer, had traded his interest in the Biscayne Building on Flagler Street in downtown for two marsh islands in the bay, off what would become Bal Harbour. Like Bal Harbour, Bay Harbor Islands was a planned community and a product of the MiMo era.

In recognition of the growing importance of the automobile, parking areas were placed behind the stores along Kane Concourse. The convenient additional parking known as parkways and the dual-access to the commercial spaces from the sidewalk and rear parking lots were touted as modern innovations. In 1951, Broad opened the eponymous Broad Causeway to North Miami providing an essential lifeline for his development.

The rapid pace of development in the 1950s and early 1960s and the compact, traditional layout of the East Island fostered what is surely one of the finest and most cohesive collections of midcentury Modernist multifamily residential and commercial architecture in the world. Kane Concourse offers an unparalleled array of high-style MiMo commercial buildings.

1069 Kane Concourse, Igor B. Polevitzky, Johnson & Associates, 1958

Polevitzky's small one-story commercial pavilion is a quasar in the exceptional constellation of MiMo storefronts along Kane Concourse. The storefronts in large part have remained in their original condition, since Bay Harbour Islands never experienced the decline in other neighborhoods along Biscayne Boulevard.

The building is an adaptation of Miesian minimalism to the subtropics. A wafer-thin canopy supported by square aluminum posts and edged with black-and-white tile floats atop a clerestory. The storefronts consist simply of a continuous white parapet above aluminum-framed plate-glass doors and windows. The flat, projecting canopy forms a sheltering arcade.

The scale of the palm-lined corridor is well preserved. The storefronts were built before early postwar strip shopping centers became the norm. The parking lots are concealed behind the buildings, rather than becoming the main visual element in the foreground. There was still a concern for preserving the integrity of a pedestrian-oriented line of stores, rather than isolating buildings in a sea of cars. The result is a modern townscape that is both accessible by car and pleasant to walk in

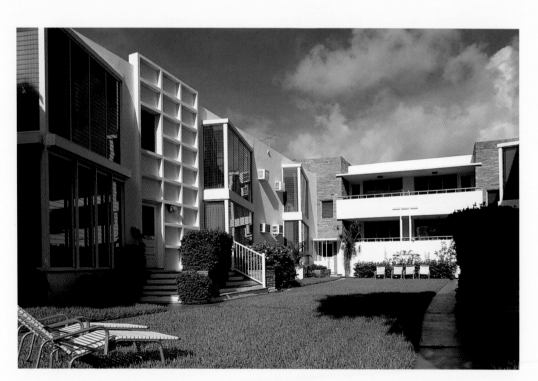

NOT FAR FROM HEAVEN: Designed by Roy France & Son in 1950, the Brownstone Apartments, a courtyard apartment complex at 10178 Collins Avenue in Bal Harbour, typifies the laid-back luxury of the MiMo era. The variation of forms within the assemblage has an almost Post-Modern feel.

SEVEN

The buildings designated as Stars are examples of MiMo architecture that stand without a neighborhood context, as if they had been whirled out by the centrifugal forces of galaxy formation. Buildings like the exquisitely detailed, self-contained Wrightian Miami Times Building and the winged Publix on the golf course look as if they had been dropped from the sky into more mundane neighborhoods. The Stars range from the elegant Latin-flavored Modernism of the Coconut Grove Bank to the Pop Art appeal of the Pepsi-Cola Bottling pavilion, and the cool subtropical minimalism of a Polevitzky house.

Miami Herald, One Herald Plaza, Naess & Murphy, 1960

The Miami Herald occupies a commanding site in a nerve center of the modern metropolis on a choice stretch of ten acres of bay-front property between the MacArthur and Venetian Causeways. Few buildings were so fully shaped by the climatic concerns of Subtropical Modernism, and fewer still were so lavishly executed. Modeled after the Sun-Times and Daily News building in Chicago, also by the firm of Naess & Murphy, the Herald was the largest building in the state of Florida at the time.

The Herald epitomizes the Subtropical Modern office building, with its eggcrate facades, sun grilles, and external expression of its interior functions. It is essentially two structures in one, an office building and a printing plant. The offices occupy the southern portion of the building, with its rows of finely crafted sun grilles, which were originally painted a pastel blue to contrast with the gold-and-butter-colored mosaic tile of the spandrels. Although the grilles are now bare metal, the brightly colored spandrels are complemented by piers clad in luxurious white marble.

The main body of the building is raised one story, to protect against flooding from the bay in the event of a hurricane. While the ground floor of the pedestal is open, exposing pilotis, the ground floor of the printing plant is screened with a luxurious

two-toned diamond checkerboard grille. The parking pedestal is clad in a contrasting brown aggregate over a folded-plane surface.

The porte cochere combines Classical proportions with Modernist detailing. A colonnade of rectilinear piers supports a canopy that tapers aerodynamically at its edges and rises three stories to serve as a low canopy over the parking pedestal. The canopy is punctured by large, round glazed openings allowing light to enter the grand lobby space.

Entering the double-height lobby, the visitor immediately encounters escalators leading to the second-floor business office, another expansive double-height space with sweeping views of Biscayne Bay and Miami Beach. On weeknights, the vast illuminated space is often distinguishable behind the rows of sun grilles.

The press building is housed in the windowless volume at the north end. The vibration of the presses was buffered from the offices by a specially designed airspace. Press design improved to the point where an additional office floor could be added to the press building, thus the top-floor windows.

Like the Sun-Times and Daily News building in Chicago, the Herald was designed to receive wood pulp for papermaking via barge. While the activity has long since ceased, vestiges of the unloading apparatus remain. It may seem odd that the narrow south facade, with a million-dollar vantage point overlooking downtown, is clad in windowless white marble, but at the time of construction, the building looked out on a gasoline depot that served the port.

Miami Times Building (originally General Capital Corporation), 900 Northwest Fifty-fourth Avenue, Alfred Browning Parker, 1959

The Miami Times Building, originally an office for the General Capital contracting company, exemplifies Parker's interpretation of Wrightian architecture. The construction looks like traditional Japanese wood joinery, even though it is made of concrete. The heavy, horizontally lined roof is cantilevered like that of a Japanese temple. Weighty beams appear to support the roof, as in timber construction, and the frieze on the cornice resembles decorative woodwork, although it is in fact copper sheeting over lath applied to concrete. "It was poured all in one chunk," Parker recalled with a chuckle. "If they ever tried to blow it up, they'd have

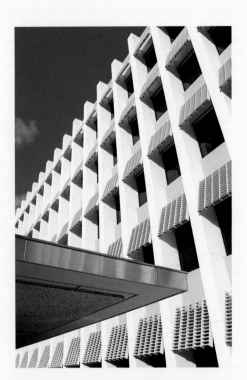

MAKING HEADLINES: The commanding Miami Herald Building of 1960 was a bid to put the city on the map with older architectural rivals like Chicago.

THE WRIGHT STUFF: Alfred Browning Parker pursued his own interpretation of Wrightian design with the well-fortified concrete headquarters for the former General Capital Corporation. Sheltering eaves were a response to Miami's sun and showers.

to blow it up in one piece, because the walls, the roof, everything, is solid concrete."

As in a Wright design, there is a dialogue between openness and enclosure. Space flows through and around the building as an active force. The bunkerlike corners are massively fortified concrete, but the lobby walls are glass. The ponderous cornice rests on an open clerestory. There are many Wrightian elements of shelter and protection, as in Wright's Robie House of 1910 in Chicago. The windows are deeply ensconced between the concrete piers under the sheltering eaves. The main entrance is indirect—an oblique approach between the corner bunker and a similarly protective concrete planter into a sheltered glass bay.

Archway, Sunshine State International Park, 1300 Northwest 167th Street, O. K. Houston and Charles Giller, 1964

Industrial parks, the manufacturing counterpart of suburban housing tracts and shopping centers, were an ideal concept for making industry compatible with the popular images of Miami and South Florida. Sunshine State International Park, originally called Industrial Park, distinguished itself from run-of-the-mill

MAKING A HOME IN THE WORLD: ALFRED BROWNING PARKER

Of the Miami architects practicing in the 1950s and 1960s, Alfred Browning Parker is the most Wrightian, both in his design style and his character. Standing in the yard of his house along a winding suburban lane near the University of Florida in Gainesville, he is an unmistakable figure, a vital man with a full head of white hair supervising a project of turning a tree stump into a base for a sculpture. He could be the very model for Ayn Rand's Howard Roark: plainspoken, with patrician features and a workman's hands.

Parker is unusual among architects in that he designed a dozen homes for himself as a way of raising capital. He would buy an empty lot, sometimes one considered undesirable, like a former rock pit over which he built a house of native stone, then design and erect a house himself and eventually sell it, parlaying each house into grander schemes. The home he built for his family in Coconut Grove was chosen by *House Beautiful* as the 1954 Pace Setter House. Frank Lloyd Wright happened to stop by the office of the magazine's editor, Elizabeth Gordon, when Ezra Stoller's photographs of the Parker house were on

her desk. Wright expressed interest in meeting the Miamian and wrote an introduction to the issue: "This Florida house aims at the highest goal to which architecture may aspire: organic architecture. Along this new but ancient way a home where the enlightened mind can flower, where people can develop their fullest potentials, is still a possibility."

"Mr. and Mrs. Wright came down for a weekend and stayed at the house," Parker recalls. "When he first came in, he went up to the fireplace and put his hand on it and rubbed the stone and he said to his wife, 'Mother, this is the same kind of stone I built the Imperial of in Tokyo.' He asked me all kinds of questions, of which he already knew the answers. I had a nice relationship with him, even towards the end of his life. I remember being in New York one time, and I walked down Fifth Avenue in a snowstorm and I got down to the Guggenheim and I was looking in the window along the sidewalk, and who's looking back at me? Mr. Wright. This is about eleven o'clock at night, and he says, 'Parker, come on in.' I went around and they unlocked the place, and he showed me around the Guggenheim at night."

The Pace Setter House, the epitome of Wrightian principles adapted to the subtropics, had open, flowing interior spaces and long concrete cantilevers. With Emersonian self-reliance, Parker dug the foundations and cut and laid the stone himself and also designed and built the furniture. *Persianas*, floor-to-ceiling louvered wooden doors typical in Cuban architecture, opened the rooms completely to the outside, yet were designed to shut tight in a storm.

The house still stands but "it's been completely destroyed," Parker says with a touch of regret. "The people that bought it messed it up, and they sold it, and every time somebody buys it they start changing it. I sold it for what I thought was a huge amount of money, $125,000. The last time it sold for $2.5 million.

"I never worked for another architect, because I didn't have time," he explains.

A later home in Coconut Grove was a swinging pad, built of solid mahogany inside and out. It featured a cantilevered carport and a spring-fed swimming lane that wound through the compound structure. In another of his jet-age houses, the rooms connect on an open court like a Spanish Colonial house, except that the space is filled with a swimming pool under a domed roof. The result looks like an idyll on Venus.

The architect's eye extends to details like designing built-in, custom light fixtures, cambering long ceiling beams upward to offset the sagging effect of long horizontals, and using exotic materials like kappa shells and copper. For his Pace Setter House, he asked his engineer to build an unusual

fourteen-foot-long cantilevered roof, no more than four inches thick. "The city wouldn't approve it, so I went ahead and built it," he recalls, "and invited the building inspector down to see it when it was built."

His work includes a Modernist church, Hope Lutheran, built in 1954 in Miami for $1 million, whose structure incorporates a cross motif. He also designed schools, a concrete yacht club in Bal Harbour (now demolished), and thousands of moderate- and low-income homes.

Born in Boston in 1916, Parker moved to Florida with his family at the age of eight, because of concerns about his fragile health and influenza. His father sold real estate for George Merrick, the founder of Coral Gables. Parker got a degree in architecture at the University of Florida, taught there briefly, then practiced architecture in Miami for half a century before retiring to teach graduate seminars in Gainesville in 1998.

He is still active as a designer. A rendering of a project for a circular house is pinned to the wall, next to a plan for a horizontal slab spanning New Jersey to the Battery in New York, a proposed monument to replace the World Trade Center. He

waxes enthusiastic about patents he and his son hold to create energy from hydrogen rather than from burning fossil fuels, and rails against the state utility company, Florida Plunder & Light as he calls it, for interfering.

Although revered by many as the "Cher Maître" of Miami architects, Parker lives according to his own lights and does not really think about his relation to schools of architecture. "I have had a marvelous time making a living and doing what I love—building things."

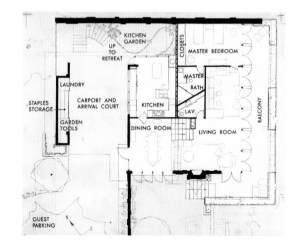

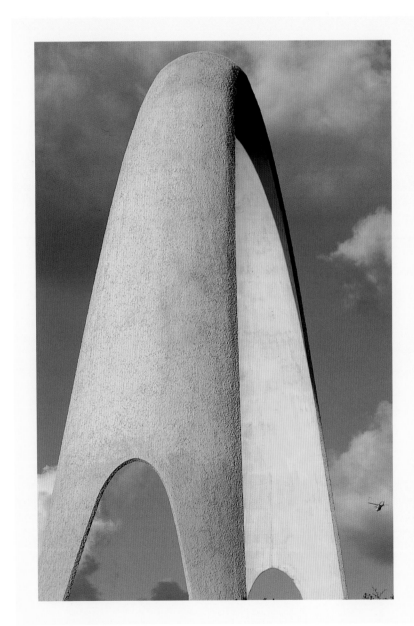

ARCH RIVALS (LEFT): The Sunshine State Arch was inspired by Eero Saarinen's Gateway Arch in St. Louis, also completed in 1964. The parabola had connotations of riches at the end of the rainbow promised by technology.

PURE POP (OPPOSITE): A freestanding round pavilion for the Pepsi-Cola Bottling Plant by an unknown architect represents a giant bottle cap.

complexes with architecturally appealing buildings.

Contractor-turned-developer William Webb selected the site for an industrial park in 1955 knowing that it would be strategically located once the Palmetto Expressway and Florida's Turnpike (originally the Sunshine State Tollway) were completed. To give his project high visibility from the expressway and the nearby Golden Glades interchange, Webb erected a gigantic concrete parabolic arch over the entrance that evokes Eero Saarinen's Gateway Arch of the same year in St. Louis. The park itself features MiMo office and industrial buildings, some still in their original state.

Pepsi-Cola Bottling Pavilion, 7777 Northwest Forty-first Street, Daverman and Associates, circa 1965

This two-story, circular pavilion is an update of architecture parlante, a style popular between the wars in which the shape of the building represented the owner's product, like Los Angeles's legendary 1930s Tail o' the Pup hot-dog stand in the shape of a frankfurter and bun. Supported by four pilotis, the Pepsi-Cola pavilion looks like a

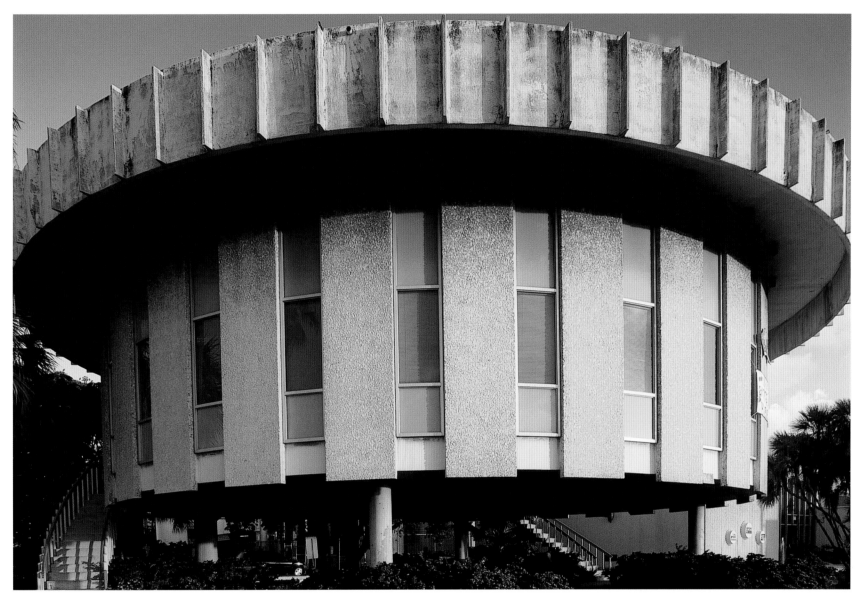

bottle cap, but at the same time suggests a Classical column.

The frieze of narrow vertical projections on the heavy, overhanging cornice are a kind of visual pun, referring both to the crimping on a bottle cap and the dentiles of a Classical column cap. Likewise, the alternating strips of greenish glass spandrels can be read as the fluting of a column and a representation of a Pepsi bottle.

The scale is Post-Modern in its audacity, but the effect is MiMo sci-fi: like Robert M. Little's 1961 music library at the University of Miami, the Pepsi-Cola pavilion resembles a flying saucer. The open ground floor makes the building appear to hover, while the curvilinear floating staircases tentatively touch the earth.

STARS OF MIAMI BEACH

Publix on the Golf Course, 1045 Dade Boulevard, Charles N. Johnson, 1962

Everyday life, especially consumerism, was a celebration in the early 1960s. Charles N. Johnson's big-scaled detailing turns the local supermarket into a destination, and shopping

into an event. The jet fins in the arrowhead-like central motif were the true "V for victory" sign of the postwar world. Features like the story-tall parapet that serves as a billboard and the immense canopy look hyperbolically exaggerated, but fitting at the same time.

The Publix facade is based on the balanced symmetry of the Beaux Arts style. The central arrow motif is essentially an arch and column magnified to Cineramic proportions. The almost Post-Modern exaggerated scale melds perfectly with pure Modernist design. The ground floor, which seems to disappear under the cornice, consists of symmetrical glass-block panels and verd antique marble flanking a recessed plate-glass entry. Within the huge-scale features, there is some deft detailing: the glass block is framed by a lightly projecting lip of marble, and the canopy is supported by three beanpoles anchored in a delta-wing-shaped marble planter box that matches the prow shape of the central attached neon column.

You can just imagine pulling up in your 1962 Chevy Bel Air with that new-car smell to park "where shopping is a pleasure."

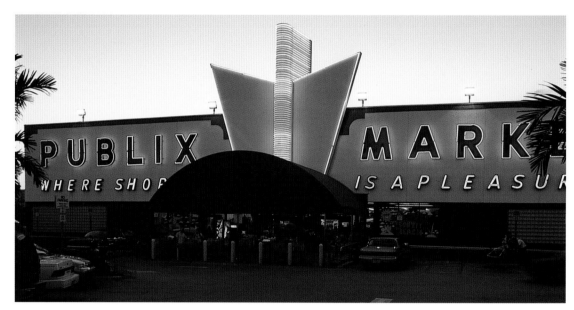

1200 Ocean Drive, Gilbert M. Fein, c. 1955

MiMo even made its presence felt on South Beach's Ocean Drive, the heart of the Art Deco district. A multi-hued fieldstone pylon provides a background for a projecting signage parapet with the raised numerals 1200. Seen from the Twelfth Street side, the balconies appear almost to be an afterthought, as if they were tacked on by the diagonally projecting beams, which resemble tabs in a build-it-yourself paper model.

From an oblique angle, the wall is revealed to enclose a wraparound section of the balconies, so that it also has a structural function. The pylon also plays sophisticated variations on form versus function. Its solid stone appearance is belied by remarkable thinness of the parapet, as well as by the cutout space at ground level. The parapet continues around the corner as a solid wall.

The windowlike cutout makes the stone-clad pylon seem insubstantial, but its structural function is seen clearly from Ocean Drive, where the narrow, columnlike side of the pylon wall pierces the projecting balconies. From this vantage point, the balconies are revealed to be fully integrated into the structure.

Giller Building, 975 Forty-first Street, Norman M. Giller, 1957

Giller's own headquarters is one of his more abstract designs. The building's signature feature is a shimmering, abstract mosaic of colored glass tile imported from Japan, in shades of green with red and yellow accents. Giller used the material because it had just become available in the United States, and because color was an essential element of the Florida environs. The facade combines some of the chief elements of Giller's practice during the era: the resort flamboyance of the mosaic and the International Style restraint of the office wing and the annex.

Like the swatches of color in the mosaic, the building is a quiltwork of solids, open spaces, and enclosed glass volumes. The patterns take surprising twists as you gaze along the facade, built on an irregular footprint of setbacks. The lot is a trapezoid with a rounded corner, but Giller did not want to build a circular building as other architects of the time might have, so the plan is a series of acute and oblique angles.

Eiber House, 5160 North Bay Drive, Morris Lapidus, 1958

Lapidus was not only a deeper talent than contemporary critics gave him credit for; he was also far more versatile. This single-story house, one of a handful of residences that Lapidus designed, evinces a sensitivity to Subtropical Modernism, but with a characteristic Baroque twist.

The home, which belongs to cardiologist and art collector Dr. Al Eiber, who has filled it with Gaetano Pesce artwork and furniture, features splashy effects associated with Lapidus's resort work—changing levels, contrasts in scale, color, and materials, and masterfully directed vantage points—but it seems that Lapidus wanted to prove he could do Subtropical Modernism on a domestic scale.

Al Eiber relates an anecdote about the original owner, a Dr. Finn, who was Lapidus's dentist and prevailed upon the architect to build him a house. "I do buildings, I don't do houses," Lapidus grumbled. The dentist replied that he would just have to keep on drilling until Lapidus agreed.

The house incorporates many Wright-influenced elements associated with Coconut Grove School homes, such as those in Kenneth Treister's own residence, but Lapidus adds

CHANGE IN LATITUDE AND ATTITUDE (ABOVE): Modernism as practiced in Miami was distinguished from its pale Northeastern counterpart by bold use of color, as in the green glass-mosaic facade of Norman M. Giller's headquarter's building.

POPULUXE AT THE PUBLIX (OPPOSITE): Giant signage turns the entire facade into a billboard.

his own twist. The entryway is marked by louvers that cast geometric patterns, as in the Treister home, but Lapidus throws in a wall of screen block for dazzle. A pilaster next to the door composed of an aggregate of highly polished woggle-shaped pebbles sets forth the keynote for the house. The woggles are restated fortissimo in the flagstones in the yard facing the bay.

As in the Treister house, the swimming pool is surrounded by a deck of keystone and incorporated as an extension of the house under a mesh ceiling. But again Lapidus tosses a curve: the pool is entered on one side through traditional wooden French doors, but on the other through Modernist sliding glass panes. This juxtaposition of contrasting styles, and materials makes a journey through the house an adventure. Luxe materials like matched marble floors abut what were (at least in 1958) new materials like marble-patterned linoleum. A wall-to-wall plate-glass window in the dining room is set off by sparkling, gold-flecked linoleum tile, like the surface coat of a custom roadster. A sink with gold-plated Sun King–style French fixtures rests lightly atop Lucite legs with delicate gold-tipped feet.

It is as if Lapidus was saying that he was sensitive to everything that architects inspired by nature were doing, but wanted to design on his own terms. The house even features a mazelike side entrance with a low screen-block wall of Miami oolite. Meditative reflections from the pool's surface shimmer on the ceiling of a small sitting room, but the curved rear wall is covered in lustrous black-and-gold-threaded wallpaper.

The house has the feel of a small, freestanding pavilion belonging to a modern-day Baroque palace. Few of the rooms have right angles and, instead, frame a wide-angle view that focuses on the bay. The rooms are set on an angle and cannot be seen fully through the doorways, so that spaces seem to flow into further vistas. Changes in floor levels and ceiling heights as you step from the grand, floor-to-ceiling double doors of the entry to the sunken living room intensify the impression of space in motion.

"Donut House," 4595 Avenue, Morris Lapidus, 1954

Lapidus's main concern in this one-story house centered around an open-air swimming pool appears to have been providing a maximum amount of privacy on the open corner site. The curved walls are punctured only by a clerestory slit set above eye level under the flat round cornice, allowing in light, but not an unwanted line of sight.

The overall effect is as if the walls are flying away due to centrifugal force, revealing different layers of the core. From the road, you can see some deft Lapidus touches: a freestanding screen wall defines the entry by the carport, and the hidden front door is marked by a curiously industrial detail of segmented metal banisters that resemble oversized croquet loops.

Jackie Gleason House, 2232 Alton Road, Lester Avery, 1959

Like the man himself, Jackie Gleason's home is a monument to excess. CBS gave the Great One the two-story house with a balcony overlooking the Bayshore Golf Course as an incentive to move his show to Florida. He also was given a golf cart tricked out like a mini Rolls-Royce, with a fully stocked wet bar.

Gleason's pad is a va-va-va-voom 1950s bombshell of a house. The voluptuous twin bays that greet the visitor resemble bosoms or buttocks. This is MiMo with a Russ Meyer sensibility. The main entrance

"AND AWAY WE GO—TO FLORIDA!"

Soon after Cassius Clay beat Sonny Liston in February 1964, Miami publicity maven Hank Meyer announced that TV's biggest star, Jackie Gleason, was moving his show to Miami Beach. The Beach was Big, with a capital B. He invited Gleason to move to Florida after seeing an item in Earl Wilson's column: the Great One was weary of waiting out long New York winters to pursue his chief passion, golf.

Gleason never did anything in a small way. To gratify a whim, he uprooted more than two hundred CBS employees and their families. He commandeered a dozen railway cars stocked with six wet bars to take a retinue of one hundred and three reporters, seventeen feather-clad showgirls, and three bands for the trip south. The well-lubricated Great Gleason Express rolled out of New York to the strains of Dixieland jazz and arrived in Miami after a thirty-six-hour eating-and-drinking binge. The shindig cost CBS a cool quarter of a million.

With its opening camera shot gliding over the water to reveal the miraculous Miami Beach skyline, and the salutation "from the sun and fun capital of the world," the Gleason show was an unabashed advertisement for the South Florida lifestyle. Gone was the proletarian gloom of the original *Honeymooners* and its bare-bones kitchen setting. Instead, the new cast went off on a kitschy around-the-world tour, rank and filers on a spending spree like the rest of America, interrupted by the lovely June Taylor dancers, whose only duty was beauty. Gleason always closed the show with the tag line, "The Miami Beach audience is the greatest audience in the world."

Indicative of Florida's emergence in the national consciousness, rival NBC stacked two Florida-based shows against Gleason on Saturday night: *Flipper*, set in Biscayne Bay and its environs, and *I Dream of Jeannie*, about a sexy genie in a two-piece harem outfit serving an astronaut in Cape Canaveral, which astonishingly managed to synthesize the twin postwar preoccupations of exotic kitsch and the space race.

The show went off the air in 1969, but Gleason stayed on in Florida. His dying wish was to be buried in his beloved Miami Beach, but no cemeteries are allowed within the city limits, so he was buried at Our Lady of Mercy Cemetery at 11411 Northwest Twenty-fifth Street. His tombstone reads, of course, "And away we go."

beyond the frosted-glass gates is on the second-floor level, up a sweeping modern Baroque staircase with daintily filigreed metal railings. You can almost see the comedian's balloon form on the balcony as he gestures with a tumbler of bourbon cradled in swollen knuckles while extolling the pleasures of year-round golfing. The sounds of sprinklers and golf balls being hit sift over the susurrant traffic on Alton Road.

Everything about the house flows from front to back, like the lines of a big, bucking 1950s luxury car with all the extras. Inside, bold, wide red-and-yellow stripes in the terrazzo flooring lead the eye to a sunken circular dining area, surrounded by another metal railing, and out the back to an enclosed patio. Below the exterior staircase stands an entrance to a wet bar/kitchen under a woggled ceiling. The design recalls the rounded arris of streamlining, but the 1950s exuberance is unmistakable.

HOW SWEET IT IS: The pop baroque sweeping staircase leading up to the entrance of Jackie Gleason's former house on Alton Road epitomizes the era's large-scale lifestyle.

Weinberg–Swedroe House, 1300 Biscaya Drive, Surfside, Igor B. Polevitzky, 1958

Spaces and solids, interiors and exteriors are so artfully conjoined in this two-story residence that they can only be viewed as parts of a continuum rather than dualities. One attribute does not exist except in the presence of the other. The house was restored to MiMo splendor by its current owners, Howard Weinberg and Lulu Swedroe, an architect and the daughter of Robert Swedroe, who was Morris Lapidus's chief designer for fifteen years at the end of Lapidus's career.

The front entrance is nothing less than a piece of legerdemain. Wide walnut doors give the impression that you are entering the house proper, but instead you pass into another space still open to the outdoors. What appeared to be the barrier of the house was only a patio. Three sides are paneled in glazed yellow brick under a sheltering overhang, but the fourth is completely open to the air, facing a Japanese rock garden and low parapet.

You are led by the hand of a master architect, laying out his magical cards one at a time. A second set of doors raises the expectation of finally arriving in the house proper, but yet another spatial reversal is in store. The entire rear wall is composed of twelve-foot-tall glass panels supported by the dernier cri in 1950s technology, reinforced steel, so that the moment you arrive inside, the light-filled view draws you outside again. The entire

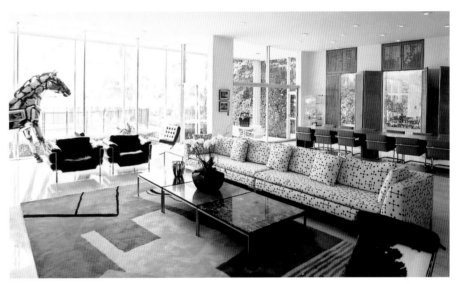

SPEAKING VOLUMES: The Weinberg-Swedroe House, designed by Polevitzky in 1958, is a High Modernist journey through penetrable solids and glass-enclosed spaces.

passage through the house is an experience in the modulation of space and the unity of opposites: solids conceal open space, and volumes are contained in transparent glass.

There are many delightful moments along the way. The central staircase to the second floor seems to float in midair, suspended by strips of reinforced steel from the ceiling, above a burbling fountain. The kitchen is a stellar example of 1950s futurism: hidden fluorescent lights glow from beneath the cabinets, and a work island is set in the center, unusually forward looking for the era. A bath leads to a screened-in aviary. The bedrooms are the most traditionally enclosed areas.

Golden Strand Hotel, 17901 Collins Avenue, Igor B. Polevitzky, 1947

Igor B. Polevitzky was a remarkably versatile talent, able to design a wide range of commercial buildings while pursuing his individual exploration of the interplay of exterior and interior space. His Golden Strand Hotel, which predated the development of Motel Row in Sunny Isles, now stands well preserved as a condominium (but with a bland addition to the north). The architect took components of the MiMo vocabulary—cantilevers, sun grilles, color accents, and stucco walls—and fused them with the International Style. The prewar eyebrow was extended to form continuous horizontal bands. Metal grilles obscure the windows, taking the place of glass ribbons in an International Style building, but becoming even more abstract compositional objects.

Polevitzky strayed from strict functionalism to give the building a more decorative feel, in keeping with the resort tradition. The roof connecting the two wings has a lively curve, evoking an ocean wave. The wings themselves are set at oblique angles from the central structure, adding visual dynamism. Purely ornamental flourishes like the framed mosaics of sea horses in cobalt, celadon, and rust tile, underscored by wavy lines in bas-relief, are a link to MiMo's Deco antecedents.

The work of Igor Boris Polevitzky is a MiMo sub-genre in its own right, because the prolific, Russian-born architect did not adhere to any one school. Instead, he pursued his own formalist experiments in the dialectical relationship between space and structure on a case-by-case basis in each of his more than five hundred buildings, all built in South Florida and the Caribbean between 1934 and 1978.

In 1918, seven years after his birth in St. Petersburg, Russia, Polevitzky and his family fled the Russian Revolution to Finland. In 1922, they immigrated to Philadelphia. He received his degree in architecture from the University of Pennsylvania in 1934 and moved to Miami, where he formed a partnership with Thomas Triplett Russell.

The Polevitzky-Russell homes of the 1930s were a synthesis of International Style ideas such as thin horizontal planes and curved arris. Early on, Polevitzky revealed his interest in modulating the transition from the environment to domestic interiors.

His Gulf Service Station and Hotel of 1936, once located on the MacArthur Causeway entry to Miami Beach, combined marina, lighthouse, gas station, and hotel in an extraordinary Modernist fantasy of transportation and unlimited access. The building looked ready to set sail, with its curving, wrapped staircase, semicircular sundeck, portholes and conning-tower-like hotel set at the base of a working, four-story beacon visible in Miami.

The Albion Hotel on Lincoln Road designed with Russell in 1939—with its trim nautical

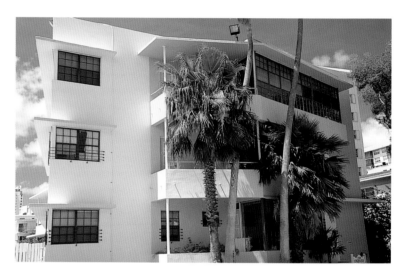

styling and second-level pool with viewing portholes—is one of the grandes dames of Miami Beach Nautical Moderne, but Polevitzky is also known for developing the screened-in, aluminum-framed extension of the tropical home.

His Birdcage House of 1959 was one of his most striking visual compositions. A double-height, screened enclosure predominates as the visual image of the house and defines its volume. Wood and steel trusses support mesh screens that envelop a split-level patio with a swimming pool and a full-grown black olive tree. Interior living areas are subsumed to the open, screened-in deck, ideal for tropical living in the age before air-conditioning.

There are strong parallels between the Birdcage House and the Case Study houses by Charles and Ray Eames and Eero Saarinen, in the open plan, use of industrial materials, and concern for the integration of interior and exterior. The Birdcage House was published in *Architectural Forum* in 1950 and featured in the influential Museum of Modern Art exhibit, *Built in the USA–Post War Architecture*, in 1952.

Polevitzky designed everything from a small shopping strip in Bay Harbor Islands to an Arthur Murray Dance Studio in Miami Beach with a retractable roof that opened to the stars. One of his most famous designs is the Habana Riviera Hotel in Cuba, built for gangland boss Meyer Lansky in 1957 on the city's Malecón. The MiMo-style hotel reflects Morris Lapidus's sculptural flair, with a Y-shaped footprint, cantilevered, scalloped concrete balconies, and a casino under a ceramic-covered half dome.

Although Polevitzky was well published in his time, he died in relative obscurity in 1978 in Colorado, where he had moved in the mid-1960s. Some critics say his deserved fame was eclipsed because he succeeded too well in naturally adapting homes to the tropics, and the advent of air-conditioning made his designs obsolescent. Such an inventive and protean regional talent is worthy of rediscovery.

Coconut Grove Bank, 2401 South Bayshore Drive, Coconut Grove, Weed-Johnson, 1959

As you drive south on verdant Bayshore Drive, the Coconut Grove Bank appears like a brightly plumed tropical bird in a jungle clearing. With its Latin-inflected coloration and Modernist response to the site on a bayside escarpment, the bank building is a unique celebration of MiMo and the landscape of Coconut Grove.

By the 1950s, the bank's original home in Coconut Grove had become too small and lacked access to parking. The location in the middle of the village also could not accommodate drive-through tellers, a sine qua non in the new automobile economy. A prime site was chosen at the prominent intersection of South Bayshore Drive and Twenty-seventh Avenue, on a scenic slope covered by a hardwood hammock.

The new bank, composed of a two-story pedestal with both walk-in and drive-through tellers, and a five-story office superstructure, is as fresh and graphic as any building today. The street facades of the pedestal consist of large panels of floor-to-ceiling reflective glass. The pedestal is capped by a concrete band in a high-contrast,

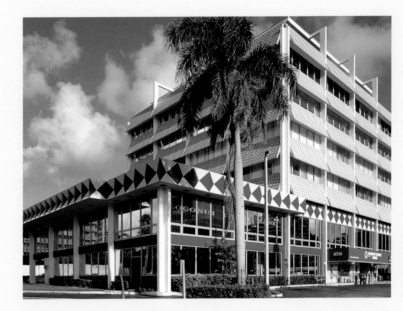

SUPER GRAPHICS: The well-maintained Coconut Grove Bank of 1958 looks as fresh as the day it opened. Decorative diamond and pinwheel patterns on the cornices and louvers give the building a crisp, contemporary quality.

folded-plane diamond checkerboard pattern. In the building's theme of op-art visual devices, the diamond pattern appears to exist in three dimensions.

The brise-soleils are the tower's most visually striking element. Blue-and-white mosaics form rows of circles that seem to spin like pinwheels. Continuous piers rise above the sixth floor to enclose the terraces of penthouse.

While the building is designed to be viewed from the street, beyond the apron of vegetation and parking, its primary entrance is from the parking area located at the top of the escarpment. After finding a space, bank patrons make their way through the wooded hilltop parking area, cooled by bay breezes, to a pedestrian bridge. The bridge leads over the executive parking area to the lobbies of the office building and bank, but not before passing a pleasant covered terrace at the entrance. The entrance terrace and lobbies are on the second floor of the bank, which is approximately at the level of the escarpment. Inside, a metal screen divides the banking lobby from the building lobby.

In the decades since it opened, Coconut Grove Bank has been surrounded by an entire skyline of office, hotel, and residential towers along Bayshore Drive. Like many of the MiMo office buildings on Brickell Avenue, Coconut Grove Bank is now overshadowed by its neighbors. Still, the bank remains a colorful expression of Miami Modern.

Bea and Morris Lapidus Apartment, Apt. 3-I, 3 Island Avenue, Miami Beach, Morris Lapidus, 1960

For anyone with a love of art, architecture, or design, a visit to Morris Lapidus's apartment was always a treat. It was in a building he designed on the Venetian Causeway, and it occupied space on two lower floors, low enough so that the water was no farther than it might be from a stateroom on an ocean liner. In fact, though Lapidus could have had an apartment of any size, he chose to work with compact dimensions for his and his beloved wife Bea's residence.

The first sight upon entering was a teak-veneered spiral stairwell leading down to the lower level. Display niches for the Lapiduses' extensive collection of curios punctuated the cylindrical wall. A descending spiral line of single bulb pendants, in a rainbow of glass globes, hung from the ceiling above the staircase. While the first impression was very midcentury modern, the next was anything but.

The dining room, to the right, shone like something out of a fairy tale or the set of *Barbarella*, or both. The walls of the oblong room were covered in mother-of-pearl. A daintily proportioned colonnade of thin fluted columns, with gilded palm-leaf capitals, created a sense of enclosure and separation from the living area. The Lucite dining table was appointed with Lucite chairs with gilded metal arms and legs. Any meal in this dining room was an event, with its distant echoes of the Prince Regent's Brighton Pavilion. At the same time, the Modernist transparency of the room created a sense of greater space than actually existed.

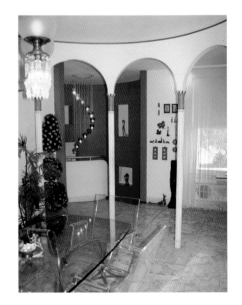

Opposite the dining room, the living area offered a long, low couch with cushions done in a gilded fabric. A shelf at the same height as the back of the sofa was filled with small sculptures, both primitive and modern, collected during the couple's extensive world tours. At the far end, a tall female statue was complemented by three single pendant bulbs in Lucite cubes. The wall behind was plain white marble as a foil to the visual richness. One felt surrounded by mementos of a life lived fully, and assured that there would always be something interesting to talk about in this living room.

The low sofa was one of many devices employed by Lapidus to create the illusion of greater space. The layout of the entire apartment offered lessons in efficient spatial organization. From the living area, the space flowed to a bright alcove filled with plants, a Lucite writing table, and Lucite chairs with gilded members similar to those in the dining room set. Directly across from the couch, against the opposite wall, was a console that camouflaged a television, augmenting the sense of spaciousness.

The den opened between the writing alcove and a panel of bookshelves with compressed arches. The placement of the den in relation to the living area created a disappearing sight line, which fostered the illusion of a larger space. Filling up half the den was a baby grand piano in white with gold trim, covered with dozens of photographs of family and loved ones and of Bea and Morris together. On a wall hidden from the rest of the living area was the hi-fi system. On the opposite wall hung one of Morris's paintings of a lone cardinal with expressive eyes, perched on the edge of a concrete balcony parapet against a cloudless blue sky.

A narrow hallway of compact, nautical proportions led from the dining area to the bedroom. To one side, doors opened to Morris's bath and closet and his collection of bow ties. On the other, a door led to a guest bath in tile and iridescent wallpaper in dark red and purple tones. Part of the wall was covered by a continuous, floor-to-ceiling grid of small photographs.

The master bedroom was a joyous pink fantasy with Mod-Baroque and East Asian overtones. To the left of the doorway was the bed set into an alcove. The bed was simple and spare, to complement the matching nightstands in black lacquer with matching Chinese lanterns above. The opposite wall was a closet behind multiple panel doors in pink with Miami Beach Baroque accents.

The most unforgettable feature was Bea's bath. The mirror was a simple rectangular panel of generous proportions. Surrounding it on all four sides was a garland of gilt leaves and flowers. In each flower shone a twinkle light. The bright, golden effect never failed to uplift.

The spiral staircase led to the lower entertainment level. The first thing to come into view was the cowhide-clad bar. The visual equivalent of the shake-shake of maracas, the bar provided Latin spice to any impromptu gathering. The space flowed to a small dance floor adorned with Morris's narrative paintings. Off this area was another scintillating bathroom. Lapidus sometimes remarked to visitors that he "specialized in bathrooms."

(TOP) The architect at the head of his Lucite dining set.

(ABOVE) An overscaled end table made the space seem grander, rather than diminishing it.

GRAND ILLUSION (OPPOSITE): For his own home, Lapidus preferred to work his space-modulating legerdemain on a small scale. The compact duplex was made to look larger with delicate colonettes and colored globes marking a spiral staircase.

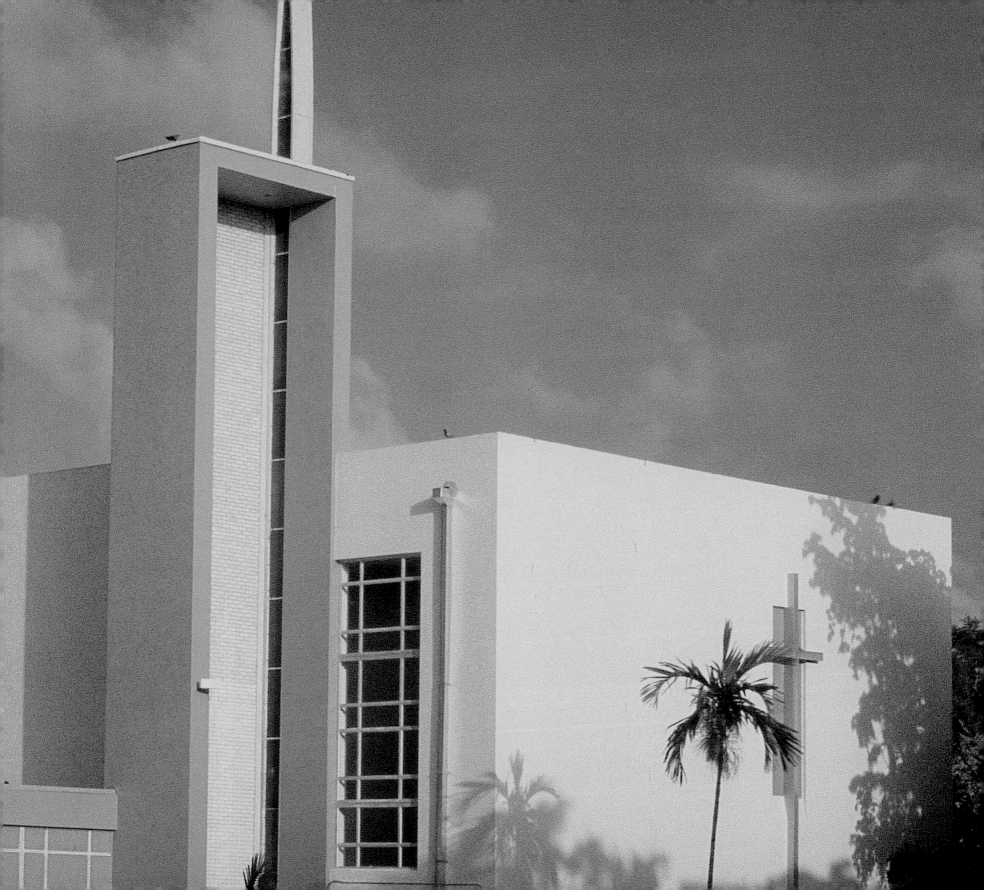

EIGHT

Miami Modern architecture proved flexible enough to express the aspirations of civic buildings as diverse as fire stations, churches, and football stadiums. Classical elements like colonnades and friezes, traditionally used to confer importance, were reinterpreted in a Modernist idiom with specifically regional forms like compressed arches, breezeways, and sun grilles.

Monumental MiMo also followed more general trends in Modernist architecture by using first minimalist and later Brutalist styles for public buildings, but these styles were always modified with tropical elements like screen block and a focus on the blending of interior and exterior space. After the MiMo era, Subtropical Modernism continued as a popular style for institutional buildings like hospitals and government offices.

MIAMI BEACH MONUMENTS

Lincoln Road Mall, Lincoln Road between Washington Avenue and Lenox Avenue, Morris Lapidus, 1960

The heart of Miami Beach developer Carl Fisher's domain was Lincoln Road, which ran down the center of the property given to him in 1913 by Thomas Pancoast to guarantee the completion of the Collins Bridge. Fisher, nicknamed the Fabulous Hoosier and Mr. Miami Beach for the breadth of his accomplishments, envisioned Lincoln Road as a grand thoroughfare that would connect his bayside resorts to the beach and serve as a prestige shopping corridor. Like his Lincoln Highway, the first coast-to-coast motorway, the street was named for his hero, Abraham Lincoln.

At one hundred feet, Lincoln Road was the widest public right-of-way on the Beach. The generous width allowed for double sidewalks, one at the building line for window-shopping, the other at the curb for circulation. A row of coconut palms stood on both sides of the street, imparting a grand tropical effect. Despite the hurricane of 1926, Lincoln Road went on to become the glamorous capital of

consumption Fisher imagined, and the premier names in retailing gave it the sobriquet "Fifth Avenue of the South."

Lincoln Road remained unchallenged as Miami's center of chic until the opening of the Fontainebleau in 1954. Aware of the Fontainebleau's distance from Lincoln Road, Ben Novack made sure that the zoning allowed for sufficient space in his hotel to provide a critical mass of upscale retail establishments. All the major resort hotels of the 1950s followed suit with shopping arcades of their own.

To stem the outflow of sales, the merchants of Lincoln Road taxed themselves to raise funds for a substantial renovation. Morris Lapidus, who helped instigate the decline with his self-contained design for the Fontainebleau, was hired to come up with a plan. Lapidus proposed an open-air pedestrian mall with the slogan "A car never bought anything."

Inspired by the work of the Brazilian Modernist landscape architect Roberto Burle-Marx, Lapidus took cues from the vibrant paving patterns of the broad promenades along Ipanema and Copacabana beaches in Rio de Janeiro. He envisioned black-and-white-striped pavement stretching the entire width of the right-of-way from building face to building face, but budgetary constraints limited him to keeping the original 1920s sidewalks and filling in the asphalt roadway. Other ideas that did not see fruition include a series of bridges to maintain unimpeded pedestrian flow at the cross streets and an elaborate, atmospheric night-lighting scheme.

"I envisioned a parklike mall with pools and fountains and exotic concrete shelters, an open-air-theater-like structure and beautiful landscaping throughout the eight or nine blocks stretching from the ocean on the east to the bay on the west," Lapidus wrote in *Too Much Is Never Enough.* "I was given the commission, one of the first open malls in the United States. In the end, only six blocks were closed to traffic."

The principal nodes of Lapidus's pedestrian mall were the Washington Avenue and Euclid Avenue intersections. An information kiosk shaped like a figure eight in plan once greeted visiors at the Washington entrance. At the Euclid intersection, Lapidus placed a raised oval of lawn opposite a soaring modern-styled band shell, to simulate the experience

A FEW OF HIS FAVORITE THINGS: Morris Lapidus, who was fond of the glamour of nightlife and dress-up and was famed for his collection of bow ties, may have had cufflinks in mind when he designed this folly for Lincoln Road.

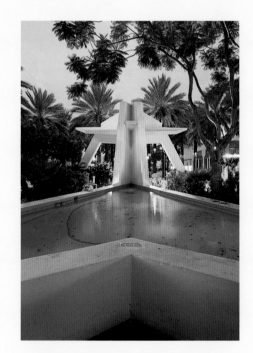

IN PRAISE OF FOLLY: Always ahead of his time, Lapidus was a pioneer in incorporating pedestrian spaces into the urban environment and adapting new idioms. Lincoln Road was inspired by Modernist promenades that Lapidus had seen in his travels in Brazil.

of hearing a concert in the park found in many large cities. From the rear of the band shell, water cascaded down to a delta-shaped pool surrounded by plants. The oval of grass was the only invitation to relax and linger on the mall. To ensure that visitors to the mall shopped rather than simply enjoyed it for its own sake, the merchants asked that all horizontal surfaces be too low or too high for sitting.

A delightful parade of architectural follies marches down the center of the mall. Between Meridian and Jefferson, the most delicate of the follies, a zigzagging canopy, is complemented by equally delicate mature thatch palms. At its western end, the canopy is anchored by a pool in the shape of a long acute triangle clad in rough Keystone. Water jets shoot laterally over the surface of the pool. The visual delights continue unabated all the way to the west end of the pedestrian mall at Lenox Avenue. The delta-wing-angled, woggle, and zigzag forms exhibit the unlimited optimism of world's fair pavilions. Two of these follies even resemble a pair of elegant cuff links.

The pink electric trams that once ran along Lincoln Road can be glimpsed in the background of a shot in the 1967 film *Tony Rome*, where Sinatra places a call from a phone booth.

In spite of the short-term success the new mall brought, Lincoln Road continued to decline. New life came in the mid-1980s, when the South Florida Arts Center opened between Meridian and Lenox Avenues. In the early 1990s, the Miami Beach Community Development Corporation organized a consensus-building process that led to a multi-million-dollar capital improvement program.

A lively debate ensued on whether or not to reopen the street to traffic. The mall's early renaissance, even before improvements, was the winning argument in favor of keeping the road free of cars. Ben Wood, of Thompson & Wood in Cambridge, Massachusetts, was chosen as the lead designer of the renovation and, with consultation from Morris Lapidus himself, successfully retained the originality of Lapidus's work, while retrofitting the streetscape for its new role as South Florida's premier public space.

Warner Building, Mount Sinai Hospital, 4300 Alton Road, Morris Lapidus, 1966

Lapidus's Warner Building is a MiMo folly amid the more sober-sided institutional buildings on the medical campus of Mount Sinai Hospital. Perhaps to draw on positive associations between progress in modern medicine and advances in Modernist architecture, Lapidus chose to add his own sculptural touches to Subtropical Modernism.

Horizontal lines of operable metal louvers, accented by continuous cantilevers at the top and bottom of the window bands, contrast with vertical concrete fins that divide the main facade into six bays. The corners of the pavilion are one of the best expressions of intersecting planes to be found in any MiMo building.

The mass of the building is softened by a setback penthouse with an eye-catching shallow zigzag roof. The cantilevered, arched entrance canopy is a distant relative of Melvin Grossman's 1957 Deauville Hotel porte cochere. As in the Herald Building across the bay, much of the ground floor of the Warner Building is unenclosed, to lessen damage from hurricane floods.

U.S. Post Office, Normandy Branch, 525 Seventy-first Street, H. E. Brown, 1961

Like Francis Hoffman's nearby Union Planters Bank, the Normandy Branch post office reflects America's midcentury image of itself. Through the Depression, post offices were often the grandest edifices in small towns, symbols of the power of the distant federal government, like an outpost of imperial Rome. In the postwar era, America presented itself, on the home front at least, as a friendly and open government of the people, reflected in the more modest scale of its institutions.

Brown's long, horizontal one-story building recalls the austere proportions of Mies's Barcelona Pavilion of 1929. The building balances a variety of forms and spaces: the solid wall, the open space supported by a pillar, the screen-block panel, the glass-enclosed volume, and the open space of the cantilever. Balance and proportion are also precise. The heavy Keystone wall on the east visually counterbalances the open space on the west.

North Shore Band Shell, 7251–75 Collins Avenue, Norman M. Giller, 1961

Situated in a landscaped park in a bend of Collins Avenue, the North Shore Band Shell is a futurist take on a Roman amphitheater. A circular, head-height wall is penetrated by three double-height gate structures that function as ceremonial pillars. Two side gates consist of two curved walls, forming cylinders that support disk-shaped concrete canopies. The disks have the effect of compressing space before the release of the open-air theater, a contrast often employed by Frank Lloyd Wright. The central gate, which frames the stage, is topped by a low strut and a crow's-nest-like balcony. The close-set circular walls of the gates seem to embrace you individually as a citizen.

The stage updates trabeated construction with a convexly bowed proscenium neatly supported on either side by twin piers that pierce the cornice to present symbolic capitals. Two screen-block panels with quarter-moon recesses flank the stage.

Temple Menorah, 620 Seventy-fifth Street, Gilbert M. Fein, 1951; Morris Lapidus, c. 1960

MiMo synagogues are as prevalent as mezuzahs on doorways of older Miami Beach apartments, but few are as visually prominent as Temple Menorah. Its tower, covered on four sides with

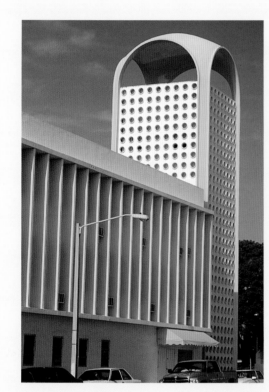
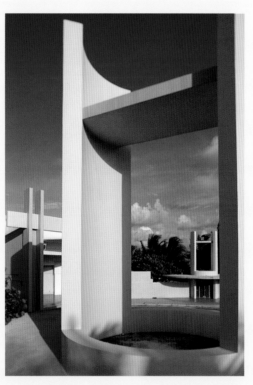

METRO MIMO: The MiMo vocabulary was fluid and expansive enough to provide for the synagogue Temple Menorah **(LEFT)**, with its vertical louvers and tower decorated with cheesehole screens, as well as the North Shore Band Shell, **(RIGHT)** a space-age update of a Roman amphitheater.

bank of screen-block panels. A Y-shaped stairwell canopy projects above the parapet. This simple, yet sophisticated composition is an evolution of Miami Beach's masonry vernacular dating back to the mid-1930s.

Surfside Community Center, 9301 Collins Avenue, Surfside, Francis R. Hoffman, 1962

One of the showiest MiMo civic buildings, the two-story Surfside Community Center provides a razzle-dazzle image of carefree fun in the sun. The basic shape of a rectangular box is enlivened by a zigzag-roofed arcade on the principal facade. The diamond-sectioned columns of the arcade are largely obscured by foliage that now reaches the canopy, but this no doubt fulfilled the architect's vision of Modernist architecture in harmony with its subtropical surroundings.

At its center, the Modernist colonnade frames a town seal large enough to be seen by passing motorists. The seal marks a central breezeway leading to the town pool on the beach side. In addition to a pool, the town library, a tourist information center, and a snack bar, the community center offers meeting and banquet rooms with names like Reef Room, Captain's Room, Clamdigger's Room, and Lanai Room.

decorative cheeseholes, rises from the low, dense multifamily residential fabric of the North Shore neighborhood. At its base, the tower is anchored to the main facade by an open staircase, which provides exterior access to the upper floors.

The temple presents a dual image: its primary facade features tablet-shaped arches filled with stained glass, while the north facade offers vertical masonry louvers that run the length of the second and third floors. The spare rear wall is articulated with an arced section that expresses the space of the sanctuary. Next to it, the fire escape is demarcated by a vertical

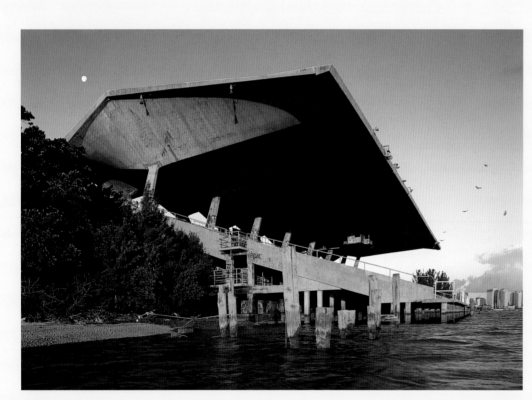

MONUMENTAL MIMO: The cantilevered concrete shell of the Miami Marine Stadium grandstand of 1963, once used for viewing speedboat races, stands like the ruins of a heroic age on the waterfront of the Rickenbacker Causeway.

MIAMI MONUMENTS
Miami Marine Stadium,
1900 Rickenbacker Causeway, Pancoast, Ferendino, Spillis & Candela, 1963

The Miami Marine Stadium is an extraordinary relic, like the ruins of the Coliseum in present-day Rome. The jungle is reclaiming the massive concrete structure. Palm trees grow in the main entry gate, and vines have split the concrete flooring. The walls are splashed in savage graffiti, but the stark beauty of the structure still shows through.

The stadium was built like a wharf directly into the water of an inlet on Virginia Key to provide a venue for watching speedboat races, a sport that now seems as superannuated as chariot racing. The grandstand is a triumph of structural expression combined with MiMo flair. Eight cyclopean-scaled sets of V-shaped piers support the folded concrete plane of the grandstand, providing tiers for seating.

Seen from either side, the daringly cantilevered roof and the grandstands, which extend over the water supported on pylons, form a giant C-shape. The cantilever design placed the supporting posts well to the rear of the stands, so that unobstructed views were available from most seats. The roof appears to float unsupported over the grandstand. The massive sheets of concrete are folded as delicately as origami, accentuated by the subtly tapered width of the piers and the folded edges of the triangular bays above the beams.

The stadium can be seen in its prime in the otherwise forgettable Elvis Presley musical, *Clambake* (1967), featuring footage of the Orange Bowl Regatta speedboat race.

In interminable water-skiing sequences and wooden musical numbers, Elvis was

just going through the motions, too bored even to ogle the wiggling bikini bottoms.

Robert King High Towers,
1403 Northwest Seventh Street,
Smith & Korach with Pancoast, Ferendino,
Spillis & Candela, 1963

Martin Fine, head of the City of Miami Housing Authority from 1956 to 1960, produced one of Miami's finest Subtropical Modern ensembles, a watershed in public housing for the elderly. Named for former Miami mayor Robert King High, the complex consists of a thin, thirteen-story apartment superblock, an administration building, a recreation building, and a community building added later, set on a rolling, wooded riverside site.

The apartment block is divided into three segments joined by two elevator cores. The apartments open to the northwest and are accessed by open galleries with views of the Miami skyline to the southeast. The west face of the superblock is dominated by the floor-to-ceiling, operable metal louvers of the apartments.

The apartments were designed to function comfortably without air-conditioning. (In 1997, in response to outcry from residents,

the housing agency installed room units throughout.) The galleries are faced with individual panels of aggregate river rock that appear to float between the piers of the east facade. The fire escapes parallel to each elevator core and at the ends of the superblock are faced in concrete panels molded to form rough-textured vertical ribbing. Continuous vertical ribbon windows create subtle separation of the planes encasing the fire escapes.

Orange Bowl Mosaics, 1501 Northwest Third Street, artist unknown, 1963

The Orange Bowl Football Classic and Parade began in the 1930s as part of Miami's perennial winter tourism promotions to compete with California's popular Rose Bowl festivities. The original 25,000-seat stadium was built in 1936 as a WPA project and was expanded in 1948 and 1955 to 68,000 seats.

A million-dollar renovation in 1963 included a new 8,600-seat grandstand, which provided the stadium's principal facade. The facade is faced in vertical banks of precast screen block, with a triptych of tile mosaics depicting football, baseball, and the performing arts in an abstract style. The football panel is a diagrammatic representation of a coach's classic X's and O's as a transistor. It can be read as a syncretic image of the forces at work in South Florida during the New Frontier era: the space race, the military-industrial complex, the transformation of sports into mass electronic entertainment. It is a counterpart to James Rosenquist's mural, *F-111*, which visually links the consumer culture of hair-dryers and canned spaghetti with mushroom clouds and fighter planes over Vietnam.

The Orange Bowl's turf was the site of great gridiron moments like Joe Namath's promised victory for his underdog Jets against the Baltimore Colts in Super Bowl III in 1969. The University of Miami's Hurricanes have a contract to play here through 2010, but the Orange Bowl Classic left for Pro Player Stadium on the Miami-Dade and Broward County line in 1997, along with the Miami Dolphins in 1986.

On a balmy, late December morning less than a year before he was assassinated, President Kennedy welcomed an emotional reunion of the veterans of Brigade 2506, the survivors of the 1961 Bay of Pigs disaster. "Cuba shall one day be free again, and when it is, this Brigade will deserve to march at the head of the free column," the forty-five-year-

CHALK TALK: Like the narrative billboard art of James Rosenquist, the mosaic graphics for the Orange Bowl of 1963 by an unknown artist can be read as schematics for New Frontier concerns of space, technology, and nationally televised sports as a consumer item.

old president proclaimed. He lofted the flag of the failed mission and promised the crowd of thirty-five thousand Cuban refugees, "I can assure you that this flag will be returned to this Brigade in a free Havana."

Miami-Dade College, Kendall Campus, 11011 Southwest 104th Street, Pancoast, Ferendino, Grafton, Spillis and Candela, 1967 and ongoing

Miami's own brand of Subtropical Modernism reaches its peak in the Kendall Campus of Miami-Dade College, whose chief architect has been the Cuban émigré Hilario Candela. The horizontal lines of the campus seem to rise organically from the flat limestone earth and lush verdure of the Kendall area. The human-scaled campus successfully blends Modernist, Classical, Japanese, and local influences into a unified architectural statement that remains fresh nearly four decades after the initial buildings were completed in 1965. The latest addition, the Fine Center for the Arts completed by the firm of Spillis Candela DMJM in 2000, brings the Subtropical Modernist tradition into the present.

The reliance on exposed concrete is indicative of the direction Modernist architecture took in the 1960s. But the combination of the material with Miami oolite, glass mosaic tile, and terra-cotta-colored Cuban floor tile reflects a broad spectrum of local influences from pioneer vernacular to Resort MiMo. The adept manipulation of concrete into myriad textures and fluid forms distinguishes the campus from the Brutalist exposed-concrete architecture popularized by Louis Kahn and Marcel Breuer.

The campus's most distinguishing feature is the attention throughout to climatic adaptation. From the ubiquitous use of vertical concrete fins and metal sun grilles around windows to the extensive cantilevering of upper over lower floors, the campus is superbly suited to the warm, rainy weather. The border between interior and exterior is effectively erased because most of the internal circulation and gathering spaces are open to the elements.

The original campus buildings are connected by covered walkways that form unexpectedly urban spaces between them. Landscaping is fully integrated into the design, and its maturity has further softened the graceful, Japanese-inflected lines of the architecture.

Candela, who arrived from Cuba in the 1950s and joined the illustrious local firm of Pancoast, Ferendino, Skeels & Burnham, exhibits a rare ability to adapt Modernism to the subtropical climate and to impart a human-scaled, urban character within an undeniably Modernist framework. The architect brings to the fore a grasp of tropical architecture that is an integral part of Caribbean culture. Shaped by Havana, the only preindustrial city in the region, Candela brought a sense of pedestrian-oriented urbanism that was being sacrificed in Miami to the time-space-warping effects of the private automobile.

Former Pan Am Training Facility, Miami International Airport, 4900 Northeast Thirty-sixth Street, Steward-Skinner Associates, 1963

The former Pan Am Training Facility, known affectionately as the "Taj Mahal," is a gilded, jewel-box-scaled tribute to Edward Durell Stone's U.S. Embassy in New Delhi of 1958. Stone's treatment of lacy screen block and his attempt to elevate the material to the realms of High Modernism were enormously influential on Miami architects.

Both the Taj Mahal and Stone's embassy are single-story pavilions raised on a plinth, crowned by wide-eaved roofs. While Stone cited the Taj Mahal as his inspiration and strove for Classical restraint, the architects go for the glitz with gold anodized-aluminum columns and piers of concrete screen block. Behind the screen block are bays of small, head-height windows punctuated by gold anodized-aluminum piers.

The whole building plays on the trapezoidal shapes of the screen block. There are trapezoids everywhere: the shape of the concrete planters that line the balcony and the squat legs that support the planters, the door handles, and the beveled soffit of the canopy that extends through the lobby to form a canopy on the inner courtyard. Even the delicate brass railings of the floating staircase in the lobby form trapezoidal shapes. The courtyard centers on a fountain and its walls are covered with large, square panels displaying the Pan Am globe insignia.

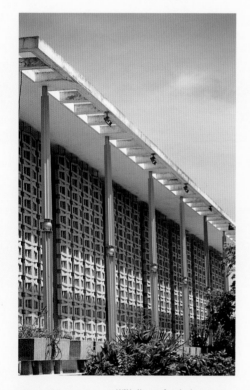

STONE TEMPLE (ABOVE): With its perforated screen-block facade, the former Pan Am Training Facility was influenced by Edward Durell Stone's U.S. Embassy in New Delhi. Sunlight creates myriad patterns of shadows through the use of screen block and cutouts in flat eaves.

(LEFT) Detail of a delicate corner formed by cutouts and decorative columns.

The ornamental qualities of the screen-block panels spring to life when the facades are hit by direct sunlight. The openings in the screen block and the rectangular cutouts in the eaves cast trapezoidal shadows until the building's image blurs in an ever-shifting basketwork pattern of sun and shadow. The alchemy of sunlight turns the Taj into a sculptural object that interacts with its environment. The acute angles not only are built into the design, but also channel sunlight into similar patterns.

Jet-age angles are appropriate for an airline building. The resemblance to the New Delhi pavilion makes you think of far-off places that an airline serves, and the flanged ball-and-socket columns suggest the aviation technology to take you there.

Temple Judea, 5500 Granada Boulevard, Coral Gables, Morris Lapidus, 1967

At Temple Judea, across U.S. 1 from the University of Miami campus, Lapidus employed compressed arches as the synagogue's central structural element. Synagogues display a variety of architectural traditions, often conforming to the locale and epoch in which they are built. Even the Temple of Solomon was built in the prevailing style of the Roman rulers of Jerusalem.

Lacking historicist references, Modernist synagogues instead employ metaphors. The story of the Jews before the founding of the Temple was of a nomadic, desert people, so tents are a central metaphor. Lapidus's arches suggest tents, which serve as both structure and symbol.

Elizabeth Virrick Park, bordered by Day Avenue, Hibiscus Street, Oak Avenue, and Plaza Street, Kenneth Treister and Richard Schuster, 1960–2003

Kenneth Treister's enthusiasm for social projects becomes evident in a tour of Elizabeth Virrick Park, a community center in a black section of Coconut Grove, one of the poorest neighborhoods in the United States. He knows everyone by name, is familiar with all the details from the number of functioning sprinkler heads to progress on the tiling of the walls, and shows off the features of the gymnasium as if they were new toys.

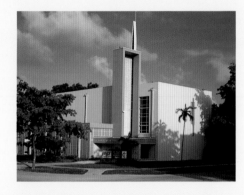

HEAVEN'S DOOR (ABOVE): A collage of rectangular volumes rises from the lush suburban landscape of North Miami at St. Paul's Methodist Church, designed by Robert Fitch Smith in 1958.

DIGGING THE GARDEN (OPPOSITE): Kenneth Treister's Gunite-and-wire-mesh "flower" sculptures in Virrick Park look like an early manifestation of psychedelia, but were inspired by his young family.

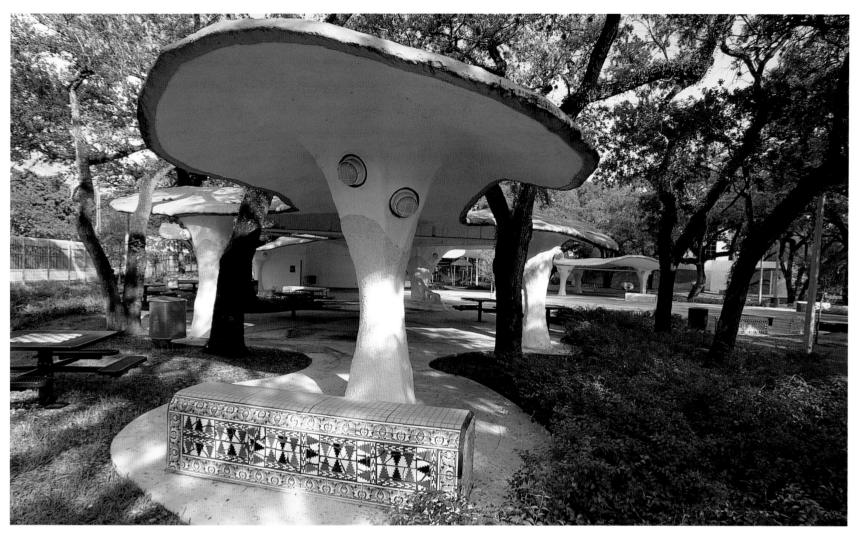

Treister threw himself into the project in 1998, when he found the park that he designed in 1960 had fallen into disuse and ruin due to crime, weeds, and graffiti. He helped raise a half-million dollars in public money to build a gymnasium and a theater complex, with Schuster serving as the architect of record. The park provided the first community center in Miami's nearly one-hundred-year history.

"It was so exciting the other night. They had two high schools playing each other," he said, lighting up. "They had cheerleaders and referees with whistles, they had scoreboards so we could keep track of the score. I couldn't believe it."

Treister designed the giant, petal-shaped concrete structures in the center of the five-acre park in 1960. The flowers are sixty-foot-long cantilevered concrete panels supported on columns. Treister and his engineer raised steel-ringed, metal-mesh forms with a crane and sprayed them in place with Gunite, a type of cement used to make swimming-pool shells. The forms have a childlike sense of play that he attributes in part to having young children of his own at the time.

One delightful anachronism is an oversized Gunite frame for a television set. "In the early days of television, people in this block didn't have television," he says. "We used to sit here in chairs and watch television. This is historic."

AUTOBIOGRAPHY OF A HOUSE

The home an architect builds for himself can be considered a form of autobiography. Kenneth Treister, who identifies with the Coconut Grove school of architecture, which falls under the wide umbrella of Subtropical Modernism, has lived on the same property with his wife, Helyne, since he was a struggling architect forty years ago. As his career and thinking evolved and matured, so did his house.

A tall, effusive man with wide-ranging interests, Treister meets his guest at the front gate and straight away launches into a discourse on his passion, courtyard housing. "This is a Chinese or Japanese idea, where you do not see the front door," he says, leading the way through an interior maze covered by an open trellis of Brazilian ironwood, past a reflecting pool blooming with bougainvillea, orchids, staghorn, elkhorn, and tall palms nurtured from saplings. "You go through a series of spaces, each one different, some small, some tall, some wide."

The foundation of Treister's architecture lies in circumscribing the lot with a high wall for privacy, like an Indonesian kampong. "The beauty of this concept when you walk in," he says, "is that you have infinite variety of architectural designs—shapes, geometry, color, texture—within that wall." The sun throws slanted shadow patterns from the trellis on the walls, and maidenhair ferns have found a congenial eco-niche in the crevices of the oolite walls.

Courtyard housing returns to the Classical idea of man as the measure of all things. "Not only do the interior rooms seem bigger, but they are private, more secure and friendlier, and in human scale," Treister points out. "If we were outside in a typical backyard, the scale is to a neighborhood, to telephone poles and another house and roofs, so a human looks smaller. Here, you're relatively larger. The human becomes bigger and the environment becomes smaller."

Treister has had a varied career—he designed the Gaudíesque 1980s Mayfair shopping complex in Coconut Grove and developed the successful concept of "turnkey" housing—but he feels that the idea of a walled enclosure never caught on. "People want to see their homes from the street," he says. "It's called curb appeal. People want to have their wealth displayed." Curb appeal is the essence of one brand of MiMo, which like a 1953 Oldsmobile Rocket 88 was designed to look fast even when standing still, but the Coconut Grove school of custom-designed residences is more inward facing, private, and exurban.

The first view of the house beyond the heavy wooden doors that Treister carved himself could be a spread from *Florida Architecture* magazine, circa 1960. Planks of stained-gray Chilean cypress lead the eye up to a clerestory. The far wall of the living room is made up of forty-foot-long, eight-foot-high plate-glass panels and sliding doors, with a view beyond of a sunny, plant-filled deck under a mesh cover. Johnny Mathis filters softly from hidden speakers.

As a young man, Treister designed the house on an eight-foot module, so that he could convert screened-in sections into walled rooms as his family and fortunes expanded. Later he built an art studio on the roof high in the treetops. The

result is a complex, organic piece of work that seems to have been grown rather than planned.

"Real architecture of quality has to be lived in," Treister says. "It has to be enjoyed over a period of time. It's better to grow up in a complicated or intricate house." Treister's three children, two of whom are practicing architects, had the benefit of growing up here as the house evolved: the reflecting pond started out as a concrete space for riding bicycles and later became a basketball court, and finally a pond when they went off to college.

The house is a textbook of the Coconut Grove style, the foremost exponent of which is Alfred Browning Parker. Other practitioners include Rufus Nims, George Reed, Bob Brown, Earl Starnes, and Joe Rentcher. Born in 1930 and raised in Miami Beach, Treister received a degree in architecture from the University of Florida.

"There was a school of a few architects who were not mainstream who were trying to create a tropical architecture," Treister says. "It was a school to the extent that we knew each other, we used the same craftsmen, we used the same builders." Commonalities include an emphasis on custom-designed homes rather than commercial buildings, the use of jalousies for privacy and ventilation, and the use of wood. Frank Lloyd Wright remains a hero to the Coconut Grove architects.

Treister is an architect with a social conscience. In the go-go period of the 1960s, he made a conscious decision to turn his back on the more glamorous and profitable field of designing high-profile homes for the rich to work on public housing. "I studied the field and came up with the idea that instead of having the government build public housing, which was expensive, ugly, prisonlike, and cost a lot of time and money, the architect and developer would team up in a slum area and buy land."

Competitions were held for the best design, the projects were built and then turned over to the city so that the "government wouldn't be involved in the building," Treister notes. "It was really privatization before its time. It worked for many years. The whole country became interested in turnkey public housing, so I made that contribution."

NINE

Fort Lauderdale, which features a museum-quality selection of MiMo architecture, is facing a midlife crisis at the age of fifty. Many of its MiMo structures are now of an age that allows them to be historically designated and protected at the same time real-estate pressures are bringing about their demolition at an unprecedented rate.

In the heart of the beach district of Birch Waterfront Estates, twenty-one of eighty-nine postwar apartment and motel buildings have been torn down, eight within the past six years, and the rate of demolition is accelerating, according to the Broward Trust for Historic Preservation. The Art Deco Lauderdale Beach Hotel at 101 South Fort Lauderdale Beach Boulevard was the first major resort on the beach built after the beginning of the Depression, and once served elite clientele including President Harry S. Truman. In a less than Solomonic compromise, the developer and the city agreed in 2003 to preserve the hotel's ocean facade and public interior spaces.

Preservationists Diane and Bill Smart live in Birch Tower in the beach district, the center of the storm both physically and politically. Diane Smart says that the trust needs to educate the public about the virtues of twentieth-century architecture. "The Lauderdale Beach Hotel is our only Deco building, and no one knew anything about it," she says. Preservation presents special problems in Broward, "because we're a very young county compared to Miami-Dade and Palm Beach."

The history of Fort Lauderdale is the story of Miami on a more modest scale. There is a similar cast of quixotic characters—seers, celebrities, and crooks—confronting a landscape by turns paradisiacal and pitiless. Like Miami twenty-six miles to the south, Fort Lauderdale originated as a military outpost at the mouth of a river during the Second Seminole War, in this case a fifty-by-sixty-foot picket fence fort on the New River named for its commanding officer, Major William Lauderdale, on March 16, 1838. The settlement is so new that it can identify its first permanent resident: a civil engineer named William C. Valentine, who drowned in the New River before the town was incorporated on June 2, 1911.

A onetime roustabout and gunrunner with the immodest sobriquet of Napoleon Bonaparte, Broward was elected governor in 1904 and saw the potential in the land surrounding Fort Lauderdale if the nearby Everglades could be drained. The black muck beneath the shallow, brackish water and sawgrass was said to be the richest soil in the world outside the banks of the Nile.

During Prohibition, Fort Lauderdale flourished with rum-running. Al Capone, an avid sport fisherman, came up from his suite at the Biltmore in Coral Gables when the tarpon were running. The city offered pari-mutuel betting and gambling in plush private casinos owned by Meyer Lansky and his brother Jake, until it was cleaned up by the Kefauver Committee in 1948.

In the 1920s, the city was famed for its "surf bathing," as well as its game fishing and yachting. The New River, "the deepest river of its length in the world" with a sounding of 140 feet proved ideal for pleasure craft.

Fort Lauderdale underwent a similar cycle of boom and bust as Miami, when the balloon of real-estate speculation was abruptly punctured by the 1926 hurricane. Unlike in Miami Beach, the Depression in Fort Lauderdale lasted up until the war, so

the city has few Deco structures. Postwar prosperity had a relatively greater impact on the small town. Scarce housing lots quadrupled in value because of the unprecedented demand by returning vets.

"Money was far more plentiful than there were attractive ways to spend it," wrote Philip Weidling and August Burghard in their history of Lauderdale, *Checkered Sunshine*. "The winter season of 1945–46 was one of new and bewildering prosperity. Never had so many people, with so much money, descended upon Fort Lauderdale."

Like Miami, Fort Lauderdale served as a military base, and returning Navy personnel made their homes in neighborhoods such as Victoria Park, which mushroomed in the

postwar period. Whole sections of Fort Lauderdale were platted and developed in a few years, so that the architecture is uniformly MiMo. Fort Lauderdale's equivalent of Condo Canyon rose along the Galt Ocean Mile, and High Modernist houses still dot the verdant residential neighborhoods west of the Intracoastal Waterway.

Although Miami managed to hold onto its downtown core throughout the postwar expansion, Fort Lauderdale simply sprawled along Federal Highway and its east-west boulevards, producing a vast landscape of Modernist shopping centers and small office and commercial buildings. Entire streetscapes along the man-made islands off Las Olas Boulevard remain virtually intact, including signage and decorative details of beanpoles, sun grilles, angled roofs, and framed windows.

Fort Lauderdale became imprinted on the national consciousness for originating the postwar rite of sun, sand, surf, sex, and suds known as spring break. The origins of spring break are steeped in mythology, or at least clouded in an alcoholic fug, like the experience itself. Some historians attribute it to the tame beginnings of the National Collegiate Athletic Forum, a Christmas convention formed in 1935 to promote winter collegiate swimming in Florida. Others say it was a Johnny Appleseed of a publicist, who papered midwestern colleges with brochures. A more likely explanation is that veterans stationed at Fort Lauderdale during the war who attended college on the GI bill returned as the first spring breakers.

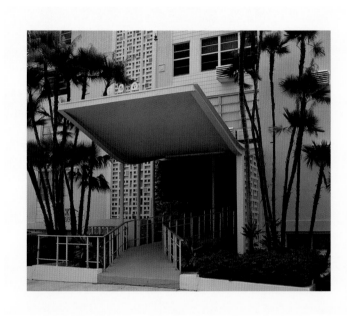

MAKING A GRAND ENTRANCE (LEFT):
Charles F. McKirahan's exuberant entryway
features a rising cantilevered canopy, screen-
block panels, and a fanciful ramp like a moat
bridge leading to a landscaped grotto.

A DIFFERENT SLANT (OPPOSITE): Because
of rapid postwar expansion followed by a
period of benign neglect during an economic
downturn and now a committed conservation
movement by the Broward Trust for Historic
Preservation, Fort Lauderdale may still
maintain its midcentury feel.

In 1960 the phenomenon reached its peak of recognition when Glendon Swarthout's
mawkish drugstore novel was made into *Where the Boys Are*, the *Citizen Kane* of spring-
break movies. For decades, Fort Lauderdale was almost as much a rite of spring for thou-
sands of college students as when Yvette Mimieux and Connie Francis made the scene at
the Elbo Room and cruised Ocean Boulevard in low-slung foreign convertibles.

One architect in particular puts Fort Lauderdale squarely on the MiMo map: Charles
Foster McKirahan. Best known for the Castaways Island Hotel in Sunny Isles—which a
contemporary writer noted was "all that Oriental and Collins Avenue architecture have
to offer"—McKirahan traveled widely in the South Pacific after the war and was broadly
influenced by his work with Oscar Niemeyer for the Modernist city of Brasília. Born in
Oklahoma in 1920, McKirahan received his degree in architecture from the University of
Illinois. He died young at the age of forty-four.

Fort Lauderdale's Modernist treasure trove cries out not only for preservation but
for a book of its own. As a first step, Smart and her colleagues are looking to document
all the postwar buildings by date and
architect. A group of hoteliers is dedicated
to maintaining the village-scale charm of
the small postwar beach hotels and making
Fort Lauderdale Beach the Modernist coun-
terpart to Deco's South Beach.

The Jolly Roger, (now Ramada Sea Club Resort), 619 North Atlantic Boulevard, Tony Sherman, 1956

The shipshape Jolly Roger blends space-age
Modernism with Populuxe embellishments.
With its portholes and mastlike spire, the Jolly
Roger is nautically inspired, but the incorpo-
ration of spiral motifs both inside and out
take it to a different plane. The interior
space is vertiginously intersected into a
split-level base and a double-height tower,
which is ascended by a garagelike ramp.
Porthole windows peek out from the
Keystone base.

Manhattan Tower, 701 Bayshore Drive, Charles F. McKirahan, 1953

With its lighthearted, fifty-foot-tall circular
tower constructed of steel pipes, McKirahan's
Manhattan Tower is a sparkling seaside folly.
The apartments were built as a winter
retreat for General Motors executives, and

the tower incorporated the Frigidaire logo, a former GM division and a symbol of air-conditioning. The whimsical turret contrasts with the clean-lined International Style integrity of the interiors. In a central apartment that now serves as a library for the boutique hotel, narrow, floor-to-ceiling jalousies that meet at pillarless corners define a V-shaped space with extraordinary views of the Intracoastal Waterway.

Birch House, 600 North Birch Road, Charles F. McKirahan, 1959

The entrance to McKirahan's apartment building expresses all the joie de vivre of postwar America. The upturned canopy seems to soar magically in the air, welcoming you home, while a zigzag ramp spills forth from the entrance. The grottolike Keystone entryway features a waterfall.

Birch Tower, 3003 Terramar Street, Charles F. McKirahan, 1960

Along with its seven-story adjunct the Birch House, the luxury eighteen-story Birch Tower was the dernier cri in technology on the New Frontier when it opened for tenants in January 1961, just in time for the Kennedy inauguration. Developer Leo Goodwin, who made his fortune founding Geico Insurance, proudly declared that with the building's advanced central air-conditioning, "You will be able to dial your own weather!"

With Cold War jitters at their height and because of Florida's proximity to Cuba, Goodwin ordered astonishingly robust exterior walls: a foot of concrete, reinforced with steel rods and able to withstand a hurricane or an atomic blast. Birch Tower was briefly the tallest building in South Florida.

The architect is known for the Brazilian influence on his structures. The enormous V-shaped columns supporting the building above an open breezeway are stylistically reminiscent of Niemeyer's tropical-inflected Modernism in Brasília. The columns transfer the load and wind-shear forces to single piers, driven seventy-five feet down through limestone to bedrock. Intact period details still delight: the backlit, eighty-foot-tall signage on the elevator tower, the Pop-Baroque grace figure outside the lobby, and the building's initials in bronze on the elevator doors.

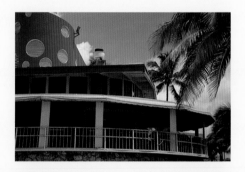

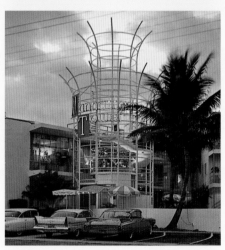

FABULOUS FORT LAUDERDALE (TOP): The Jolly Roger, a MiMo twist on marine imagery, has been a landmark on the beach since 1956.

(ABOVE) A vintage image of Manhattan Tower, the architectural equivalent of the tail-finned cars parked in front.

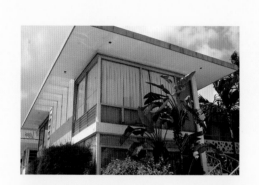

PRIMO MIMO (TOP): Charles F. McKirahan's unerring eye for proportion and simple, elegant materials is seen in his Sea Chateau Motel of 1959, with its glass walls and cutouts in thin, flat eaves.

(ABOVE) Open circles in the metal railing of the Sea Chateau's floating staircase contrast with the cheese-hole cutouts of the second-floor balcony.

Sea Chateau, 555 North Birch Road, Charles F. McKirahan, 1959

This small-scale motel, with its exquisitely proportioned flat, cantilevered roof and glass-walled second story, is one of the most elegant of MiMo compositions. Touches of color like the pink mosaic tile wall and the minimalist play of light created by cutouts in the eaves are at once simple and sophisticated. The railings and balconies feature some of the most exquisite cheeseholes in all MiMo. Appearing as thin circular outlines in the railings, they contrast with perforated concrete in the balcony parapets to create a harmonious play of solid and void. Nearly every Resort MiMo element is included, perfectly executed and preserved, from the original marble floors to the pink Cuban tiles of the patio.

Best Western Marina Inn and Yacht Harbor (originally American Motor Inn), 2150 Southeast Seventeenth Street, McKirahan & Russell, 1965

The American Motor Inn, with its extraordinary seven-pointed folded-plane concrete roof, was completed shortly after McKirahan's untimely death and was designed either by the architect or by his partner Richard Riley. Tucked below the bridge of the Seventeenth Street Causeway, the motel works a dozen MiMo motifs simultaneously: sail shape, manta ray, Panama hat, even hyperparabolic tiki hut. The roof is a wild roller-coaster ride as it swoops and dips like a circus tent and thrusts into space in jutting peaks. The two-story pavilion brilliantly contains positive and negative space, with a glassed-in lobby on one side and an open porte cochere on the other.

Schubert Resort, 855 Northeast Twentieth Avenue, Lester Avery, 1953

Built on the site of the Clyde Beatty Jungle Zoo, Fort Lauderdale's first tourist attraction from the Depression, the Schubert Resort is a splendidly restored example of Motel Modern. All the stops are pulled out here, from the delta-wing-shaped movie-marquee-like street sign to the floating staircases and geometric pool. The Schubert was substituted for the Hampton House in Michael Mann's period film *Ali* in 2001.

Sea Tower, 2840 North Ocean Boulevard, Igor B. Polevitzky, 1957

Polevitzky designed this airy, eleven-story condominium with a boomerang footprint and cantilevered floor slabs extending out from all sides in a pattern he used two years later in the the Habana Riviera Casino built for Meyer Lansky in Cuba. The building's half mile of cantilevered balconies feature filigreed screen block that casts cool shadows on the floors below. The canopy, like a sketched line, has an ethereal feel.

Las Olas Citgo Service Station, 2366 East Las Olas Boulevard, William Crawford, 1954

The canted glass walls, surprising cutout spaces, and diamond motif of this gas station offer the visual excitement of Albert Frey's famed hyperparabolic-canopied gas station in Palm Springs, California. The interior of this station, managed by three generations of the same family since 1961, is in museum condition, with the original terrazzo floor, wood cabinetry, and Formica-topped desk.

Sheraton Fort Lauderdale Yankee Clipper, 1140 Seabreeze Boulevard, Tony Shermann, 1955

Resembling an ocean liner, the jaunty Yankee clipper continues the architecture

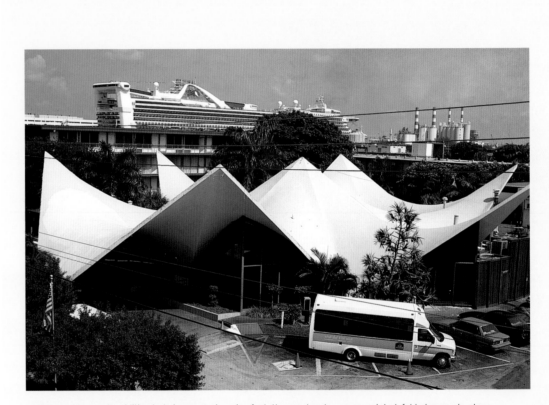

CONCRETE ORIGAMI: In addition to being an engineering feat, the spectacular, seven-pointed, folded-concrete plane roof of McKirahan's American Motor Inn of 1965, completed after the architect's death, lends itself to manifold tropical interpretations, from Panama hat to catamaran.

parlante tradition of seaside resorts. From its dynamic flatiron footprint to the mast on top, the motif is thoroughly nautical: the cantilevered, spritlike balconies aft, trig railings, small, square porthole windows port and stern, and long decklike balconies aft. The large signage recalls 1920s supergraphics.

Mai-Kai Restaurant, 3599 North Federal Highway, George Nakashima and Florian Gabriel, interiors, 1956

The Mai-Kai Restaurant is one of the most perfectly preserved temples of tiki in the United States and is distinguished by having the longest continuously running Polynesian floor show in the country. The temple is particularly delightful because it features that oxymoron, "authentic tiki"—real relics dragged in from all over the Pacific to represent a unified culture that existed only on a Hollywood sound stage. In fact, the restaurant's gift shop, a must for raiders of the lost tiki, is said to have once been a movie set. Here you will find such diverse tiki artifacts as Mexican jaguar gods, Balinese dancers, and Dorothy Lamour–style sarongs.

A true feast for the senses, the Mai-Kai features a sunken galleon bar, high-quality black velvet paintings, and a floor show of "fierce warriors performing the spectacular fire-knife dance" and "lovely island maidens swaying to music of native drums and ukuleles," according to the restaurant's promotional materials, along with a vaguely Chinese menu with the requisite PuPu Platter and drinks including the Zombie, Jet Pilot, and Shrunken Skull (the Maru Amu comes in a souvenir ceramic tiki mug).

The gardens are the most outstanding feature, with a bridge and tranquilly flowing waterfall under the marvelous primitive-modern syncretic image of a cantilevered, delta-wing-shaped Polynesian gable. Dramatically lit tiki figures, those "uncouth jolly-looking images," as Melville called them in *Typee: A Peep at Polynesian Life*, stand guard in a mazelike garden, an objective correlative for the return to the primitive unconscious.

The restaurant was built by two brothers from Chicago, Bob and Jack Thornton, who hired the premier Polynesian designers of the era, George Nakashima and Florian Gabriel. Over time, it was expanded from a four-room hut to a village compound of eight dining rooms. Bob Thornton's wife, Mireille, who came from Tahiti, choreographed the Polynesian revue. The restaurant was also widely known for its bikini-clad handmaidens, shown in calendars and in an 8mm color movie featuring saronged serving girls performing the "Mystery Drink Ritual."

HOLDING THE FORT: Finely preserved examples that show the vitality of Fort Lauderdale's MiMo legacy include the Schubert Motel (TOP), and the immaculate Las Olas Citgo Services Station (ABOVE), with its low fieldstone parapet, canted plate-glass walls, and long, horizontal canopy.

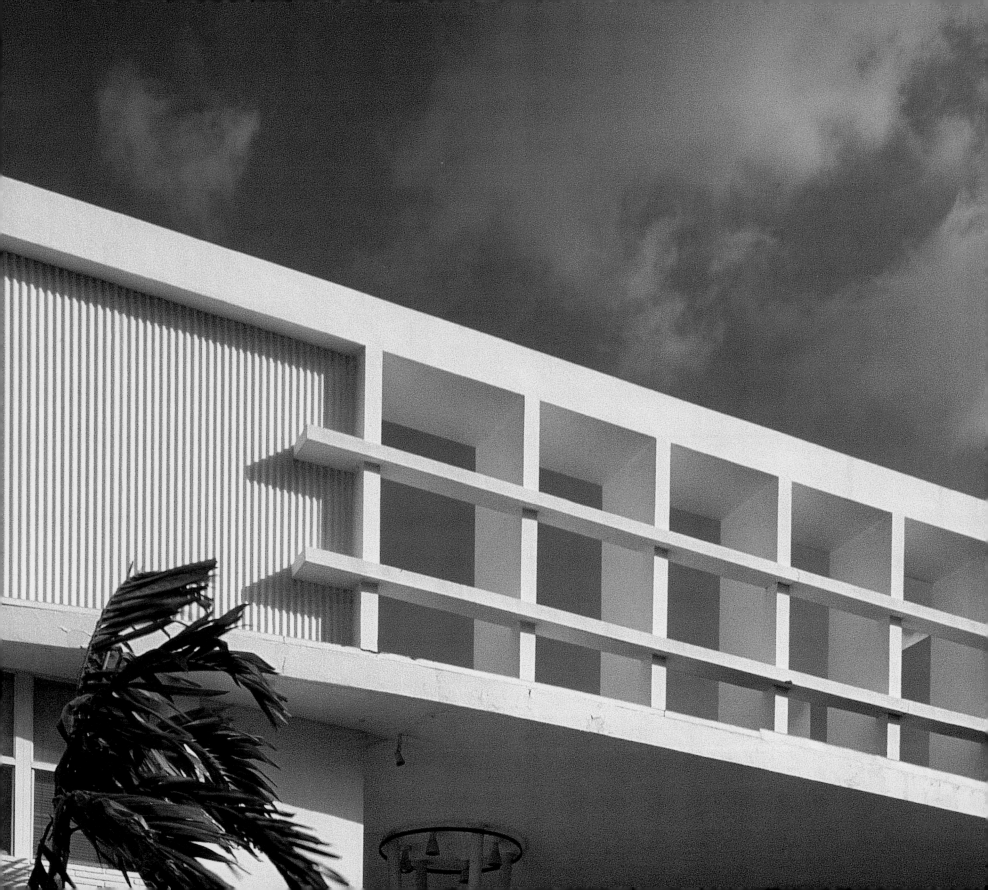

FOREVER FABULOUS

TEN

MiMo architecture is at a tipping point. Just in the course of writing this book, MiMo highpoints like the Saxon Manor Apartments and the original accordion wall of the Carillon Hotel, both in North Beach, have vanished from the landscape. The kitsch confections of Sunny Isles' Motel Row are vanishing like sand castles at high tide. The same process of destruction and the formation of a nascent preservation movement is being repeated in Fort Lauderdale.

The long senescence of the Carillon is finally giving way to rebirth. The magnificent accordion wall is gone, but will be replicated and given a special place in the new scheme. Astonishingly, the Fontainebleau and the Eden Roc remain undesignated and unprotected, all the more bewildering in light of the tremendous economic gains South Beach received from protecting its Tropical Art Deco heritage.

The newly designated North Beach Resort Local Historic District, encompassing the Casablanca, the Deauville, the new Carillon and the Sherry Frontenac among others, must face twenty-first-century demands for adequate parking.

Unlike the dense, urban, and human-scaled model of South Beach, revitalization of North Beach will require new infill construction in its historically underbuilt center at Seventy-first Street and Abbott Avenue, as well as rerouting pedestrian-unfriendly traffic patterns that resulted from its peculiar geography.

One encouraging sign is that the concept of MiMo architectural conservation is spreading beyond Miami Beach to Bay Harbor Islands and Miami proper. As property values rise on Biscayne Boulevard, protection of its outstanding collections of MiMo buildings becomes imperative. As this book went to press, the City of Miami took the extraordinary step of considering the designation of a MiMo conservation district on Biscayne Boulevard from Fiftieth Street to the Little River, encompassing dozens of motels, sleek gas stations, Robert Law Weed's splendid 5600 Biscayne Boulevard, smart, small-scale office buildings, and even a Wrightian church with a neon cross atop its stone-clad pylon.

With the recent designation of the Vagabond Motel and the tantalizing possibility of the formation of an architectural district, the prognosis for MiMo conservation on Biscayne Boulevard is promising. As is often the case in historic preservation success stories, the boulevard's economic decline may turn out to be its salvation. Nearly all of the boulevard motels remain, and the only real damage has been misguided attempts at updating them.

The challenge for the MiMo preservation movement will be to find creative means of adaptive reuse of older structures, like the Biscayne Boulevard motels. As part of a student competition sponsored by Design+Architecture Day 2000, Teri D'Amico, a leader in the MiMo preservation movement and adjunct professor at the Florida International University School of Architecture, taught an interior design studio on retrofitting boulevard motels for new uses. Students proposed new uses ranging from retail to live-work projects.

However, owners of the Biscayne Boulevard motels must still be convinced of the economic benefits of preservation. The effort to bring back from the brink the Hampton House, a MiMo landmark of Miami's African-American legacy, requires raising of significant funding.

The process of modernization in the 1950s and 1960s left Greater Miami with a complex architectural legacy. To be sure, not everything from that period in Miami was good: expressways cut damaging swaths of blight across the city, Miami Beach's extraordinary architectural heritage was seen as an embarrassment and everywhere pedestrian scale was given a backseat to parking and automobile access. Public buildings mystifyingly plopped in the middle of parks, completely out of touch with their environs. The choices are not simple: even Igor B. Polevitzky's exquisite Shelborne Hotel of 1940 was marred by an enormous addition designed by none other than Morris Lapidus, the godfather of the whole movement.

The hope is that this book will help distinguish what is worthwhile and exceptional about this much misunderstood and maligned era in architecture, and that South Florida will be able to save for future generations the best of this formative period from its brief yet epochal life.

BIBLIOGRAPHY

Allman, T. D. *Miami: City of the Future*. New York: The Atlantic Monthly Press, 1987.

Armbruster, Ann. *The Life and Times of Miami Beach*. New York: Alfred A. Knopf, 1995.

Bacon, James. *How Sweet It Is: The Jackie Gleason Story*. New York: St. Martin's Press, 1985.

Bayley, Stephen. *Harley Earl and the Dream Machine*. New York: Alfred A. Knopf, 1983.

Bruce, Lenny. *How to Talk Dirty and Influence People: An Autobiography*. Chicago: Playboy Press, 1972.

Capitman, Barbara Baer. *Deco Delights: Preserving the Beauty and Joy of Miami Beach Architecture*. New York: E. P. Dutton, 1988.

City of Miami Beach Planning Department, Design, Preservation and Neighborhood Planning Division. "Collins Waterfront Historic District Designation Report." August 10, 2000.

City of Miami Beach Planning Department, Design, Preservation and Neighborhood Planning Division. "North Beach Resort Historic District Designation Report," August 12, 2003.

Cooper, Gail. *Air-Conditioning America: Engineers and the Controlled Environment, 1900–1960*. Baltimore: The Johns Hopkins University Press, 1998.

Curry, Christopher Wayne. *A Taste of Blood: The Films of Herschell Gordon Lewis*. Great Britain: Creation Books International, 1999.

D'Amico, Teri, and David Framberger, eds. "Beyond the Box: Mid-Century Modern Architecture in Miami and New York." New York: The Municipal Art Society of New York, Exhibition Catalog, 2002.

Dunlop, Beth. *Miami: Trends and Traditions*. New York: Monacelli Press, 1996.

Düttman, Martina, and Friederike Schneider, eds. *Morris Lapidus: Architect of the American Dream*. Boston: Birkhauser, 1992.

Exner, Judith, and Ovid Demaris. *My Story*. Glasgow, Scotland: William Collins & Sons, 1977.

Farrow, Mia. *What Falls Away*. New York: Nan A. Talese, 1997.

Fisher, Jane. *Fabulous Hoosier: A Story of American Achievement*. New York: Robert M. McBride, 1947.

Gehman, Richard. *Sinatra and His Rat Pack*. New York: Belmont Books, 1961.

Giller, Norman M. *An Adventure in Architecture*. Miami Beach: Virgo Press, 1976.

Henry, William A., III. *The Great One: The Life and Legend of Jackie Gleason*. New York: Doubleday, 1992.

Hess, Alan. *Googie: Fifties Coffee Shop Architecture*. San Francisco: Chronicle Books, 1985.

Hine, Thomas. *Populuxe*. New York: Alfred A. Knopf, 1986.

Hitchcock, Henry-Russell, and Philip Johnson. *The International Style*. New York: W. W. Norton, 1995.

House Beautiful, "The 1954 Pace Setter House." November 1953.

Jung, C. G. *Flying Saucers*. New York: MJF Books, 1978.

Kelley, Kitty. *His Way: The Unauthorized Biography of Frank Sinatra*. New York: Bantam Books, 1987.

King, Larry, with Peter Occhiogrosso. *Tell It to the King*. New York: G. P. Putnam's Sons, 1988.

King, Larry, and Emily Yoffe. *Larry King*. New York: Simon & Schuster, 1982.

Kleinberg, Howard. *Miami: The Way We Were*. Miami: The Miami Daily News, 1985.

Kleinberg, Howard. *Miami Beach: A History*. Miami: Centennial Press, 1994.

Kirsten, Sven A. *The Book of Tiki*. Cologne, Germany: Taschen, 2000.

Lacey, Robert. *Little Man: Meyer Lansky and the Gangster Life*. Boston: Little, Brown, 1991.

Lapidus, Morris. *Architecture: A Profession and a Business*. New York: Reinhold Publishing Company, 1967.

Lapidus, Morris. *Too Much Is Never Enough: An Autobiography*. New York: Rizzoli, 1996.

Lenček, Lena, and Gideon Bosker. *The Beach: The History of Paradise on Earth*. New York: Viking, 1998.

Levy, Shawn. *King of Comedy: The Life and Art of Jerry Lewis*. New York: St. Martin's Press, 1996.

Lewis, Jerry. *The Total Film-Maker*. New York: Warner Paperback Library, 1973.

Mailer, Norman. *Miami and the Siege of Chicago: An Informal History of the Republican and Democratic Conventions of 1968*. New York: Signet Books, 1968.

Mehling, Harold. *The Most of Everything: The Story of Miami Beach*. New York: Harcourt, Brace and Company, 1960.

Nagler, Richard. *My Love Affair With Miami Beach*. New York: Simon & Schuster, 1991.

Pancoast, Russel T., and James Deen. *A Guide to the Architecture of Miami*. Miami: American Institute of Architects, Florida South Chapter, 1963.

Parker, Alfred Browning. *You and Architecture: A Practical Guide to the Best in Building*. New York: Delacorte Press, 1965.

Parks, Arva Moore. *Miami: The Magic City*. Miami: Centennial Press, 1991.

Parks, Arva Moore, and Carolyn Klepser. *Miami: Then and Now*. San Diego: Thunder Bay Press, 2002.

Peters, Thelma. *Lemon City: Pioneering on Biscayne Bay, 1850–1925*. Miami: Banyan Books, 1976.

Rayl, A. J. S. *Beatles '64: A Hard Day's Night in America*. New York: Doubleday, 1989.

Redford, Polly. *Billion-Dollar Sandbar: A Biography of Miami Beach*. New York: E. P. Dutton & Co., 1970.

Remnick, David. *King of the World*. New York: Vintage, 1998.

Ringgold, Gene, and Clifford McCarty. *The Films of Frank Sinatra*. New York: The Citadel Press, 1971.

Sadowsky, Sandy, and H. B. Gilmour. *Wedded to Crime: My Life in the Jewish Mafia*. New York: Berkley Books, 1993.

Saxton, Martha. *Jayne Mansfield and the American Fifties*. New York: Bantam Books, 1975.

Schulke, Flip, and Matt Schudel. *Muhammad Ali: The Birth of a Legend, Miami, 1961–1964*. London: Souvenir Press, 1999.

Scully, Vincent. *Modern Architecture: The Architecture of Democracy*. New York: George Braziller, 1974.

Singer, Arthur J. *Arthur Godfrey: The Adventures of an American Broadcaster*. Jefferson, N.C.: McFarland & Company, 2000.

Standiford, Les. *Last Train to Paradise: Henry Flagler and the Spectacular Rise and Fall of the Railroad That Crossed an Ocean.* New York: Crown Publishers, 2002.

Starr, Michael Seth. *Mouse in the Rat Pack: The Joey Bishop Story.* New York: Taylor Trade Publishing, 2002.

Suberman, Stella. *When It Was Our War: A Soldier's Wife in World War II.* Chapel Hill, N.C.: Algonquin Books of Chapel Hill, 2003.

Swarthout, Glendon. *Where the Boys Are.* New York: Signet Books, 1960.

Teitelbaum, James. *Tiki Road Trip: A Guide to Tiki Culture in North America.* Santa Monica, Calif: Santa Monica Press, 2003.

Venturi, Robert, Denise Scott Brown, and Steven Izenvour. *Learning from Las Vegas.* Cambridge, Mass.: The MIT Press, 1989.

Waters, John. *Shock Value: A Tasteful Book About Bad Taste.* New York: Thunder's Mouth Press, 1995.

Weatherby, W. J. *Jackie Gleason: An Intimate Portrait of the Great One.* New York: Pharos Books, 1992.

Weidling, Philip, and August Burghard. *Checkered Sunshine: The History of Fort Lauderdale 1793–1955.* Fort Lauderdale, Fla: Wake-Brook House, 1974.

Wilson, Earl. *Sinatra: An Unauthorized Biography.* New York: Macmillan, 1976.

Wright, Mary, and Russel Wright. *Guide to Easier Living.* New York: Simon & Schuster, 1951.

ACKNOWLEDGMENTS

Eric P. Nash would personally like to thank: Don and Nina Worth, for their warmth and love of all things Floridian, from Weeki Wachee to The Creature from the Black Lagoon, and to Don, for godfathering the whole project; Robin and Cindy Hill for opening their hearts and home to me; my sister, Laura, for taking the heat; Lisa Palley, publicist extraordinaire, for making all the introductions; John Kriskiewicz, for keeping the pulse of all things modern, and to Randall Robinson, my own Virgil to the wonders of Miami.

Also, thanks to Alan E. Rapp at Chronicle for keeping our eyes on the prize; Norman Giller, Al Parker, Ken Treister and, in memoriam, Gilbert Fein, gentlemen of the old school, and Laurinda Hope Spear, their counterpart.

To Tess, and the summer wind. And to the people of Miami Beach, the greatest audience in the world!

Randall C. Robinson, Jr. would personally like to thank: My parents, for my mostly modern upbringing; Teri D'Amico for sharing her eyes, her passion and her laughter and for always being there; Allan Shulman, Jan Hochstim, Rick Ferrer, Juan Lezcano, and Ari Millas for exposing me to the full breadth of the subject; Larry Wiggins, for his stellar collection of vintage postcards, many of which are reproduced in this volume; my bosses at the Miami Beach Community Development Corporation, Denis Russ for supporting MiMo from the very beginning, and more recently to Roberto Datorre, for his patience and understanding during the writing of the book.

Also, Jacques Caussin and Tony Fusco, for welcoming "This Is MiMo" with open arms at the Miami Modernism Show and Sale; Laurie "Lulu" Swedroe, Donald Shockey and Su Rudy at NBDC, for the encouragement and the resources; Amy Seidman for quoting Ira Gershwin: "A Title is Vital"; Glenn Albin and Bill Wisser at Ocean Drive Magazine for getting the scoop; Nina Korman and Emma Trelles, the muses of Biscayne Boulevard, for massaging the meaning; William Cary and Joyce Meyers at the City of Miami Beach Planning Department, and Eric Nash for making the connection.

To Design+Architecture Day and the spirit of Judith Arango, Excelsior!

Our thanks to the following for their time, support and encouragement: Nancy Liebman, Carolyn Klepser, Reuben Caldwell, Saul and Jane Gross, Neisen Kasdin, Burt Harrison, Michael Hughes, Sarah Ingle, Sarah Eaton, Raelene Mercer, Dick and Merrie Thomas, Joe and Betty Fleming, Bill Lane, Michael Larkin, Beth Dunlop, Mitch Novick, Mike Kerwin and AIA Miami, Arva Parks McCabe, Anne Swanson, Tony Abbate, Diane and Bill Smart, Shelly Shiner, Don Siedler, Peter Whoriskey, Maria Ricapito, Sonji Jacobs, Amy Streelman, Richard Aleman, Wayne Curtis, Mark Cantor, Barbara Hoffman, Esq., George Neary, Clotilde Luce, David Framberger and Leonard Wien Jr.

Additionally, the authors would like to acknowledge the contributions of the volunteer Urban Arts Committee of Miami Beach, which organized and curated two major MiMo shows, "Miami Modern Architecture, 1945–1972: A Photography Exhibit" and "Beyond the Box: Mid-century Modern Architecture in Miami and New York," for which many of the images that appear in this book were originally commissioned.

The photography exhibits would not have been possible without the generous sponsorship of the North Beach Development Corporation, and the support of Jerry Libbin, Barry Klein, T. Neil Fritz, Jeannie Tidy, and Cristina Fernandez. All rights to the exhibit photographs are owned by the North Beach Development Corporation and may be reprinted only with their express written permission.

Finally, special thanks to all the individual, corporate and organizational sponsors that helped the Urban Arts Committee put MiMo in its best light.

For more information on MiMo, search www.mimo.us, the website of the Urban Arts Committee of Miami Beach, www.gonorthbeach.com, the website of the North Beach Development Corporation, and www.theseymour.org, the website of the Miami Architecture Project.

INDEX